GETTING STARTED IN
DRAWING

WENDON BLAKE

with drawings by
FERDINAND PETRIE

NORTH LIGHT BOOKS

Cincinnati, Ohio

Getting Started in Drawing. Copyright © 1991 by Don Holden. Printed and bound in the United States of America. All rights reserved. No part of this book may be reproduced in any form or by any electronic or mechanical means including information storage and retrieval systems without permission in writing from the publisher, except by a reviewer, who may quote brief passages in a review. Published by North Light Books, an imprint of F&W Publications, Inc., 1507 Dana Avenue, Cincinnati, Ohio 45207. (800) 289-0963. First edition.

Other fine North Light Books are available from your local bookstore or direct from the publisher.

00 99 98 97 96 14 13 12 11 10

Library of Congress Cataloging-in-Publication Data

Blake, Wendon.
 Getting started in drawing / by Wendon Blake ; with drawings by
Ferdinand Petrie.—1st ed.
 p. cm.
 Includes index.
 ISBN 0-89134-361-X (hrdcvr.)
 1. Drawing—Technique. I. Title.
NC730.B353 1991
741.2—dc20
 90-22370
 CIP

Edited by Mary Cropper
Designed by Carol Buchanan and Sandy Conopeotis

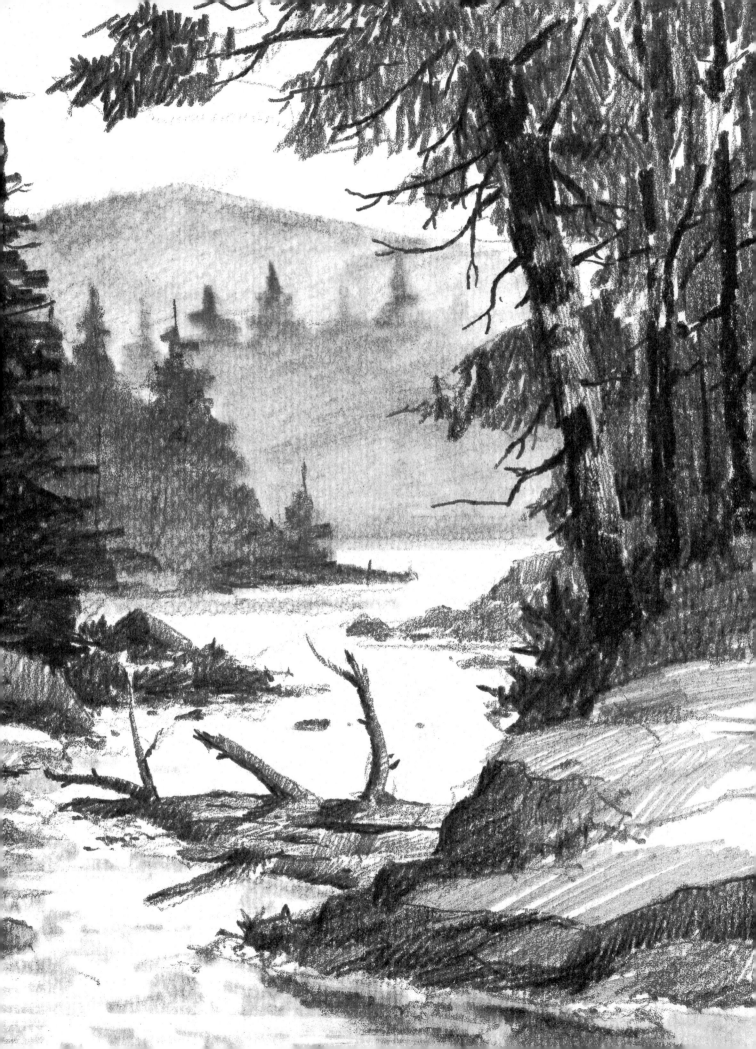

TABLE OF CONTENTS

INTRODUCTION

THE BASICS

PENCIL DRAWING

CHALK DRAWING

CHARCOAL DRAWING

INTRODUCTION

Starting to Draw. Learning to draw what you see is one of life's most delightful accomplishments. And it's a surprisingly simple accomplishment. It's probably true that great artists are born, not made, but drawing what you see is a skill that anyone can learn. Yes, anyone! Creating a *masterpiece* takes genius, of course, but a simple, accurate drawing doesn't even take talent — just reasonable intelligence and the willingness to work. Learning to draw is like learning a sport or a musical instrument: the whole secret is steady practice. If you make the decision to set aside two or three hours for a drawing session at least once a week — preferably two or three times a week — you'll discover that your drawing skill increases gradually, but steadily. Obviously, the more often you draw the more quickly you'll learn, so you'll learn twice as fast if you increase your schedule from once a week to twice a week. When you get into the habit of drawing regularly, you'll make the marvelous discovery that it's not work at all, but pure joy. You'll find that drawing is a pleasure for its own sake. If your goal is to improve your painting, you'll find that your painting skills leap ahead as you develop a greater command of drawing.

Drawing Is Logical. The ability to draw what you see isn't some magical, intuitive talent, but a simple, logical process. If you can learn to draw a few geometric shapes — cubes, cylinders, spheres, and cones — you can learn to draw practically anything. A tree trunk, for example, is basically a cylinder, while the mass of leaves often looks like a ragged sphere with holes punched in it. In the same way, a rock formation often looks like a collection of broken cubes, while many evergreens are basically cones. And if

you look at portrait drawings by Renaissance artists, you'll find that these master draftsmen often visualized the head as an egg, which is really just an elongated sphere. In the pages that follow, you'll learn to draw these basic geometric shapes and then you'll see how to convert them into the forms of nature.

Developing Your Observation. As artists and art teachers have been saying for centuries, learning to draw begins with learning to *see*. So you'll begin by learning how to measure height, width, and proportions in your mind's eye. Then you'll learn the elements of perspective, since a knowledge of perspective will help you draw objects that really look three-dimensional. Since the world is full of color, but drawings are black and white, it's also essential to learn about *values* — a word that needs some explanation. When you look at the colors of nature, you have to pretend that your mind is a camera loaded with black-and-white film that records the hues of nature as black, white, and various shades of gray. Value is the comparative darkness or lightness of your subject. Thus, a deep green pine tree has a dark value, which you'd draw as a dark gray. A sunlit beach is apt to have a light value, which you'd draw as a pale gray — or perhaps you'd leave the paper untouched so that the sand comes out white. Learning to make accurate value judgments will not only benefit your drawing, but will make a tremendous difference in the accuracy of your paintings.

Drawing Basic Forms. Your next step is to learn how to draw those basic forms — the cube, cylinder, cone, sphere, and egg — and transform them into specific shapes such as a basket, a jar, an evergreen,

an apple, and a head. You'll also learn how to construct nongeometric forms as the basis for drawing erratic shapes such as mountains and foliage.

Demonstrations. Building on this foundation, you'll learn how to do complete drawings of still lifes, landscapes, and portraits. Each demonstration is presented in logical steps that you can apply in your own drawings. And each of these step-by-step demonstrations is executed in one of three media — pencil, chalk, or charcoal — to give you a survey of the various ways of using drawing media. You'll see how to build contours and tones with lines, strokes, blending, and combinations of these methods. The demonstrations are executed on various types of paper so you'll see how pencil, chalk, and charcoal behave on different drawing surfaces. Try as many alternatives as possible to find your own way and discover which materials and methods seem most natural to you.

How to Use This Book. Because learning to draw is a logical process, the demonstrations and projects in this book are arranged in a logical sequence. You'll learn most rapidly if you follow this sequence, trying out the various drawing methods in the order in which they appear in the book — rather than dipping into the book at random and trying out the methods that appeal to you. The heart of the book is a series of twenty demonstrations with suggested drawing projects that build on what you've learned from the demonstrations. If you follow the logic of the book, the logic of drawing will gradually emerge within you — and will give you a lifetime of pleasure.

Keys to Section 1
THE BASICS

Section 1 presents drawing as an enjoyable skill that's easily learned. Begin by developing your powers of observation and transforming simple shapes into specific objects. Important keys to remember are:

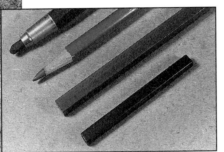

Choose the right equipment, whichever medium or paper you prefer, and get off to a good start. Experiment with a variety of pencils, chalks, charcoal and papers to expand your drawing skills.

Create the illusion of depth with perspective. What you know isn't necessarily what you see, so analyze your subjects before you begin. Discover how things change when you draw from different eye levels.

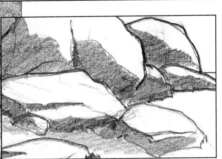

Translate colors into shades of gray when you draw in black and white. Contrast and compare values to establish tonal relationships. Simplify a picture to just a few values: Try to use only three or four.

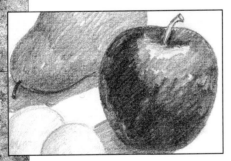

Draw almost anything by learning to draw simple geometric shapes. Even landscapes can be broken down into cubes, cylinders, spheres, and cones.

Simplify irregular shapes to make them easier to draw. Build your drawing from simple shapes to the more complex details that you see. Use very few lines; you can always add more.

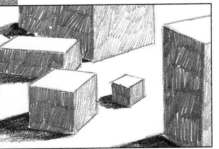

Drawing is easier when you approach it in four basic steps. Identify geometric shapes, create realistic contours, block in broad shadows, and finally, concentrate on polishing your work.

BEFORE YOU START

Keep It Simple. The best way to start drawing is to get yourself just two things: a pencil and a pad of white drawing paper about twice the size of the page you're now reading. An ordinary office pencil will do — but test it to make sure that you can make a pale gray line by gliding it lightly over the paper, and a rich black line by pressing a bit harder. If you'd like to buy something at the art supply store, ask for an HB pencil, which is a good all-purpose drawing tool, plus a thicker, darker pencil for bolder work, usually marked 4B, 5B, or 6B. Your drawing pad should contain sturdy white paper with a very slight texture — not as smooth as typing paper. (Ask for cartridge paper in Britain.) To get started with chalk drawing, all you need is a black pastel pencil or a Conté pencil. And just two charcoal pencils will give you a good taste of charcoal drawing: get one marked "medium" and another marked "soft." You can use all these different types of pencils on the same drawing pad.

Pencils. When we talk about pencil drawing, we usually mean *graphite* pencil. This is a cylindrical stick of black, slightly slippery graphite surrounded by a thicker cylinder of wood. Artists' pencils are divided roughly into two groupings: soft and hard. A soft pencil will make a darker line than a hard pencil. Soft pencils are usually marked B, plus a number to indicate the degree of softness—3B is softer and blacker than 2B. Hard pencils are marked H and the numbers work the same way — 3H is harder and makes a paler line than 2H. HB is considered an all-purpose pencil because it falls midway between hard and soft. Most artists use more soft pencils than hard pencils. When you're ready to experiment with a variety of pencils, buy a full range of soft ones from HB to 6B. You can also buy cylindrical graphite sticks in various thicknesses to fit into metal or plas-

tic holders. And if you'd like to work with broad strokes, you can get rectangular graphite sticks about as long as your index finger.

Chalk. A black pastel pencil or Conté pencil is just a cylindrical stick of black chalk and, like the graphite pencil, it's surrounded by a cylinder of wood. But once you've tried chalk in pencil form, you should also get a rectangular black stick of hard pastel or Conté crayon. You may also want to buy cylindrical sticks of black chalk that fit into metal or plastic holders.

Charcoal. Charcoal pencils usually come in two forms. One form is a thin stick of charcoal surrounded by wood like a graphite pencil. Another form is a stick of charcoal surrounded by a cylinder of paper that you can peel off in a narrow strip to expose fresh charcoal as the point wears down. When you want a complete "palette" of charcoal pencils, get just three of them, marked "hard," "medium," and "soft." (Some manufacturers grade charcoal pencils HB through 6B like graphite pencils; HB is the hardest and 6B is the softest.) You should also buy a few sticks of natural charcoal. You can get charcoal "leads" to fit into metal or plastic holders like those used for graphite and chalk.

Paper. You could easily spend your life doing wonderful drawings on ordinary white drawing paper, but you should try other kinds. Charcoal paper has a delicate, ribbed texture and a very hard surface that makes your stroke look rough and allows you to blend your strokes to create velvety tones. And you should try some *really* rough paper with a ragged, irregular "tooth" that makes your strokes look bold and granular. Ask your art supply dealer to show you his roughest drawing papers. Buy a few sheets and try them out.

Erasers (Rubbers). For pencil drawing, the usual eraser is soft rubber, generally pink or white, which you can buy in a rectangular shape about the size of your thumb or in the form of a pencil, surrounded by a peel-off paper cylinder like a charcoal pencil. For chalk and charcoal drawing, the best eraser is kneaded rubber (or putty rubber), a gray square of very soft rubber that you can squeeze like clay to make any shape that's convenient. A thick, blocky soap eraser is useful for cleaning up the white areas of the drawing.

Odds and Ends. You also need a wooden drawing board to support your drawing pad — or perhaps a sheet of soft fiberboard to which you can tack loose sheets of paper. Get some single-edge razor blades or a sharp knife (preferably with a safe, retractable blade) for sharpening your drawing tools; a sandpaper pad (like a little book of sandpaper) for shaping your drawing tools; some pushpins or thumbtacks (drawing pins in Britain); a paper cylinder (as thick as your thumb) called a stomp, for blending tones; and a spray can of fixative, which is a very thin, virtually invisible varnish to keep your drawings from smudging.

Work Area. When you sit down to work, make sure that the light comes from your left if you're right-handed, and from your right if you're left-handed, so your hand won't cast a shadow on your drawing paper. A jar is a good place to store pencils, sharpened end up to protect the points. Store sticks of chalk or charcoal in a shallow box or in a plastic silverware tray with convenient compartments — which can be good for storing pencils too. To keep your erasers clean, store them apart from your drawing tools — in a separate little box or in a compartment of that plastic tray.

CHOOSING YOUR EQUIPMENT

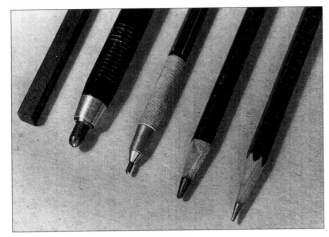

Pencils. The common graphite pencil comes in many forms. Looking from right to left, you see the all-purpose HB pencil; a thicker, softer pencil that makes a broader, blacker mark; a metal holder that grips a slender, cylindrical lead; a plastic holder that grips a thick lead; and finally, a rectangular stick of graphite that makes a broad, bold mark on the paper. It's worthwhile to buy some pencils, as well as two or three different types of holders to see which ones feel most comfortable in your hand.

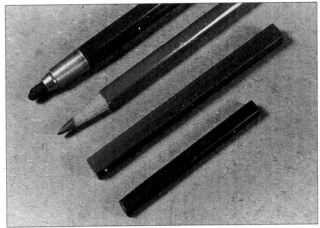

Chalk. Shown here are four kinds of chalk. Looking from the lower right to the upper left, you see the small, rectangular Conté crayon; a larger, rectangular stick of hard pastel; hard pastel in the form of a pencil that's convenient for linear drawing; and a cylindrical stick of chalk in a metal holder. All these drawing tools are relatively inexpensive, so it's a good idea to try each one to see which you like best.

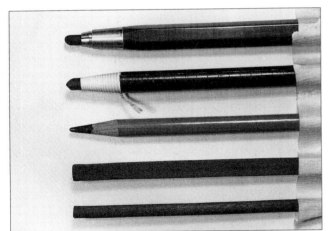

Charcoal. This versatile drawing medium comes in many forms. Looking up from the bottom of this photo, you see a cylindrical stick of natural charcoal; a rectangular stick of natural charcoal; a charcoal pencil; another kind of charcoal pencil — with paper that you gradually tear away as you wear down the point; and a cylindrical stick of charcoal in a metal holder. Natural charcoal smudges and erases easily, so it's good for broad tonal effects. A charcoal pencil makes firm lines and strokes, but the strokes don't blend as easily.

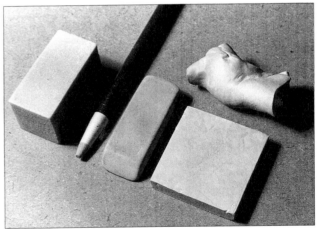

Erasers (Rubbers). From left to right, you see the common soap eraser, best for cleaning broad areas of bare paper; a harder, pink eraser in pencil form for making precise corrections on small areas of graphite pencil drawings; a bigger pink eraser with wedge-shaped ends for making broader corrections; and a square of kneaded rubber (putty rubber) that's best for chalk and charcoal drawing. Kneaded rubber squashes like clay (as you see in the upper right) and can take any shape you want. Press the kneaded rubber down on the paper and pull away; scrub only when necessary.

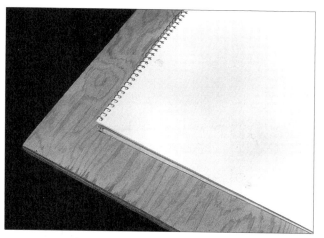

Drawing Board and Pad. Drawing paper generally comes in pads that are bound on one edge like a book. Most convenient is a spiral binding like the one you see here, since each page folds behind the others when you've finished a drawing. The pad won't be stiff enough to give you proper support by itself, so get a wooden drawing board from your art supply store — or simply buy a piece of plywood or fiberboard. If you buy your drawing paper in sheets rather than pads, buy a piece of soft fiberboard to which you can tack your paper.

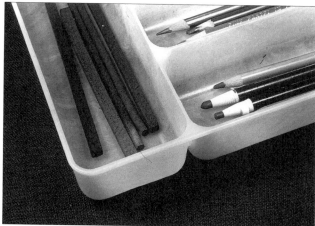

Storage. Store your pencils, sticks of chalk, and sticks of charcoal with care — don't just toss them into a drawer where they'll rattle around and break. The compartments of a silverware container (usually made of plastic) provide good protection and allow you to organize your drawing tools into groups. Or you can simply collect a few long, shallow cardboard boxes — the kind that small gifts often come in.

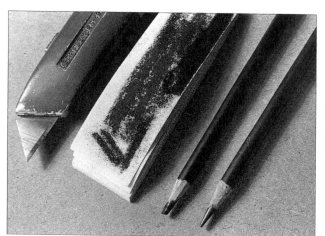

Knife and Sandpaper Pad. The pencil at the right has been shaped to a point with a mechanical pencil sharpener. The other pencil has been shaped to a broader point with a knife and sandpaper. The knife is used to cut away the wood without cutting away much of the lead. Then the pencil point is rubbed on the sandpaper to create a broad, flat tip. Buy a knife with a retractable blade that's safe to carry. To the right of the knife is a sandpaper pad that you can buy in most art supply stores; it's like a small book, bound at one end so you can tear off the graphite-coated pages.

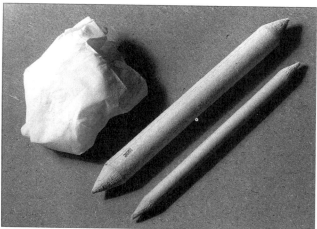

Stomps and Cleansing Tissue. To blend charcoal and push the blended tones into tight corners, you can use stomps of various sizes. A stomp is made of tightly rolled paper with a tapered end and a sharp point. Use the tapered part for blending broad areas and the tip for blending small areas. A crumpled cleansing tissue can be used to dust off an unsatisfactory area of a drawing done in natural charcoal. (It's harder to dust off the mark of a charcoal pencil.) You can also use a tissue to spread a soft tone over a large area.

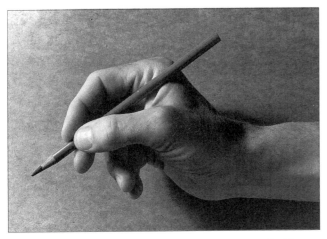

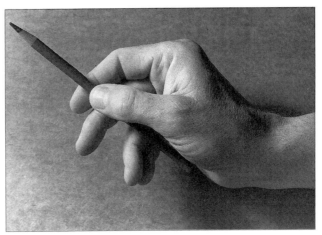

Holding the Pencil. There are two ways to hold a pencil. The most common method is to grip the pencil just as you do when you're signing your name. However, it's important to grip the pencil a bit farther back from the point, as you see here. This will give you a bolder, freer line. In fact, you might like to experiment with holding the pencil even farther back — particularly if you're making a large drawing, such as a life-size head.

Another Way. Many professionals hold the pencil as an orchestra conductor holds the baton. This grip encourages you to work with bold, rhythmic, sweeping strokes. Since it's best to work with your paper on a vertical or diagonal surface — rather than flat on a table — you may find this a convenient grip. Try holding the pencil this way and moving your entire arm as you draw.

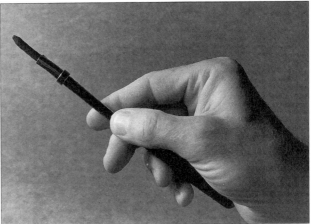

Holding the Chalk. Hold the stick of chalk the way a conductor holds the baton — *not* the way you'd normally hold a pencil. Holding a piece of chalk like a baton encourages you to make big, rhythmic movements that will give your drawing a feeling of boldness and freedom. If you're drawing with a pastel pencil or a stick of chalk in a metal holder, you may find it more comfortable to hold the tool like a pencil; but these tools also feel comfortable in the baton grip.

Holding Charcoal. When a stick of natural charcoal breaks or wears down to a small piece, you can buy a holder to grip that last fragment. Handle the holder as you'd grip a brush, keeping your fingers far back from the point so you'll draw with bold lines. If you're just working with a stick of natural charcoal — no holder — grip it the same way, but keep your fingers closer to the tip or the stick will break. When you draw with a charcoal pencil, you can try this same grip or you can hold it in the way you handle a pencil to sign your name.

WARMING UP

Contour Drawing. One of the simplest ways to get started is to arrange a few household objects on a table-top and make some contour drawings in pencil. Just sharpen your pencil to a crisp point and draw the edges of the shapes with continuous, wiry lines. Try to imagine that the point of the pencil is your fingertip, which you carefully move around the edge of the shape that you're drawing. Don't look at your drawing too often. As much as possible, keep your eye on the subject while you draw. Contour drawing is good training because it teaches you to look carefully and draw shapes simply.

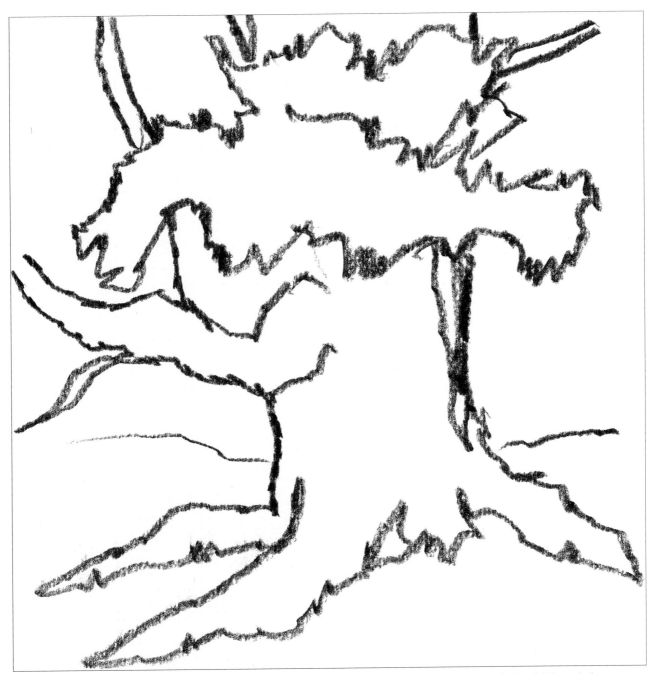

Groping Line. Now try another contour drawing with a thick, blunt pencil — or any pencil that's been worn down to a blunt point. Let your eye move *very* slowly around the shapes of the subject, while the pencil gropes its way slowly across the paper. Try to draw with as few lines as possible. And do your best to keep your eye on the subject while you draw. Don't look at the paper too often. Don't worry if your line looks thick and clumsy — in contrast with the thinner, more elegant line of the first contour drawing. A drawing doesn't have to be elegant to be beautiful. A thick line can also be powerful and expressive. The value of this groping line exercise is to make you slow down, look carefully, and capture the essential shapes of your subject without fussing about details.

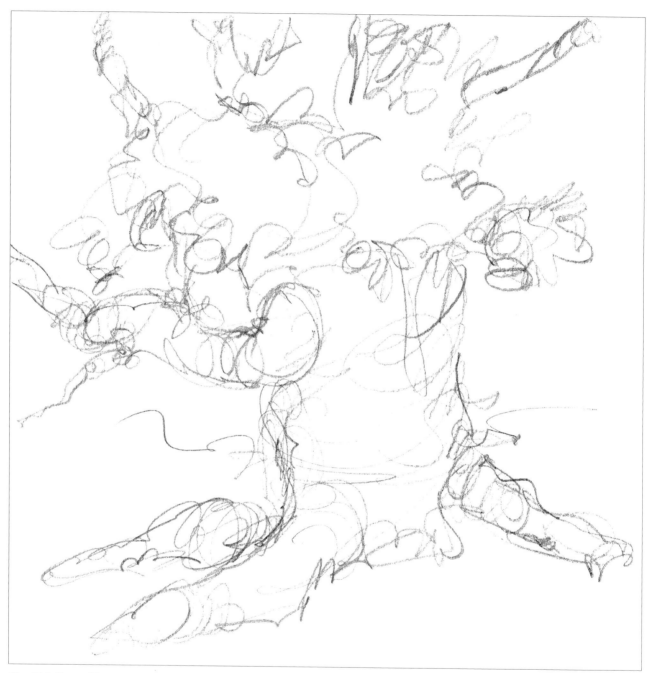

Scribbling. Now try a warm-up that's radically different from contour drawing and the groping line exercise you've just done. Working with a sharply pointed pencil once again, let your eye wander over the subject while your hand scribbles round and round on the drawing paper. Keep the pencil moving, whizzing back and forth, up and down, in zigzags and circles. You're not trying to trace the precise contours of each shape, but trying to capture the *overall shape* of the subject with rapid, intu-

itive movements of your pencil. Your scribbled drawing will look a lot messier than the other drawings you've made — but the scribbles will also have a lot of vitality and spontaneity. And that's what this warm-up teaches you: to draw freely and spontaneously, trusting your intuition and simply "letting go." In its own way, this scribbled drawing of the tree trunk is every bit as good as the more careful contour drawing and the groping line drawing.

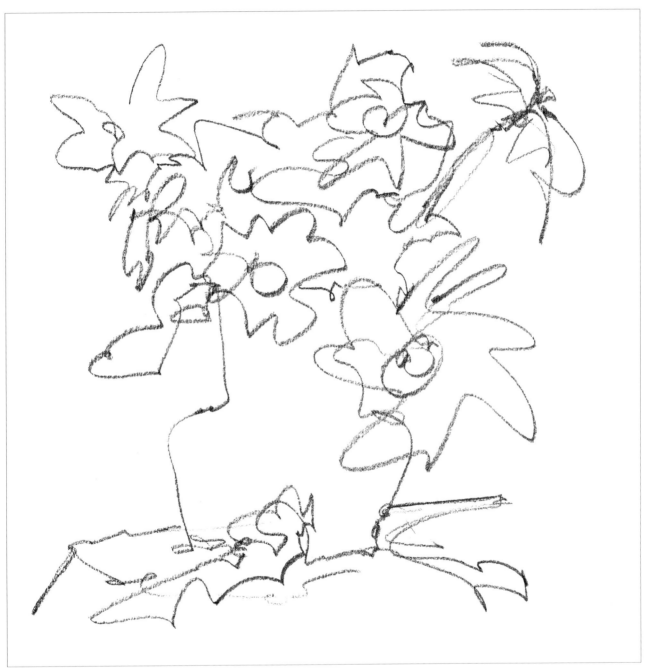

Gesture Drawing. Like scribbling, gesture drawing is a rapid process. However, the purpose of gesture drawing isn't to capture the geometric *form* of the subject, but its "movement." Of course, this vase of wild flowers is sitting quietly on a tabletop. But your *eye* moves rapidly over the subject, traveling in zigzags or graceful arcs or straight lines, depending upon the subject's form. Thus, the subject does communicate a sense of movement after all, and the purpose of a gesture drawing is to capture this dynamic feeling. Pick up a pencil and race swiftly over the subject as your eye moves. Don't stop to render shapes or contours precisely, but allow your pencil to dance freely over the paper, following the movement of the subject as a dancer follows the music. Every subject has a kind of inner vitality that's more than the eye sees — and gesture drawing helps you discover it.

DRAWING TIPS

Setting Up. Unless your drawing pad is large and stiff, rest the pad on a drawing board. If you're working with loose sheets of drawing paper, make a stack of several sheets and tack them to a piece of soft fiberboard. Resting on several other sheets, the top sheet will feel more resilient and responsive to your drawing tool. When you're working at home, prop your drawing board against the back of a chair or a stack of books so that your drawing surface will be vertical or slanted. Try to avoid drawing on a horizontal surface such as your lap or a tabletop. Your hand will move more freely on an upright or slanted surface, and you can see your subject more easily. If your budget permits, you may want to buy an upright drawing easel or a drawing table with a top that tilts to whatever angle you find comfortable.

Move Your Whole Arm. Drawing is like playing tennis: move your whole arm, not just your fingers or your wrist. If you watch professionals at work, you'll be surprised to discover that they move the entire arm, from the shoulder down, with a rhythmic motion, even when drawing something quite small. If you move just your fingers or your wrist, your lines will have a cramped, fidgety feeling. If you move your whole arm, even small lines will have a rhythmic, swinging feeling.

Warming Up. Drawing is also like a sport in the sense that it's wise to warm up. A life drawing class in an art school usually begins with a series of quick poses — from one to five minutes — that force you to record what you see with a few rapid strokes. Even if you're working at home, whether your subject is a still life or a model, start with a few quick sketches to loosen up. Your line will be freer, bolder, and more decisive for the rest of the drawing lesson.

Start with the Big Shapes. Always begin by drawing the biggest, simplest shapes of your subject with a few bold lines. Draw the boxlike shape of the rock or the egg shape of the head before you worry about the precise contours. When you've got the general shape and proportions right, then you can begin to sharpen the contours. In the same way, "rough in" the broad shapes of the shadows. When you're sure about the broad, overall contours and the large areas of light and shadow, then you can begin to think about making your lines and tones more precise. Save details — like the cracks in the rock or the sitter's eyelashes — for the very end.

Vantage Point. Before you draw, move around a bit and decide where you'd like to stand or sit. A slight change in your vantage point can make a tremendous difference in your drawing. Even if your subject is something as simple as a few pieces of fruit on a table, the lighting and composition may change dramatically if you move just one step to the right or left. From one angle, you may see a lot of light on the shapes but not much shadow. From another angle, you'll see more shadow. And the shapes may look a lot more dramatic from a different vantage point. Standing or sitting can also make a big difference. Some portrait sitters will look far more attractive if they're seated while you're standing, so you look at them from slightly above. When you're drawing the figure, distance is important. If you get too close, it's hard to see the total figure and your drawing may be distorted because you're working piecemeal, first focusing on the torso, then on the limbs, and then on the head. Step back a few paces so you can see the whole figure. When you're drawing outdoors, it's even more important to keep moving until you find the right vantage point. Those trees might look much more dramatic if you walked around them until you saw them silhouetted against the sun. Climbing a cliff may give you a more sweeping view of the shore, while drawing that same cliff from the bottom will make the rock formation look taller and craggier against the sky.

Organizing Your Own Life Class. To pay for a professional model, you can join with a group of friends to organize your own life class, sharing the cost of the model. Place the model where the light from a big window or skylight strikes the figure from one side and from slightly in front, producing what's known as three-quarter lighting — often called "form lighting" because it's easiest to see the three-dimensional shapes. If you don't have enough natural light, place lighting fixtures where they'll give you the best three-quarter light. Try to find lighting fixtures that will give you a soft, diffused light that looks like natural light — avoid harsh spotlights and photographic floodlights. If you start with a series of short poses, remember that these poses can be tiring; give the model a five-minute rest period every twenty minutes. The model can probably hold a simple standing pose for twenty minutes and a reclining pose for twenty to thirty minutes before taking a break. The model's comfort is important: keep the studio warm; give the model a private room (or at least a screen) for changing clothes; encourage the model to tell you if a pose turns out to be a problem; and be sure to invite the model to share your coffee or tea break.

PRESERVING YOUR DRAWINGS

Permanence. A drawing made on a thin sheet of paper may not look as rugged as a leathery oil painting on thick canvas—but a drawing is every bit as durable as an oil painting if you take proper care of that sheet of paper. Drawings made by the great masters of Europe have been preserved for five hundred years or more, and the brush drawings of the Japanese and Chinese masters, executed on paper as thin as gossamer, are even older. Works of art on paper are amazingly durable if you work with the right materials, do a good job of matting and framing, and store your drawings with reasonable care.

Choosing the Right Paper. Some papers yellow and crumble in a few years, while others remain white and resilient for centuries. Inexpensive papers are usually made of wood that's ground to pulp. These mass-produced wood pulp papers often start out snow white (or come in lovely colors), have interesting surfaces, and respond beautifully to your drawing tools. But such papers deteriorate with the passage of time. In the beginning, it's wise to buy lots of inexpensive paper so you can draw, draw, draw without worrying about the cost. The more paper you use up, the more rapidly you'll learn. However, once you reach the stage when you're not just practicing, but want to make drawings to save and enjoy for a lifetime — or perhaps exhibit and sell — then you should switch to "100 percent rag" paper. Although few papers are still made of rags (as they were in the last century), manufacturers of the fine papers still use the phrase "100 percent rag" to designate durable paper that's made from chemically pure cellulose fibers.

Drawing Tools and Fixatives. Graphite pencil, black chalk, and charcoal are totally permanent in the sense that they won't fade or change color with the passage of the years. However, they'll smudge if you pass a careless hand over the drawing. Applying a coat of fixative is the simplest method of protecting a drawing from such damage. Fixative is a thin varnish that's virtually invisible. You can buy fixative in spray cans or in bottles. The bottled kind is sprayed with a mouth atomizer that you can buy in any art supply store. A few artists object to fixative because they say that it darkens the drawing slightly, but the difference is minute. A can or a bottle of fixative is standard equipment in the studios of most professionals.

Matting. A mat (called a mount in Britain) is essential protection for a finished drawing. The usual mat is a sturdy sheet of white or tinted cardboard, generally about 4 inches (100 mm) larger than your drawing on all four sides. Into the center of this board, you cut a window slightly smaller than the drawing. You then "sandwich" the drawing between this mat and a second board the same size as the mat. Thus, the edges and back of the picture are protected and only the face of the picture is exposed. When you pick up the drawing, you touch the "sandwich," not the drawing itself.

Boards and Tape. Unfortunately, most mat (or mount) boards are made of wood pulp, which contains corrosive substances that will eventually migrate from your board to discolor your drawing paper. Just as you buy "100 percent rag," chemically pure paper for drawings that you want to last, you've also got to buy chemically pure, museum-quality mat board, sometimes called conservation board. Ideally, the backing board should be the same chemically pure board as the mat. But if your budget is limited, the backing board can be less expensive "rag-faced" illustration board, which is a thick sheet of chemically pure, white drawing paper with a backing of ordinary cardboard. Chemically pure mat board is normally white or cream color, but some manufacturers make it in other colors that you may consider more flattering to your drawings. Too many artists paste their drawings to the mat or backing board with masking tape or Scotch tape. Don't! The adhesive stays sticky forever and will eventually discolor the drawing. The best tape is the glue-coated cloth used by librarians for repairing books. Or you can make your own tape out of strips of discarded "100 percent rag" paper and white library paste.

Framing. If you're going to hang your drawing, the matted picture must be placed under a sheet of glass (or plastic) and then framed. Most artists prefer a simple frame — slender strips of wood or metal in muted colors — rather than the heavier, more ornate frames in which we often see oil paintings. If you're going to cut your own mats and make your own frames, buy a good book on picture framing, which is beyond the scope of this book. If you're going to turn the job over to a commercial framer, make sure he or she uses museum-quality mat board — or ask the framer to protect your drawing with concealed sheets of rag drawing paper inside the mat. Equally important, make sure that he or she doesn't work with masking tape or Scotch tape — which too many framers rely on for speed and convenience.

Storing Unframed Drawings. Unframed drawings, with or without mats, should always be stored horizontally, never vertically. Standing on its end, even the heaviest paper or the stiffest mat will begin to curl. Store unframed drawings in envelopes, shallow boxes, or portfolios — kept flat in a drawer or on a shelf.

LEARNING TO MEASURE

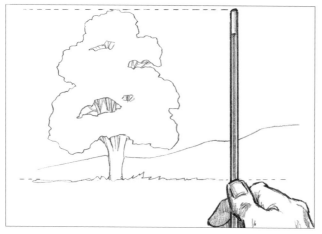

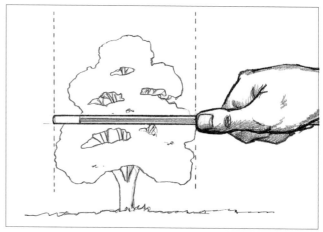

Measuring Height. Before you can draw any shape you must be able to measure it. That is, you must know how its height relates to its width — and how its internal dimensions relate to its total shape. One tried-and-true method is to hold the pencil at arm's length in front of the subject, aligning the top of the pencil with the top of the shape, and sliding your thumb down the pencil to align with the bottom of the shape. (Be sure to hold the pencil absolutely vertical, and don't bend your elbow.) This gives you the overall height of the subject.

Measuring Width. Now, standing in exactly the same spot, turn your wrist so the pencil is horizontal. One end of the pencil should align with one side of the shape. Slide your thumb across the pencil until the tip of the thumb aligns with the other side of the shape. Now you have the width of your subject. Comparing the first measurement with the second, you can see that the width is roughly three quarters the height. (Another way to put it is that the tree is about four units high by three units wide.)

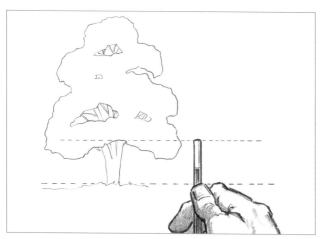

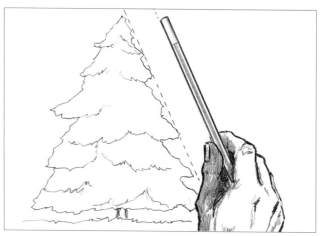

Measuring Internal Dimensions. Within the overall shape, there may be smaller shapes that you also want to measure — such as the trunk of this tree. Repeating the procedure for measuring height, you discover that the exposed section of the tree trunk is about one quarter the total height of the tree (from the ground to the top of the leafy mass). At some point you may be able to make measurements in your head — without thumb and pencil — but this method is a good way to start.

Measuring Slope. You can also measure diagonal shapes with a pencil. Hold the pencil so it lines up with the diagonal line of the form — such as this cone-shaped evergreen. With the angle of the pencil firmly fixed in your mind, quickly draw a diagonal line that matches the angle at which you were holding the pencil. Using the diagonal line as a guide, draw the zigzag shape of the tree right over it.

JUDGING PROPORTIONS

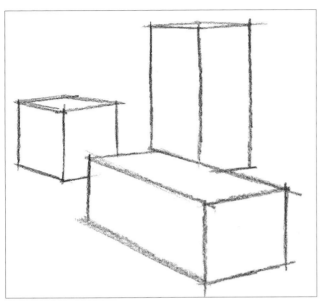

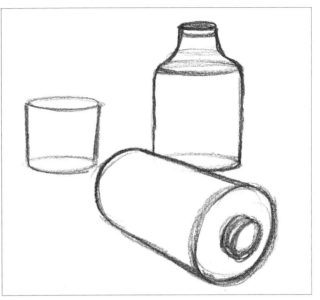

Boxes. To develop your ability to judge proportions, arrange some ordinary cardboard boxes on a table. Use the thumb-and-pencil method to measure all the boxes. The box at the left is a cube; on each face of the box, the height and width are roughly the same. On the upright box, each plane is roughly three units high by one unit wide. Measure the horizontal box yourself.

Bottles. When you look at a cylindrical object, ask yourself what kind of box it would fit into. The proportions of these cylindrical shapes are surprisingly similar to the boxes in the previous drawing. To draw these shapes, you might even start by drawing boxes — then draw the cylinders inside them.

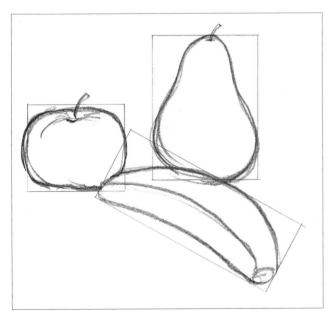

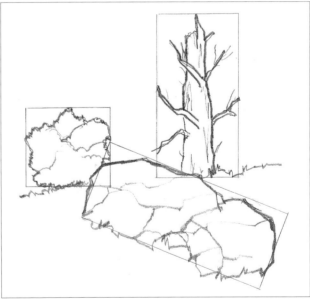

Fruit. When you draw rounded forms — such as this apple, pear, and banana — you can also play the box game. Imagine what sort of box each shape would fit into. You can even draw the boxes. Like the cylindrical shapes, the curving forms of these fruits would fit quite comfortably into the boxes above.

Irregular Forms. You can play the box game with irregular forms such as a bush, a broken tree trunk, and a rock formation. The bush at the left fits into a box that's roughly a cube. The tree trunk fits into a box that's about two units high by one unit wide. And the slanting rock formation fits into a box with a length that's roughly two and one half times its height.

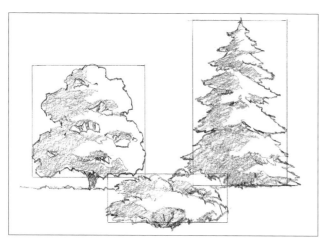

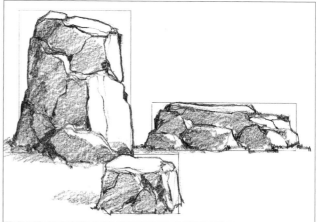

Trees. The tree at the left fits into a box that's one unit high by one unit wide. The evergreen at the right fits into a box that's roughly two units high by one unit wide: its height is about twice its width. And the low shrub in the middle fits into a box that's about three units wide by one unit high: its width is three times its height.

Rocks. Blocky shapes like rocks are particularly easy to fit into imaginary boxes when you want to measure proportions. The tall rock at the left fits into a box that's four units high by three units wide: its width is three quarters its height. The low rock formation at the right fits into a box that's about three units wide by one unit high: its width is three times its height. And finally, the small rock in the center foreground fits into a box that's four units wide by three units high: its height is three quarters its width.

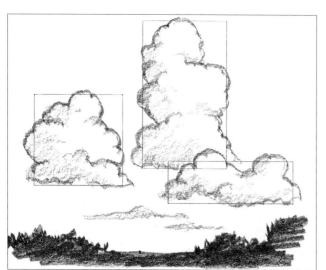

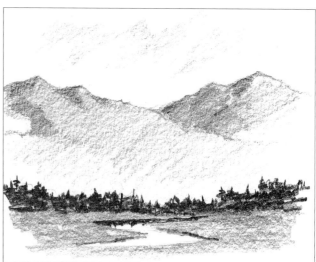

Clouds. Because clouds are big, soft, and puffy, you may think that it's harder to put their shapes into boxes. But the method is essentially the same. The cloud at the left fits into a squarish box; the tall cloud in the center fits into a box with a height roughly twice its width; and the low cloud at the right fits into a box with a width roughly three times its height. You can also use the thumb-and-pencil method to measure the internal shapes: the round puff at the top of the vertical cloud in the center is roughly one quarter the cloud's total height.

Landscape. When you focus on a specific segment of the total landscape to draw your picture, you're drawing an imaginary box around that piece of landscape. Within the imaginary box, there are proportions that you can measure. The tops of the mountains are about one third the distance from the top line of the box to the bottom line. And the dark line of the trees is about three quarters of the way down. The line of trees is also about two thirds of the way down from the tops of the mountains to the bottom line of the picture.

UNDERSTANDING BASIC PERSPECTIVE

Rectangular Objects. The parallel sides of a straight road seem to converge as they recede. The same is true of all straight, parallel lines. This phenomenon is called *perspective*. When you stare straight ahead, your eye establishes an imaginary line called the eye level line — for example, the horizontal line across the center of this drawing. Every straight line is related to this eye level line in someway. In these boxes, the horizontal lines are parallel to the eye level line, while the vertical lines are at right angles to it. A big difference is seen in the diagonal lines: above the eye level line they converge downward, while below it they converge upward. All diagonal lines meet at the eye level line.

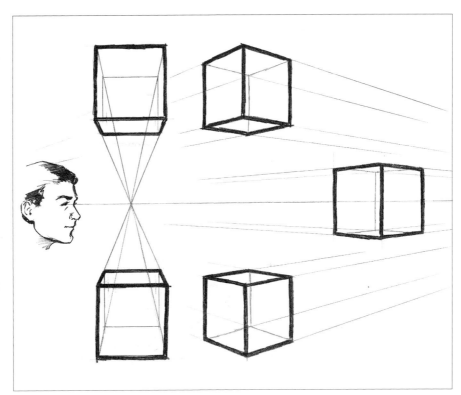

Drawing Rectangular Objects. To practice perspective drawing, make a pencil drawing of some books on a table. Sit down so your eye level line is roughly at the height of the back edge of the table. (Remember that your eye level line becomes higher when you stand up and lower when you sit down.) The vertical lines of the upright books are at right angles to the eye level line. The tops of these books are above the eye level line, so their edges slant downward. The three books that lie flat on the table are below the eye level line, so their slanted edges converge upward.

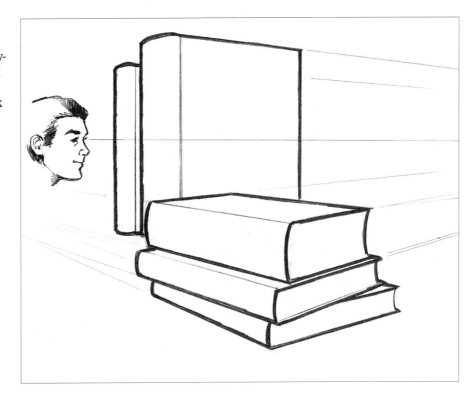

Cylindrical Objects. Cylindrical objects also obey the rules of perspective. The vertical sides of cylindrical objects are at right angles to the eye level line, whether the cylinders are above or below the line. We tend to see the tops and bottoms of cylinders as ellipses. The ellipses gradually become flatter as they approach the eye level line. Conversely, they become rounder and more open as they move away from that line. In this illustration, boxes have been drawn around the cylindrical forms to show you how the cylinders and the boxes conform to the same rules.

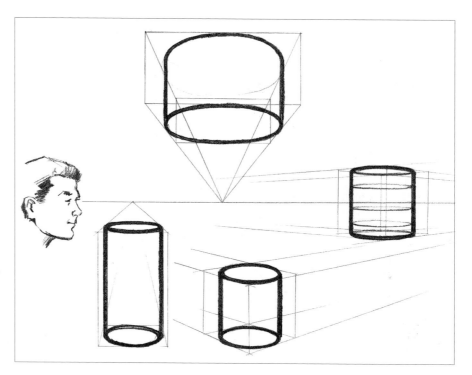

Drawing Cylindrical Objects. Arrange a group of kitchen vessels on a table: glasses, bowls, cups, saucers, whatever. Draw them in pencil from a standing position. Then draw them from a seated position so you can see how things change as your eye level line moves up or down. In this drawing, the eye level line happens to coincide with the back edge of the tabletop, just below the top of the drawing. Everything is below the eye level line except for the top of one glass. Notice how the shapes of the ellipses change: The ellipses at the bottom of the drawing are much rounder than the ones that are closer to the eye level line.

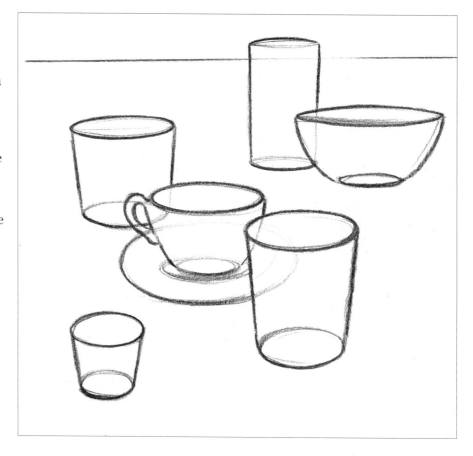

WORKING WITH LINEAR PERSPECTIVE

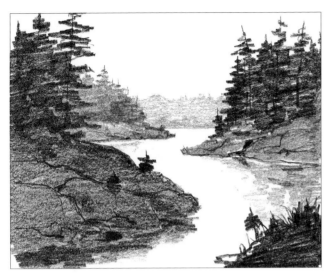

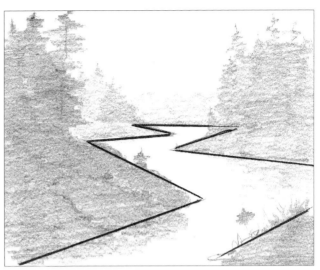

River. You've certainly observed the phenomenon called linear perspective. The parallel sides of roads, railroad tracks, and the tops and bottoms of walls all seem to converge as they recede into the distance. Although the natural landscape has very few straight lines comparable to those of a man-made landscape, the rules of perspective still apply. The shoreline is far from straight, but you have to remember linear perspective in order to draw the wandering shape of this stream.

Perspective Diagram. Though the edges of the stream aren't exactly parallel, this diagram of the stream shows how the lines of the shore do seem to converge as they move into the distance. This perspective diagram isn't meant to be mathematically perfect. And you don't have to draw one every time you draw a stream or a path across a meadow. Just look at your subject carefully and *imagine* the perspective lines receding, so your drawing will have a convincing sense of space.

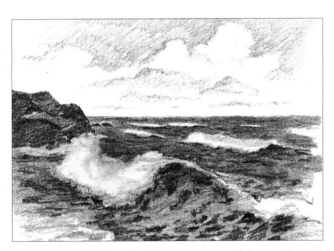

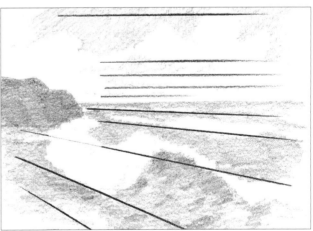

Waves and Clouds. Even a wave, with its rapid movement and curving shape, obeys the rules of linear perspective. At first glance, those imaginary perspective lines may be hard to visualize, but look at the next diagram to see how the lines work.

Perspective Diagram. If you draw imaginary lines across the tops and bottoms of the waves, you'll see that these lines seem to converge as they move toward the horizon. It's also interesting to note that the perspective lines in the foreground are distinctly diagonal, while they become more horizontal in the waves just below the horizon. And just as the waves look thinner and flatter as they approach the horizon, so do the clouds. The diagram shows that the clouds high in the sky are round and puffy, but they grow flatter toward the horizon.

17

APPLYING AERIAL PERSPECTIVE

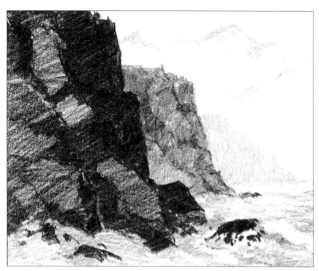

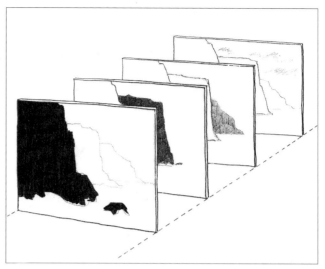

Headlands. Aerial perspective is the tendency of objects to grow paler and less detailed as they recede. In this scene, the headland in the foreground is the darkest and shows the strongest contrast between light and shadow; you can also see the details of the rocky shapes most clearly. The headland in the middleground is paler, shows less contrast between light and shadow, and has fewer details. The remote headland is simply a pale gray shape with no contrast and no detail.

Perspective Diagram. It's often helpful to visualize your landscape as a series of planes or zones, as shown in this diagram. First there's the dark, distinct headland in the foreground. Then there's the paler headland in the middleground. Next there's the very pale headland in the distance. And finally, the palest plane of all is the sky, with its slight hint of clouds.

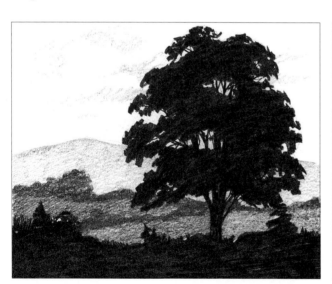

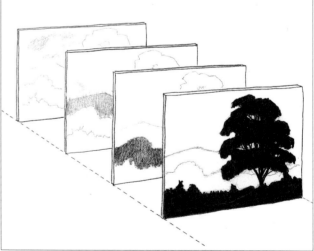

Trees and Hills. Here's another example of aerial perspective in a landscape. The tree and the grassy field in the foreground are darkest, most distinct, and most detailed. The field and foliage in the middleground are paler, less distinct, and less detailed. The hill in the distance is simply a pale gray shape. And the sky is bare white paper with an indication of pale clouds.

Perspective Diagram. This diagram shows the four planes or zones that appear in the previous landscape. You can see the dark, precisely detailed foreground; the paler, less detailed middleground; the very pale, highly simplified hill in the distance; and the even paler sky. Those four planes won't always be so distinct in every landscape you draw, but always look for an opportunity to apply the rules of aerial perspective to give your landscapes a convincing feeling of space, atmosphere, and distance.

DRAWING FROM VARIED EYE LEVELS

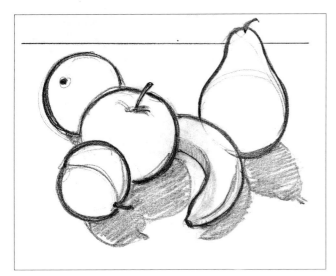

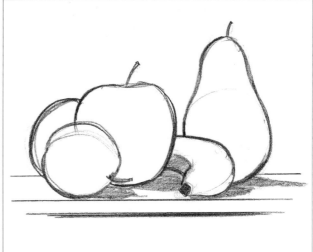

Fruit: One View. Everything you draw relates to your eye level in some way. Make some pencil drawings of fruit to see how this works. Shown here are some pieces of fruit below your eye level line. You're standing up and looking down at them. You see the tops of all the shapes. You also see the big shadows from above.

Fruit: Another View. If you sit down so your eye level line drops, you see a different view of the same pieces of fruit. In this drawing, you're looking at them from the side and all the shapes have changed radically. The shadow shapes are particularly interesting. When you looked at them from above, they were far below your eye level line and were round; now that they are close to the eye level line they are much flatter.

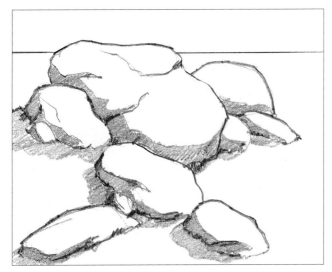

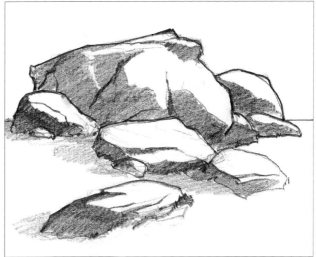

Rocks: One View. Now go outdoors and find some shapes that you can draw from several different eye levels. Climb enough rocks so that your eye level is fairly high; then look down at some of the other rocks and draw them. You see a lot of their tops and just a bit of their sides. You also see a lot of the shadows that the rocks cast on the ground.

Rocks: Another View. Climb back down so your eye level drops, and seat yourself in front of the same rock formation. Now you see more of their sides and less of their tops. The shadows on the ground have also become flatter. Whether you're drawing a still life or a landscape, it's fascinating to discover how a change in eye level creates a totally new picture.

ANALYZING VALUES

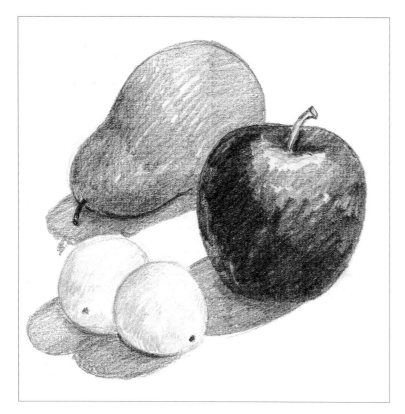

Translating Color into Value. When you draw in pencil, chalk, or charcoal, you translate the colors of nature into black and white. You pretend that your eye is a camera loaded with black-and-white film. The film sees the colors of nature as black, white, and various shades of gray, and it converts the colors into what artists call *values.* Every color has a value. As you see here, a red apple is fairly dark, almost black, while a green pear is a medium gray, and two yellow lemons are a very pale gray, almost white. Go around the house drawing objects of different colors; try to determine the correct value for each.

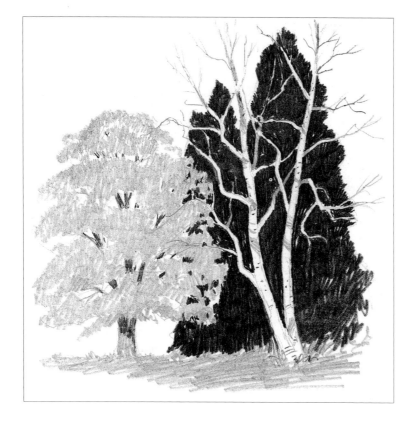

Finding Values Outdoors. Go outdoors with your sketch pad and try to translate the values of the landscape into black, white, and various shades of gray. The dark green of an evergreen will probably be a deep gray, almost black. Silhouetted against that dark shape, the pale trunk of a birch will look white or very pale gray. In this pencil drawing, the light green foliage of the deciduous tree at the left is a soft gray, while the slightly darker green of the grass is a darker gray.

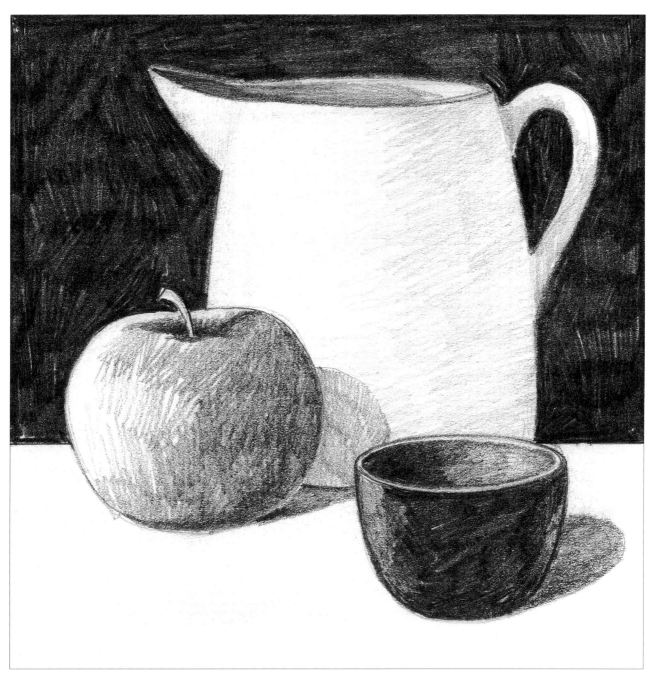

Three Values. Nature contains an infinite number of colors that become an infinite number of values. It's hopeless to try to record every subtle variation in value. Besides, too many different values make a confusing picture. Artists normally try to simplify a picture to just a few values, which are easier to draw and also make a more satisfying pictorial design. With a fairly simple subject, you can make a surprisingly good picture by concentrating on just three values. Half-close your eyes and you'll see that this picture consists mainly of a black-ish gray, which appears in the background and in the cup at the lower right; a medium gray, which appears on the apple, within the openings of the pitcher and cup, and in the shadows; and the white of the paper, which appears in the pitcher, the tabletop, and the lighted side of the apple. When you reopen your eyes and look at the picture more carefully, you'll see hints of other values, such as the pale shadow on one side of the pitcher and the variations within all the tones. However, the artist has visualized the still life as essentially a three value picture.

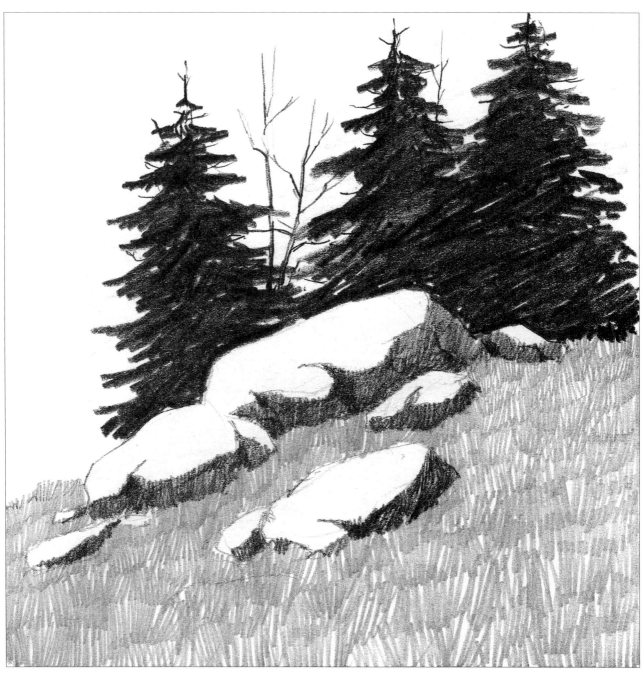

Four Values. Outdoors, values are even more complicated than they are indoors, so it's even more important to find a way to simplify the colors of nature to just a few values. Three values may not be enough, but four will often do the job. Once again, half-close your eyes so you'll see this picture as broad patches of tone. There are just four basic values: the dark gray of the evergreens; the lighter gray of the shadowy sides of the rocks; the still lighter gray of the grass; and the bare white paper of the sky and the sunlit tops of the rocks. When you open

your eyes and look at this landscape drawing more closely, you can see hints of other values within all the tones, but it's essentially a four value picture. This is an important lesson to carry over into your landscape *painting*. Many successful landscape artists train themselves to visualize the landscape in four broad tones: dark, light, and two so-called middletones. The four value system is one of the most effective ways to create a bold, dramatic pictorial design.

DETERMINING VALUES

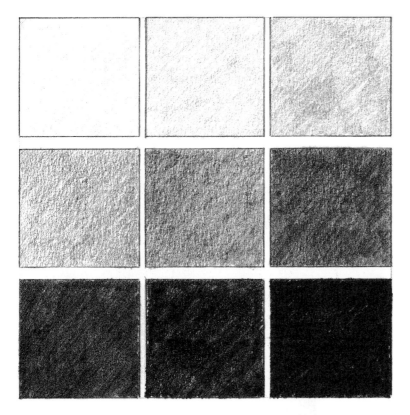

Value Scale. Drawings are generally done in black-and-white media, such as pencil, chalk, and charcoal. This involves translating the colors of nature into shades of gray, plus black and white. These tones of black, white, and gray are called *values*. Theoretically, the number of values in nature is infinite, but most artists find it convenient to simplify nature to about ten values: black, white, and eight shades of gray. To fix this "palette" of values firmly in your mind, draw a series of boxes and fill them with nine different values, starting with the palest possible gray and ending with black. The tenth value, pure white, is just the bare paper.

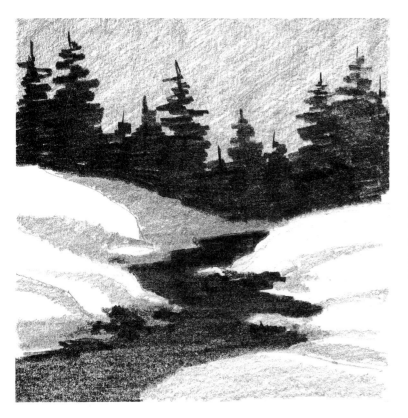

Selecting Values. With that so-called value scale on paper and firmly fixed in your mind, you're prepared to translate the colors of nature into pencil, chalk, or charcoal. Pretending that your eye is a camera loaded with black-and-white film, look at your subject and decide which colors become which values on the scale. The deep evergreens are likely to be a deep gray, just next to black. The sky and the shadows on the snow are the third or fourth gray. The frozen stream actually contains two different dark grays. And the sunlit patches of snow are white — which means bare paper. As you can see, ten values are far more than you need to make a convincing picture. Just a few values will do.

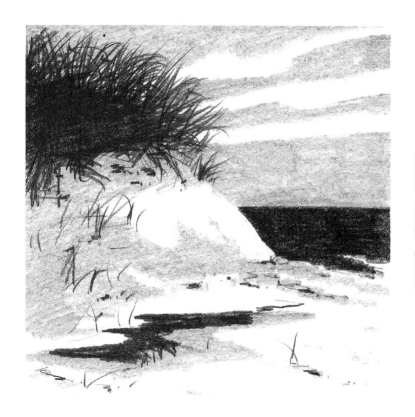

Three Value System.
Some artists feel that just three values are enough to make a good landscape — and they purposely simplify the values of nature to three tones. This coastal landscape consists of a very dark gray for the distant water, the grass at the top of the dune, and the dark reflection in the tide pool; a much paler gray for the dark strips of cloud in the sky and the shadow on the sand; and the bare white paper for the sunlit edges of the clouds and the sunlit patches on the sand. Look back at the value scale and see which values the artist has selected.

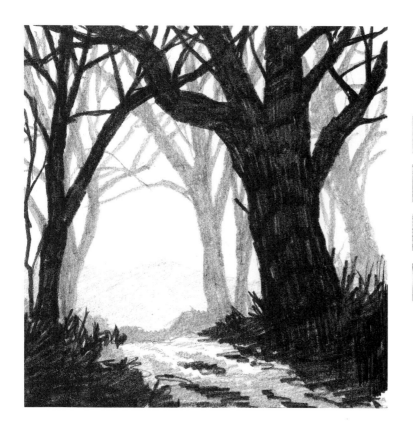

Four Value System.
Other artists feel that four values are simple enough and allow more flexibility. Here, the distant sky is bare white paper; the remote hill is a pale gray; the trees at the far edge of the forest are a darker gray; and the trees and grass in the foreground are the darkest gray — almost black. Again, glance back at the value scale and see which values the artist has chosen from his mental "palette."

THE ROLE OF CONTRAST AND KEY

High Contrast. When you study your subject and choose your values from the scale, it's important to decide how much contrast you see between the values of nature. On a sunny day, you'll see a high-contrast picture. That is, you'll see bright whites, dark grays or blacks, plus various shades of gray between the two extremes. Another way to put it is that the subject gives you a *full range of values.*

Low Contrast. On an overcast day, the same subject will present a much more *limited value range.* The light areas of the picture aren't as bright and the darks aren't as dark. The whole picture consists of grays: a pale gray for the lightest area, a not-too-dark gray for the darkest areas, and a couple of medium grays in between. Note that the values of a high-contrast picture are widely scattered on the value scale, while the values of a low-contrast picture are close together on the scale.

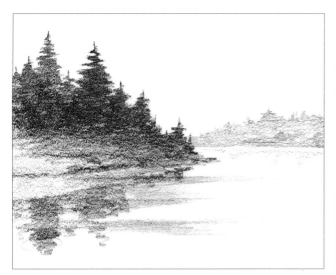

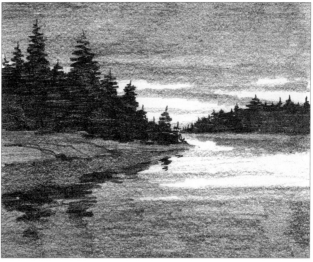

High Key. Artists also talk about the *key* of the landscape. When the overall value of the landscape is generally pale, it's called a *high-key* picture. In this case, the values are apt to come from the beginning of the value scale — pale grays and possibly white. Even the darkest areas in the picture — the trees on the shoreline at the left — are relatively pale. Foggy coastlines and misty landscapes are often in a high key.

Low Key. A *low-key* picture is predominantly dark, drawing most of its values from the dark end of the scale. A change in light or weather can convert the same subject from a high key to a low one, as you see here. Now the trees are a deep gray (almost black) and the lighter areas of the sky, water, and shore are still fairly dark. Only the strips of light in the sky and water come from the light end of the value scale. Note that the high-key picture at left is a low-contrast subject, while this low-key landscape has higher contrast.

Studying Cubical Forms

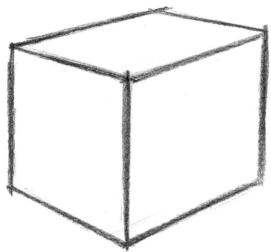

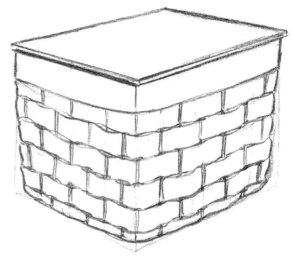

Cube. If you learn to draw simple geometric shapes, you can draw almost anything. A surprising number of objects around you are cubes or variations of that basic shape. Practice drawing cubes from different angles.

Basket. Look around the house for cubical objects. This basket, with its flat wooden top, is essentially a cube, even though its sides taper a bit. At first glance, the lines of the interwoven straw look irregular, but they actually follow the cubical shape very faithfully. Make some pencil line drawings of cubical objects like this basket.

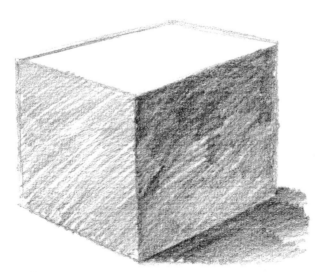

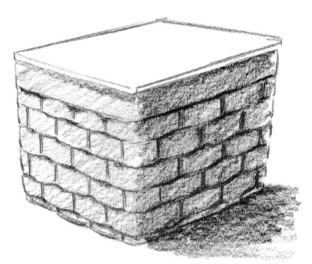

Cube in Light and Shade. When you study the effects of light and shade on a cube, you're apt to see five distinct values. The top plane of this cube is the *light*; the left plane is the *halftone* (often called the *middletone*); the right plane is the *shadow*, within which there's a hint of *reflected light* at the bottom; and the dark tone on the tabletop is the *cast shadow*.

Basket in Light and Shade. You can see the same values on the planes of the cubical basket: the lighted top, the halftone at the left, the shadow and hint of reflected light at the right, and the shadow that the basket casts on the tabletop. Reflected light, shown here at the lower right, usually comes from some secondary light source, such as a distant window.

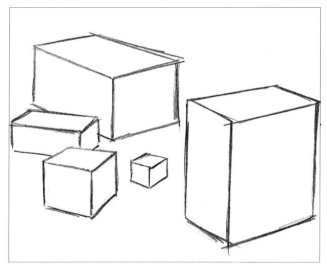

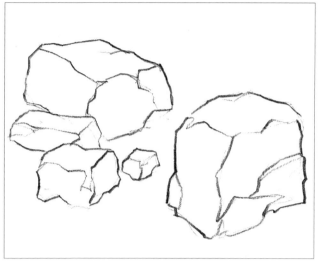

Cubes. Geometric forms are the basis of many shapes in nature, so it pays to practice drawing cubes and other blocky shapes. You can collect a variety of boxes around the house, scatter them on top of a table, and draw them from various angles. Start out drawing them with pencil lines. Keep your pencil sharp and don't hesitate to go over the lines several times until they're accurate. Don't use a ruler, but draw freehand. The lines don't have to be perfect.

Rocks. If you can draw those boxy shapes with reasonable accuracy, you can easily draw the blocky forms of rocks, which have top and side planes just like boxes — although the planes of the rocks will certainly be more irregular. You can begin to draw each rock by drawing a box. Then go back over the straight lines to transform the shapes into rocks. As you've already learned, it's also easier to visualize *proportions* if you start out with some imaginary boxes.

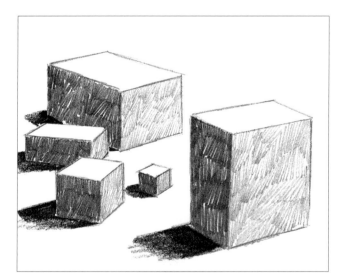

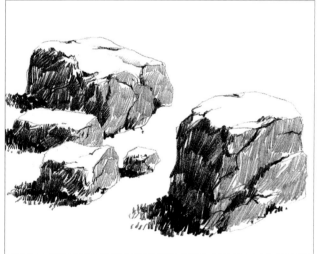

Cubes in Light and Shade. When you've had enough practice drawing boxes with pencil lines, render the values on the top and side planes of the boxes with the side of the pencil lead. Generally, you'll find that each plane of the box has its own value. In this case, the top plane catches the light and is the palest value; one side plane is a light gray halftone (or middletone); and another side plane is a darker gray, representing the shadow on the tabletop — darkest right next to the block and gradually growing paler as the shadow moves away.

Rocks in Light and Shade. Keep these planes in mind when you draw the values on real rocks. The planes won't be as neat, but look carefully and you'll find them. In these rocks, as in the boxes, the top plane is the light, one side plane is the halftone (or middletone), and another side plane is the shadow. The order of these planes can change when the light comes from a different direction: when the sun is low in the sky, one side plane could become the light and the other two planes could become the halftone and shadow.

27

SIMPLE STILL LIFE: DRAWING CUBICAL FORMS

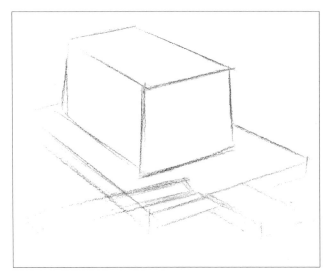

Step 1. Assemble some cubical shapes, set up a still life, and draw in pencil. This loaf of bread, bread board, and knife are all variations — or slices — of the simple cube. At the beginning, just draw the cubical shapes with straight lines and don't worry about whether they look like a loaf of bread, a bread board, and a knife. Just visualize them as geometric shapes — and remember to draw the slanted lines in perspective. Don't use a ruler. Draw the lines freehand and don't worry about making them too neat. You can go over a line several times until you get it right.

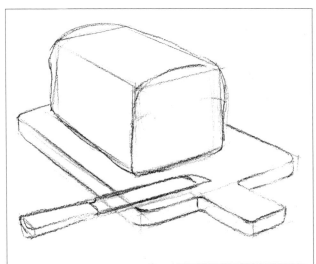

Step 2. When you're satisfied that the geometric forms are fairly accurate, go over the original lines with heavier strokes to convert those geometric forms into your actual subject. Here the artist uses the straight lines of Step 1 as convenient guidelines for drawing the soft curves of the bread, the rounded corners of the bread board, the rounded end of the knife handle, and the slanted tip of the knife blade. Whatever subject you choose for this exercise — it doesn't have to be a loaf of bread — start out by drawing simple geometric forms with straight lines, and then draw the more irregular lines of the subject right over them.

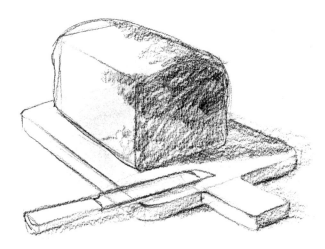

Step 3. Notice how the artist has redrawn the actual contours of the subject right over the original guidelines and then blocked in the broad areas of tone with rough, casual strokes. The shadow plane of the loaf is facing you, and you can see the reflected light at the lower edge of this plane. You can also see the shadow that's cast by the loaf on the board. Where the top and left sides of the loaf meet, the light and halftone flow softly together along the curve.

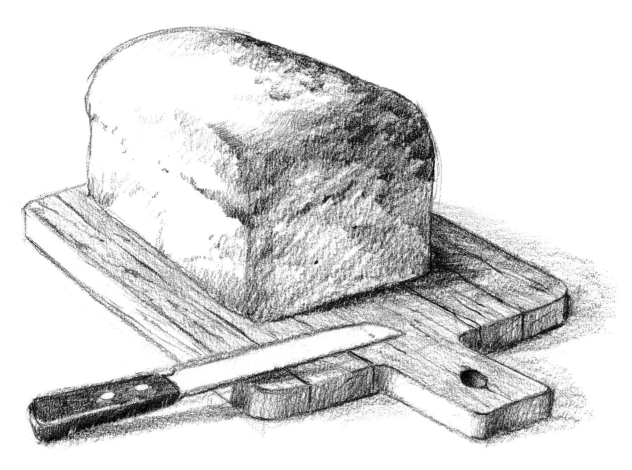

Step 4. Having drawn the shapes accurately and indicated the broad distribution of light and shade, you can then concentrate on the precise details that complete the drawing. Here the artist sharpens the lines a bit more and erases the guidelines; adds darker strokes where necessary; suggests the texture of the bread and the grain of the bread board; and defines the knife more precisely, carefully indicating the tones of the handle. Notice that the darkest edges of the bread board and knife handle all face the lower right, as does the shadowy end of the loaf. The lightest planes of the loaf and bread board are at the left.

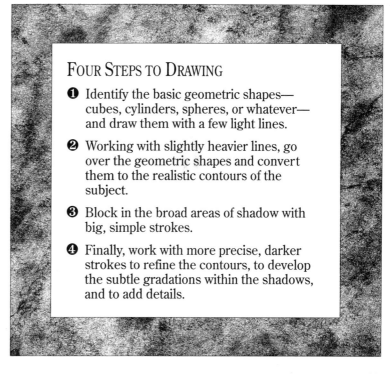

FOUR STEPS TO DRAWING

❶ Identify the basic geometric shapes—cubes, cylinders, spheres, or whatever—and draw them with a few light lines.

❷ Working with slightly heavier lines, go over the geometric shapes and convert them to the realistic contours of the subject.

❸ Block in the broad areas of shadow with big, simple strokes.

❹ Finally, work with more precise, darker strokes to refine the contours, to develop the subtle gradations within the shadows, and to add details.

OBSERVING CYLINDRICAL FORMS

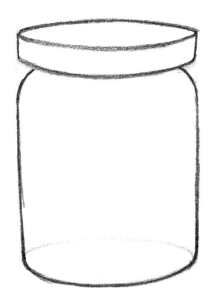

Cylinder. Another common geometric form is the cylinder, which occurs throughout nature. A tree trunk is essentially a cylinder; so are your neck and thighs. Practice drawing cylinders with sharp pencil lines. Don't worry about making neat, elegant drawings. Keep going over the lines until you get them right.

Jar. A common cylindrical shape in most households is a jar. Draw as many different cylindrical shapes as you can find. If they're not made of glass, *pretend* that they're transparent so you can draw the elliptical tops and bottoms. In this jar, as in the cylinder on the left, the top ellipse is shallower than the one at the bottom.

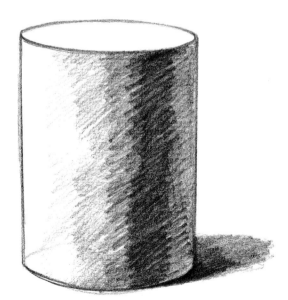

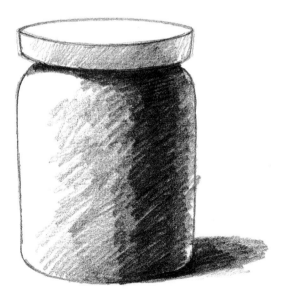

Cylinder in Light and Shade. Find an opaque cylindrical form — such as a roll of paper towels — and study how light and shade wrap around the form. On the cylinder in this drawing, you see the progression from light to halftone (or middletone) to shadow to reflected light. The cylinder casts a shadow to the right. On a cylinder, unlike a cube, these tones flow into one another.

Jar in Light and Shade. The jar shows the same progression from light to halftone to shadow to reflected light. The same sequence of tones appears on the lid, which casts a shadow over the neck of the jar. Don't hesitate to draw the gradation of tones with free, scribbly strokes, as the artist has done here. Neat drawing is less important than careful observation.

Cylinders. In outdoor subjects, cylindrical shapes are as common as blocky shapes. Trees and branches are essentially cylindrical, although the geometric shapes may be concealed under the distracting detail of foliage and bark. When you look at a group of trees, try to visualize the trunks and branches as a collection of cylinders, some upright, some slanted, and some horizontal. In fact, it's helpful to draw these cylinders with pencil lines.

Tree Trunks. When you've drawn these cylinders, you have convenient guidelines over which you can draw the actual shapes of the living trees with sharper, darker pencil lines. Now you can look for the irregularities in the contours — the bumps and dips that make the shapes of the trees and branches look real. But don't forget that the shapes are still basically cylindrical.

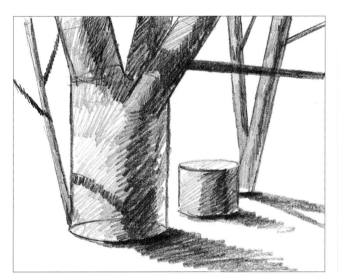

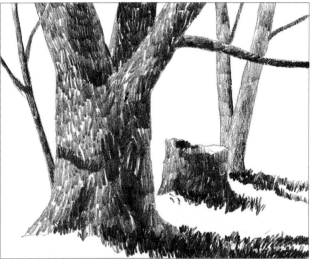

Cylinders in Light and Shade. In contrast with cubical shapes — where there are distinct planes of light, halftone, and shadow — the tones all run together on a cylinder. From left to right on the cylindrical shapes in this picture, you can see the gradual transition from the lighted left side of the tree to the halftone (or middletone) to the shadow to the reflected light within the shadow. (In outdoor subjects, shadows often contain light reflected from the distant sky or bounced off the mirror-like surface of nearby water.) These cylindrical shapes cast curving shadows on one another.

Tree Trunks in Light and Shade. When you render the gradations of light, halftone (or middletone), shadow, and reflected light on tree trunks and branches, remember how the light wraps around a geometric cylinder. You can draw the bark with small, distinct strokes that convey the texture — but press harder on the pencil as you move from light to shadow, then make the strokes lighter as the shadow curves around to pick up the reflected light. Draw the cast shadow on the ground with small "grassy" strokes.

31

EXAMINING CONICAL FORMS

Cone. A cone is very much like a cylinder in the sense that the base is circular and the sides are round — but the sides taper to a point. Precise conical shapes aren't as common in nature as cylinders, but many cylindrical shapes actually have tapering sides and therefore are a cross between a cone and a cylinder. Practice drawing cones of different shapes.

Evergreen. Outdoors, the most common conical shape occurs in various evergreens. The foliage may make the form *look* ragged, but it's essentially a cone. Hills, mountains, and dunes are often flattened cones, by the way. Go for a walk and see what cones you can find to draw.

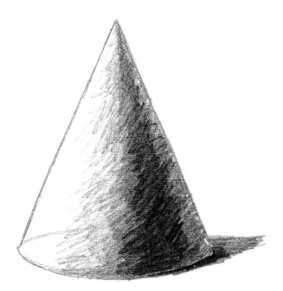

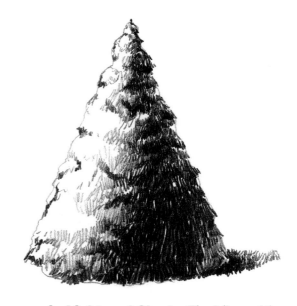

Cone in Light and Shade. When you study the gradation of light and shade on a cone, you'll see the same progression of tones that you see on a cylinder: light, halftone (or middletone), shadow, reflected light, and cast shadow. After you practice drawing imaginary cones in line, try rendering them in gradations of tone with loose, casual strokes.

Evergreen in Light and Shade. The foliage of the evergreen blurs the gradation of light and shade, but if you squint to blot out the distracting detail, you'll see the same tones that you find on the imaginary cone. The hint of reflected light at the right is apt to come from the sky. Although it's broken up by the grass, the cast shadow also moves from dark to light.

32

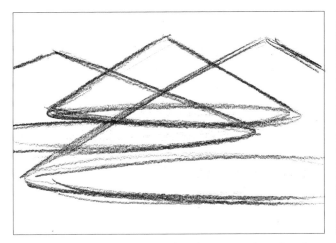

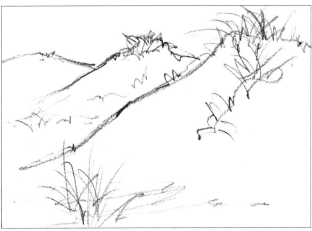

Cones. When you practice drawing cones, imagine that they're made of glass so you can see one behind the other and can also draw their elliptical bottoms. In this way, you get into the habit of visualizing cones as solid, three-dimensional forms. Ellipses are hard to draw, so swing your arm with free, rhythmic movements, and don't hesitate to keep going over the lines.

Dunes. Sand dunes — like hills — are often flattened cones with irregular sides. When you draw sand dunes, remember their basic geometric shape even if that shape seems to disappear under the realistic contours of the sand. You can actually begin by drawing geometric cones and then draw the dunes over them. Or you can draw the dunes directly and keep the cones in your head.

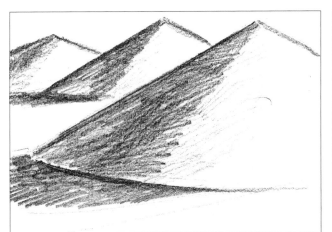

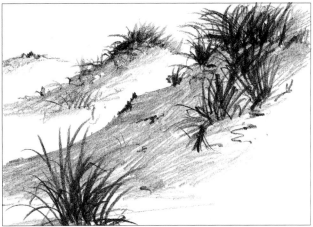

Cones in Light and Shade. Light, halftone (or middletone), and shadow on cones can be subtle, so observe them carefully. On the dark side of the nearest flattened cone in this illustration, notice how the strokes become slightly denser to indicate the change from halftone to shadow — and then the strokes become more open to suggest reflected light at the left.

Dunes in Light and Shade. When you render the pattern of light and shade on the actual dune, remember the behavior of the tones on the geometric cones. The conelike shapes of the dunes pick up the sunlight on their right sides and then curve gradually around into halftone and shadow. There isn't always a neat gradation from light to halftone to shadow to reflected light. In this case, reflected light appears throughout the shadow. The artist leaves some spaces between pencil strokes to suggest reflected light from the sky.

OUTDOOR STILL LIFE: DRAWING CYLINDRICAL FORMS

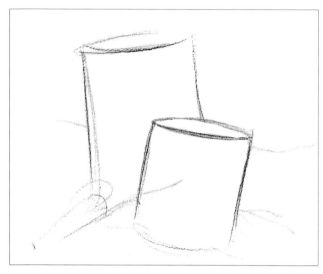

Step 1. An "outdoor still life," such as these two tree stumps, offers a good chance to draw cylindrical forms in nature. The artist begins by visualizing the stumps as short, thick, tilted cylinders with elliptical tops. The root at the left is a slender, tapered cylinder, something like a cone. The sharpened point of the pencil is moved lightly over the paper so that these guidelines can be erased at a later stage in the drawing.

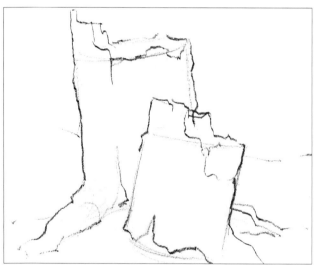

Step 2. Using the cylindrical shapes of Step 1 as a guide, the artist looks carefully at his subject and draws the ragged contours of the weathered wood over the pale lines. He doesn't follow the original guidelines too faithfully, but departs from them freely to create a more realistic drawing of the two stumps. He draws the jagged, broken tops of the stumps right over the elliptical guidelines — but he remembers that the ellipses are there. The root at the left no longer looks very cylindrical or conical, but the artist will remember the geometric form when he adds tone to the root.

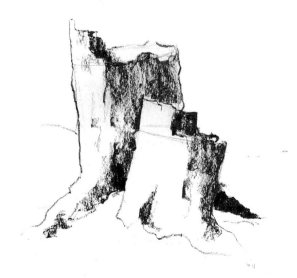

Step 3. Working with the side of the pencil, the artist carries broad strokes down the stump to establish the big shapes of the darks. Now there's a clear distinction between the light and shade on each large cylinder, as well as on the root at the left. At the tops of the stumps, strong darks are placed within the ragged shapes as they turn away from the light. A single root at the right is entirely in shadow, so this tone is blocked in.

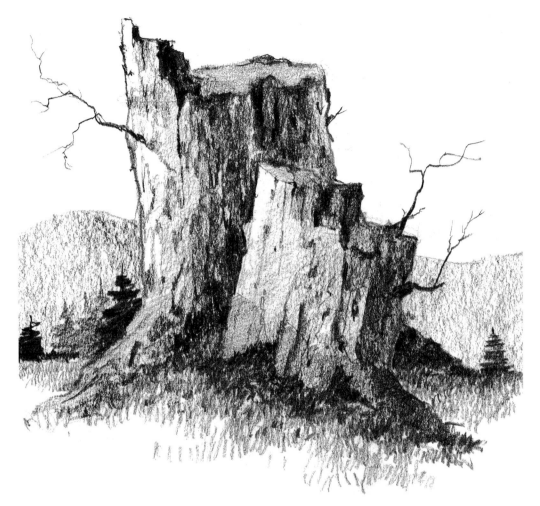

Step 4. Pressing harder on the side of the pencil, the artist darkens the tones on the stumps to make the shapes look three-dimensional. Although the tones are interrupted by the broken texture of the weathered wood, the strokes suggest the gradual right-to-left gradation: light, halftone (or middletone), shadow, and reflected light within the shadow. The darkest shadows are placed within the cracks and where the stumps overlap. The artist's final step is to draw small details, such as the twigs and cracks.

FINDING CYLINDRICAL FORMS

Trees and tree trunks are the most obvious cylindrical forms in the landscape — but look for others and draw them on location or at home. For example, rocks look craggy and complex at first glance, but look again and see if they're really fractured cylinders. Cliffs are often columns in disguise. Desert rock formations, such as buttes, are often low cylinders.

❶ Walk through the woods and take home fragments of fallen branches — thick and thin, long and short — and set up a still life that you can draw at home.

❷ Set up a still life of cylindrical fruits and vegetables — celery, carrots, bananas, and such — and draw it from different eye levels and from different angles.

❸ Draw a still life of your own cylindrical drawing tools: pencils, mechanical holders for chalks, spray cans of fixative.

ANALYZING SPHERES

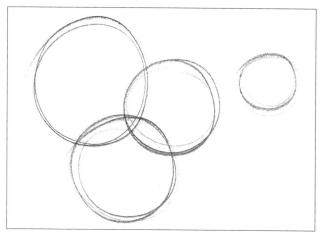

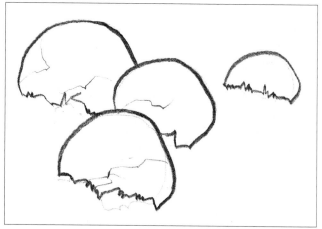

Spheres. Another basic geometric form that occurs constantly in nature is the sphere. Although there aren't many *perfect* circles in nature, practice drawing circles with the point of your pencil. The secret of drawing a really round circle is to swing your whole arm, starting from the shoulder, not from the wrist or elbow. Keep repeating that circular movement, going around and around, tracing over each circle again and again until the shape seems right. Your circles won't be geometrically perfect, but practice will make them round and full.

Rounded Rocks. Boulders are often irregular spheres, flattened here and there, and partly buried in grass or dirt. Once you've learned how to draw a circle with quick, rhythmic movements, you can draw circular guidelines and then build realistic boulders over these round shapes. Or you can go directly to work drawing the irregular contours of the boulders themselves.

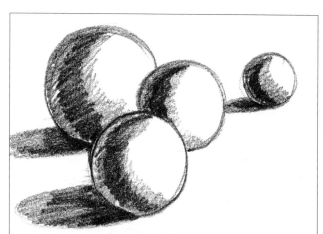

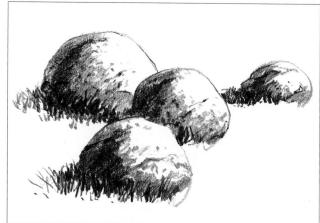

Spheres in Light and Shade. A sphere is a rounded form, so the tones wrap softly around the sphere and seem to flow together. Rendering the gradations of light and shade on a sphere takes practice. Put a tennis ball — or any kind of pale ball — near a window so that it receives strong light, and then practice rendering the tones with broad strokes made with the side of the pencil. Exaggerate the areas of light, halftone (or middletone), shadow, and reflected light, as you see here, so they remain firmly fixed in your memory.

Rounded Rocks in Light and Shade. When you draw real boulders scattered in a grassy field, the rocky textures will be rough and irregular, making the gradation of light and shade harder to see. Render the tones with rough, irregular strokes, but vary the strokes so that they're lighter or darker to match the tonal areas you've seen on the tennis balls. These boulders are lit from the right, so there's a right-to-left gradation from light to halftone (or middletone) to shadow to reflected light.

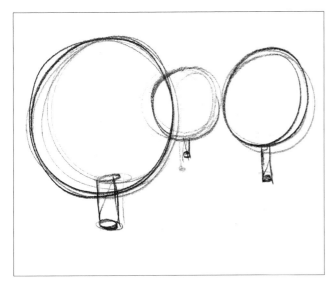

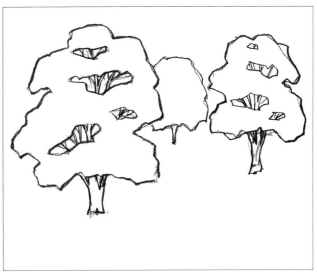

Spheres (Plus Cylinders). Trees and shrubs rarely look exactly like spheres, but it's often helpful to visualize them as spherical forms, just as it's helpful to visualize their trunks as cylinders. If the mass of foliage looks as if it would fit into a circle, you can begin with a circular guideline and then chop holes into the geometric form when you draw the actual tree.

Trees. The leafy masses of these three trees are all roughly circular, although their outlines contain big gaps and don't look circular at first glance. The trunks are basically cylindrical, even though each trunk diverges to form branches above and spreads slightly at the bottom of the cylinder where the roots go underground. These spherical and cylindrical forms will become more apparent when you add light and shade to the trees.

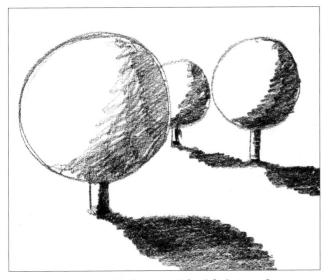

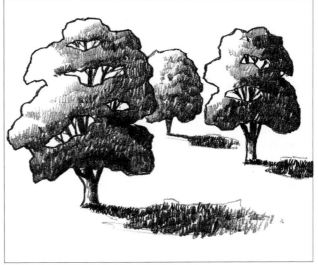

Spheres (Plus Cylinders) in Light and Shade. Before you start to add tone to the trees, remember what you've learned about the gradation of light, halftone (or middletone), shadow, and reflected light on spheres and cylinders. Also remember that a rounded form casts a rounded — or elliptical — shadow on the ground.

Trees in Light and Shade. The tones of the leafy masses follow the same progression as the tones on the geometric sphere. To convey the texture and detail of the leaves, place lighter strokes in the halftone areas, darker strokes in the shadows, and allow some space between strokes to suggest reflected light within the shadows. Follow the same sequence of tones when you render the cylindrical trunks and branches. Group your "grassy" strokes to make the shadows look like rough ellipses.

OTHER ROUNDED FORMS

Egg. An egg is a sphere that's been stretched out and slightly narrowed at one end. Many fruits, vegetables, trees, rocks, and flowers are egg-shaped. Practice drawing eggs with round, rhythmic movements, the way you practiced making circles. Keep moving the pencil around and around until the shape looks right.

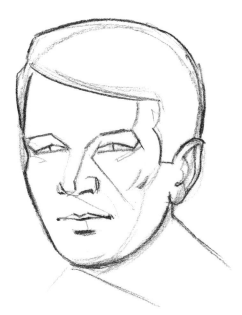

Head. The most familiar egg-shaped object is the human head. Practice drawing some. Start out by drawing the shape of an egg. The eyes are halfway down from the top; the tip of the nose is midway between the eyes and chin; and the center line of the mouth is almost halfway down from the nose to the chin.

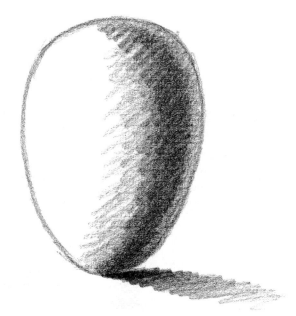

Egg in Light and Shade. Having practiced adding light and shade to the sphere, you should find it easy to do the same thing to your line drawing of an egg. You can make the egg look rounder if your pencil strokes seem to curve around it. And the cast shadow on the table will look flatter if your strokes seem to lie flat on the table.

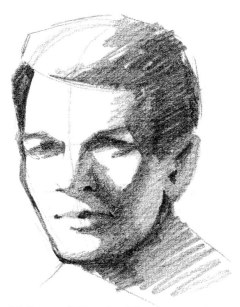

Head in Light and Shade. The tones on the human head may be harder to identify because they're broken up by the features. Look carefully at your model: the tones are really there, although they may be distributed a bit differently. Here, the forehead contains the usual progression of light, halftone (or middletone), shadow, and reflected light, while the cheek jumps more abruptly from light to shadow to reflected light.

FRUIT BOWL: DRAWING ROUNDED FORMS

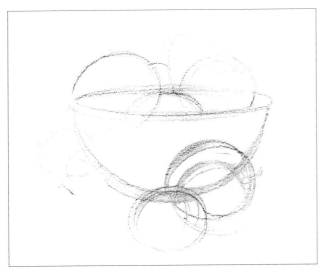

Step 1. Make a pencil drawing of rounded objects by assembling a still life of fruit, vegetables, and perhaps a bowl. Draw the bowl as the lower half of a sphere — with an ellipse at the top. The fruits and vegetables are all basically spherical, although they probably won't be perfectly round — some will be shaped more like eggs. Draw the geometric shapes with light, rhythmic lines, going over the lines several times if necessary. The shapes will look rounder if you move your whole arm.

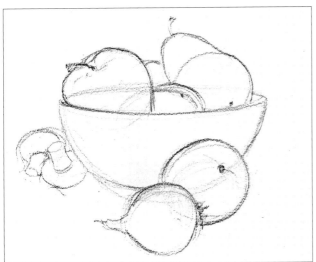

Step 2. When you're satisfied with the spheres and egg shapes, go back over them with darker lines, converting the geometric shapes into a real bowl, fruit, and vegetables. You'll have to change some of the curves to make your subject look more realistic, as the artist has done here with the apple and pear in the bowl, and with the onion in the foreground. Notice that the stems of the mushrooms at the left are cylinders with slightly concave sides; the ends of the stems are ellipses. Don't erase the guidelines left from Step 1 just yet.

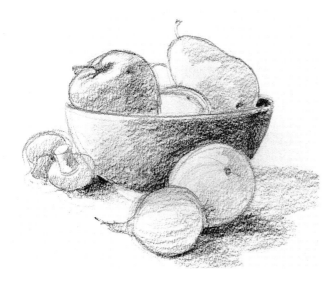

Step 3. Now, working with the side of the pencil to make broad strokes, block in the broad tonal areas. Notice that the shadows are darker when the subject is darker — such as the red apple or the wooded bowl. Conversely, shadows are more delicate on a pale object like the pear and onion. The light, halftone (or middle-tone), shadow, and reflected light are also more obvious on dark shapes.

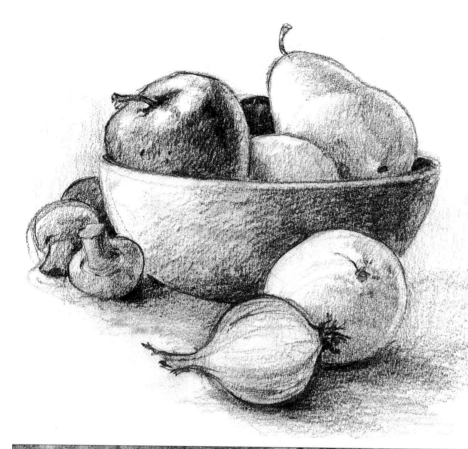

Step 4. In this final stage, you can draw more precise lines to define the contours of your subject as realistically as possible. You'll probably want to flatten some of the curves, adding dents and other irregularities. You can also strengthen the halftones (or middletones), shadows, and cast shadows with the side of your pencil. Finally, you may want to use an eraser to brighten some of the reflected lights and eliminate the guidelines that you originally drew in Step 1. This is the time for you to add stems and other final details.

LOOK FOR THOSE FIVE TONES ON ROUNDED FORMS

Your drawings of rounded forms will always look solid and three-dimensional if you practice identifying and rendering those five tones — light, halftone (or middletone), shadow, reflected light, cast shadow — on lots of rounded subjects.

❶ Take a walk outdoors and look for some rounded objects — such as boulders — that you can draw and redraw as the light keeps moving and changing throughout the day.

❷ Working with a thick, soft pencil that makes a broad, decisive stroke, draw the rounded shapes of the boulders and then render the five tones as quickly as you can, before the light changes.

❸ Now you can wait a bit until the light changes — or you can just walk around to the side of the rock formation, where you'll see a different arrangement of the five tones. Draw the rocky shapes and then render the five tones again.

❹ Keep redrawing the shapes and the five tones all day if you have the time — or just keep walking around the rock formation, making new drawings of the light and shade patterns from varied angles.

❺ On your way home, pick up a pocketful of small, rounded stones that you can place on a table and make more drawings. Put a lamp on the tabletop and keep moving the light source as you make more and more drawings of the changing tones.

STUDYING IRREGULAR FORMS

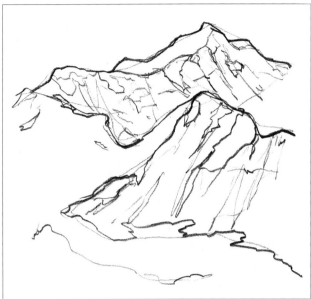

Broken Forms. Nature contains some shapes that are hard to visualize as basic geometric forms. You have to look carefully at them and try to come up with some simple form that will do the same job as the cube, cylinder, or sphere. In this drawing, study how the artist has simplified the jagged peaks to a few simple shapes.

Mountains. Having drawn a few simple shapes to act as guidelines, the artist then goes back over the lines and converts the basic shapes to real mountains with all their cracks and crags. No matter how complicated a shape may look, it's always best to start with a few simple guidelines — and then add the complex details.

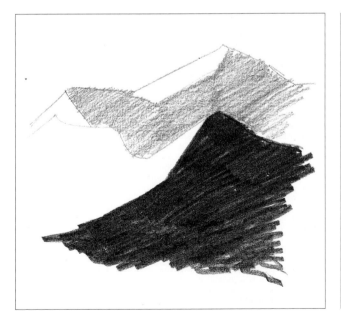

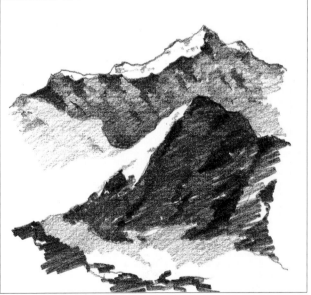

Broken Forms in Light and Shade. Once you've learned how to visualize complex, irregular shapes as a few simple forms, it's a lot easier to visualize the pattern of light and shade in the same way. Those jagged mountains really have just two big patches of light, one area of pale shadow on the distant peak, and a darker shadow on the near peak.

Mountains in Light and Shade. When the artist adds tone to his realistic line drawing of the mountains, he visualizes these tones as simply as the schematic drawing. The shadow sides of these mountains are just two tones: a pale one in the distance and a darker one in the foreground. Into these broad planes of shadow, the artist draws additional detail.

41

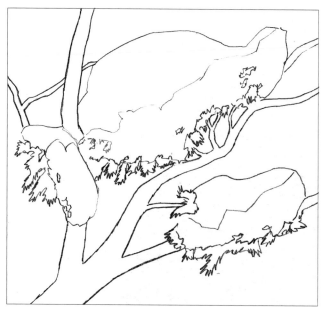

Construction Lines. There are lots of landscape subjects that you *can't* start out by drawing as cubes, cylinders, or spheres. Although you can't find a geometric shape that does the job, you can study your subject carefully and draw simple shapes that will act as guidelines. Here's how you might visualize some clumps of snow on the branches of a tree.

Snow-Covered Branch. Having drawn the simplified shape with free, rapid strokes, you can go back over those guidelines with more precise strokes that render the snow, foliage, and branches more realistically. When you erase the original guidelines, you have an accurate line drawing of your subject —handsome even without light and shade.

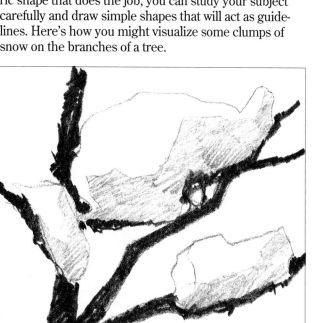

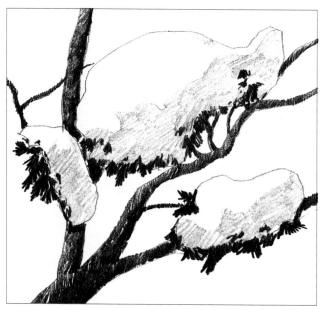

Light and Shade. On this irregular form, light and shade won't behave as they do on geometric forms, but study each shadow carefully and you'll find that it does have its own distinct shape. Begin by sketching the simple shadow shape and filling it with tone — or just keep the simplified shape of the shadow in mind when you make a realistic drawing.

Snow-Covered Branch in Light and Shade. The realistic line drawing becomes three-dimensional as the artist adds tones to the masses of snow, as well as to the branches and foliage. The clumps of snow aren't soft, shapeless masses, but have distinct planes of light and shadow that give them a feeling of realism and solidity.

FOLDS OF CLOTH: DRAWING IRREGULAR FORMS

Step 1. To learn how to draw irregular shapes, it's good practice to start with a pencil drawing of a crumpled paper bag or a towel thrown down in a heap like this one. At first glance the folds of the cloth may seem hard to draw, but try to reduce the subject to a few simple shapes and render them with a minimum number of lines. Here the artist starts out with just three shapes that will guide his drawing. Right now, those shapes look nothing like the rumpled towel, but that doesn't matter. The important thing is to visualize the shapes simply.

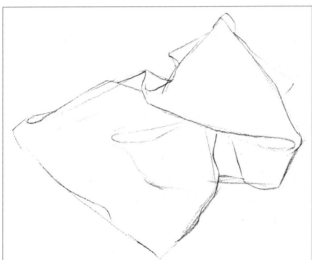

Step 2. Now the artist goes over the guidelines of Step 1 to draw the contours of a more realistic towel. Using the sharp point of the pencil, he converts straight lines into curves, and suggests additional folds and other details. The subject begins to look like a realistic — but-simplified — line drawing of a real piece of cloth. You can still see the original guidelines of Step 1. It's best to keep these lines until the drawing is finished — they'll help you keep your eye on the big shapes.

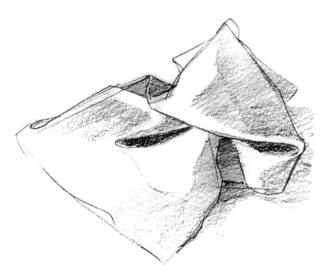

Step 3. Using the side of the pencil, the artist makes broad strokes that suggest the large tonal areas. He simplifies the tones into three values: the light areas, which are bare paper; the halftones, which he renders as a pale gray by moving the pencil lightly over the drawing paper; and the darks, which he places in the deep folds, pressing harder on the pencil. He also suggests cast shadows on the tabletop beneath the towel.

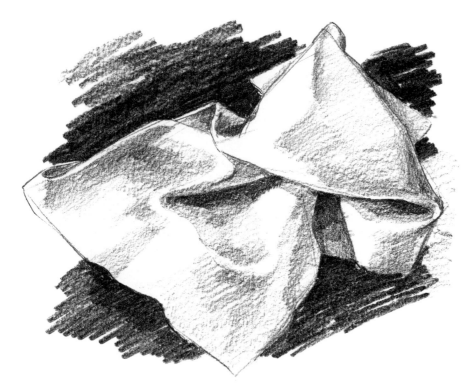

Step 4. Now the artist concentrates on the halftones and shadows, deepening the tones selectively with the side of the pencil to make a richer, more realistic pattern of light and shade. Now the folds of the towel look more solid and three-dimensional. He refines some contours here and there using the sharp point of the pencil. To make the towel really stand up from the dark wood of the tabletop, the artist uses the side of the pencil to scrub a dark tone around the cloth. Using the sharp point of a pink rubber eraser, he removes the guidelines of Step 1. But see how closely the finished drawing follows those original guidelines.

GEOMETRIC OR IRREGULAR — YOU DECIDE!

It's not always easy to decide whether you're looking at an irregular form or a geometric form that's "in disguise." Set up some still lifes and try them both ways. See which way you make a better drawing.

❶ Bring home a sturdy, neatly folded brown paper bag from the supermarket. Unfold it carefully so the open bag looks like an oblong, open box. Draw it as a cubical shape—paying careful attention to the light and shadow planes.

❷ Crush the bag and open it again. Try drawing the battered shape as a fractured cube. Now forget about geometry and draw the bag again, concentrating on the irregular shapes.

❸ Look for other "still life" objects that you might draw both ways. That coat hanging on a hook: try to draw the folds as cylinders; then try to draw them without thinking about geometry.

CLOUDS: MODELING IRREGULAR SHAPES

Step 1. Because clouds often have fuzzy edges and change constantly as they're pushed along by the wind, they may seem vague and shapeless at first glance. But every cloud has a distinct shape, even though it may not be a geometric one. Here the artist concentrates on the broad outlines of a few cloud shapes — paying no attention to the intricate contours — and quickly records these outlines with a minimum number of strokes. At this stage, the clouds don't look soft and puffy, but that doesn't matter. What's essential is to put some guidelines on paper as rapidly as possible. The clouds can be made rounder and softer in the next stage.

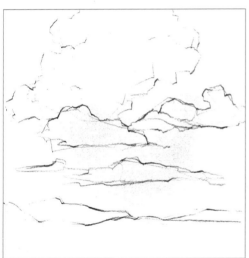

Step 2. By the time the guidelines of Step 1 are on the paper, the clouds have already begun to change form as they move across the sky. Still working quickly, the artist studies the moving shapes in the sky and draws freely around the guidelines with rounder, precise strokes that produce a more realistic rendering of the clouds. He doesn't follow the guidelines slavishly, but arrives at a kind of compromise between the highly simplified shapes of Step 1 and the rounder, softer, more intricate shapes of the clouds. Step 1 also contains guidelines for the hills, which he reinforces here.

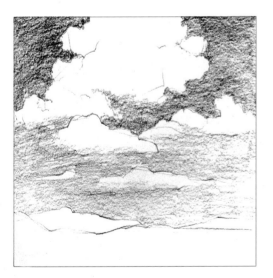

Step 3. Working with the side of the pencil, the artist moves around the cloud shapes with broad, rough strokes that are broken up by the texture of the paper. He fills the cloudless areas of the sky with tones that surround the cloud shapes and make them more distinct. Notice how the sky grows darker at the zenith and paler at the horizon.

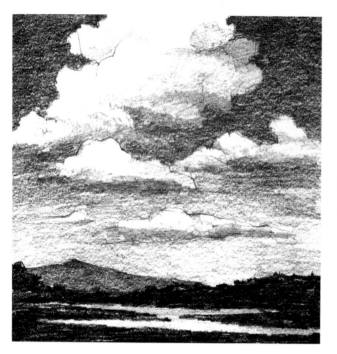

Step 4. Finally, the artist blocks in the shadow areas of the clouds with broad strokes that are paler than the surrounding sky. He doesn't scrub in patches of tone indiscriminately, but remembers that a cloud is a solid, three-dimensional form with clearly defined areas of light and shadow. In this drawing, the light strikes the clouds from above and to the left, which means that the shadow areas will be on the right sides and along the bottoms of the forms. The completed clouds look soft, but as round and solid as any geometric form. The artist finishes the drawing by darkening the shapes of the landscape with broad horizontal strokes, using the side of the pencil.

APPLYING GEOMETRY TO IRREGULAR SHAPES

When you're drawing an irregular shape — like the clouds in this demonstration — don't be discouraged by the fact that you can't see any apparent connection with geometry. You can still apply some of the lessons you've learned from drawing geometric shapes. The trick is to draw the irregular shapes as if you're looking at a geometric shape.

❶ Go out and draw trees — all sorts of trees — whose ragged, leafy masses seem to defy geometry. Take a pad of rough paper and a thick, broad drawing tool like a stick of compressed charcoal or chalk. The rough drawing surface and the broad drawing tool will force you to make big, simple shapes with minimal detail.

❷ Find a tree whose rounded clusters of leaves seem like a hopeless mass of fidgety detail. Then half-close your eyes so the details become blurry — and pretend that you're drawing fuzzy spheres. First draw the rounded spheres and then block in the tones *as if* you're modeling spherical forms.

❸ Try the same game with tall, slender trees whose leafy masses can be drawn *as if* you're looking at cylinders. Half close your eyes again to blur the distracting details. And draw the shapes as fuzzy, irregular cylinders.

❹ Keep working at this game, looking for trees whose clusters of foliage can be drawn *as if* they're blocky or conical — or fragments of blocks or cones.

❺ Don't exaggerate the imaginary geometric shapes, of course. Once you have the shapes and broad tones on paper, you can make them as irregular as you like — adding details like leaves and branches to make the trees look realistic.

PENCIL DRAWING

Section 2 helps you explore drawing with a pencil. In addition to working with basic pencil techniques, you'll have the chance to build on the drawing skills you learned in Section 1. Important keys to remember are:

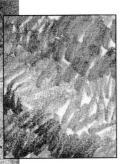

Start with simple geometric forms to practice your drawing skills. Get the basics down, then go on to more difficult subjects. You'll get a lot of variety simply by experimenting with different strokes and lines.

Try some irregular shapes as well as geometric ones. Build on what you've learned, seeing your subject as a collection of shapes. Explore the effects you can get with a combination of lines, strokes and blending.

Use light and shadow planes to model subjects indoors and outdoors. Pay close attention to values as you do this. Study the effects of the changing light when you're working outdoors.

Don't put in every detail you see; it's far more effective to suggest them, and let the viewer's mind fill in the picture. Select the essentials and you won't be overwhelmed by the mass of detail that you see.

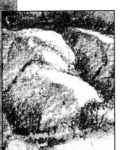

Simplify, simplify, simplify when you're drawing. Ignore intricate texture and detail in the earlier stages, block in shadows, and then add your detail. Decide what to emphasize.

Explore different strokes for different effects. You can create a wide range of textures and details with strokes. Change pencils, or change pressure on the pencil and see what happens.

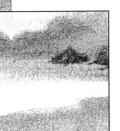

Interpret various textures with blends, strokes, lines—and with textured paper. Create a rich variety of textures with a minimum of effort. But don't get carried away; you need to get the basics, especially values, right first.

Blend, don't blur, to keep the blended tones vital. Add interest and variety to your drawings by combining soft blending and bold strokes, especially when working on textured paper.

Exploring Pencil Techniques

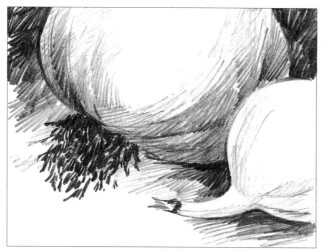

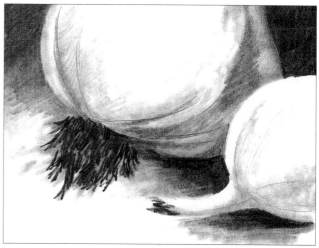

Lines and Strokes. The most common pencil drawing method is to draw slender lines around the contours of your subject, using more lines to build up some tones, and building other tones with broad strokes. In this close-up, you can see how the artist uses multiple lines to render the delicate tones and textures on the rounded shapes of the onions. The slender lines are made with the tip of a sharp HB pencil. A softer, darker 2B pencil, shaped to a flatter point, is used to render the background tones with broader, darker strokes.

Blending. Pencil strokes are easy to smudge with your fingertip or with a tool called a stomp — a paper cylinder that you can buy in art supply stores. Working with the same two pencils that he used in the drawing at the left, the artist lays in his tones with free strokes; then he goes over these strokes with his fingertip (or with a stomp) to blend the strokes into soft tones. The dark tones around the onions are then reinforced with broad strokes of the softer, darker 2B pencil. The sharp tip of the HB pencil draws the roots of the big onion.

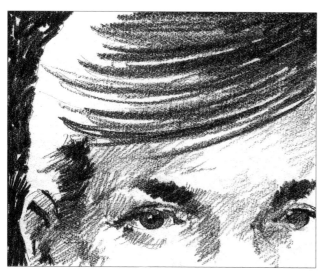

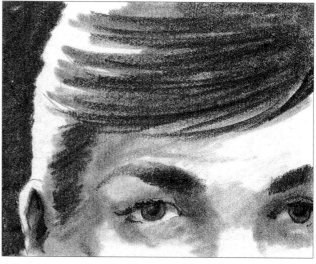

Lines and Strokes on Rough Paper. The texture of the drawing paper makes a big difference. A sheet of rough paper has what's called a *tooth* — a texture that breaks up the lines and strokes, making them look more ragged. This close-up section of a portrait is drawn entirely with a 2B pencil. The artist uses the sharp point of the pencil to make quick, parallel groups of strokes that suggest the delicate shadows of the face. Then the artist uses the side of the lead and presses harder to create the darks of the eyes, hair, and background.

Blending on Rough Paper. To create softer, smoother tones, the artist first draws the delicate shadows on the face with strokes of the 2B pencil — and then he blends them with his fingertip. The strokes merge softly into one another. The dark background is also blended. The artist exploits the rough texture of the paper to draw the hair and eyebrows with ragged strokes. The blended areas of the rough paper are livelier and more irregular than the smudged areas on the onions, which are drawn on smoother paper.

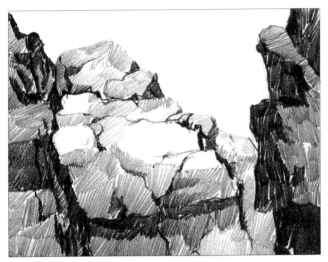

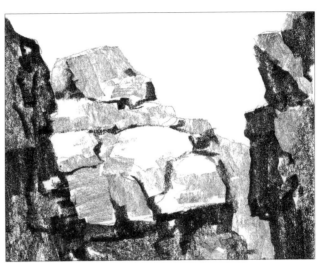

Slender Strokes. There are many ways to render landscape forms with a pencil. With the sharpened tip of the pencil, you can build up the halftones and shadows with groups of parallel strokes. Some strokes move across the tops of the rocks, while others slant down the diagonal planes and move down over the vertical planes. The artist presses lightly on the pencil for the halftones, leaving spaces between the strokes. For the darker tones, he presses harder on the pencil and leaves less space between the strokes.

Broad Strokes. You can use the side of the lead or you can sandpaper the tip to a broad, flat shape for making wider strokes — like the strokes made by the squarish end of an oil painting brush. In this drawing, the artist creates blocks of tone by laying broad strokes side by side. He uses less pressure for the paler tones and presses harder for the dark tones. He places pale strokes side by side, but piles one over another for the darker areas.

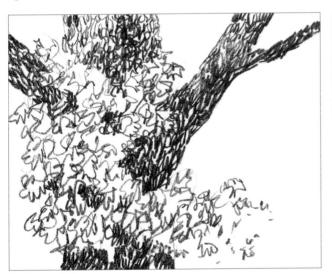

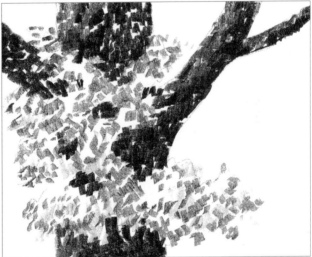

Scribbled Strokes. The movement and direction of your pencil strokes will make an important difference in the character of the drawing. To render the rough bark of a tree and the lively detail of the foliage, you might choose short, scribbled strokes. The artist moves his pencil quickly back and forth, placing strokes close together to suggest the dark tone and rough texture of the branches. A more open scribble — with more space between and around the strokes — suggests the paler tone and the lacy texture of the leaves.

Straight Strokes. Blunting his pencil point on a sandpaper block, the artist renders the tone and texture of the same branches with short, thick strokes. He packs his strokes densely, applying less pressure in the lighted areas and pressing harder on the shadow sides of the branches. He lets the strokes show to suggest the roughness of the bark. He uses the same kind of strokes to suggest the cluster of leaves, but then allows more space between the strokes, allowing the bare paper to show through to suggest the flicker of sunlight on the foliage.

KITCHEN STILL LIFE: RENDERING SIMPLE FORMS

Step 1. The best way to practice all that you've learned so far is to set up a complete still life of objects from your kitchen. Find a variety of geometric shapes: cubical objects, such as cardboard boxes; cylindrical forms, such as glasses and jars; rounded shapes, such as apples and other pieces of fruit; and irregular shapes, such as leafy vegetables. The first step is to draw all of these objects as simple, geometric shapes. Work with light strokes, using the tip of a sharp HB pencil. Concentrate on proportions and geometric shapes. At this stage, you don't have to worry about making the shapes look like the real subjects.

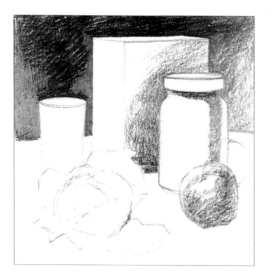

Step 2. Working with the point of the same HB pencil, go over the original guidelines to make the shapes look more like boxes, jars, fruit, vegetables, or whatever. Notice how the artist reshapes the apple, flattening some contours and breaking others, since no fruit is ever exactly round. Having drawn the cabbages as a few simple shapes in Step 1, the artist now converts geometric contours into leaves. And the cylindrical jar drawn in Step 1 has now been divided into a body and a lid, which is like a slice of a cylinder.

Step 3. This is a stage at which you begin to block in the general distribution of the darks with broad, free strokes. Here the artist reaches for a softer, darker 3B pencil and blocks in the tones with broad strokes, using the side of the lead. To suggest the darker areas of the background, he presses the lead hard against the paper. He works on a sheet of drawing paper with a distinct texture that breaks up the strokes so they seem to flow together on the sides of the box, jar, and apple. The darker strokes, where he presses harder, stand out more clearly.

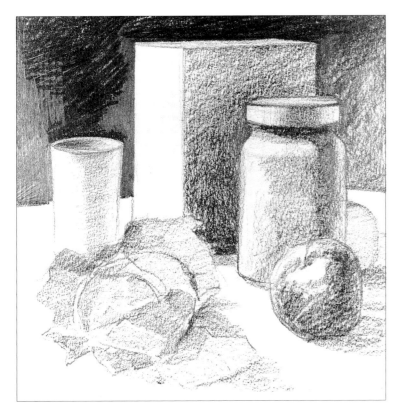

Step 4. The artist continues to cover the shapes with broad, simple tones. At this point, he pays no attention to precise detail, but moves his 3B pencil freely over the paper, visualizing his tones as big patches. Notice how the tones are scrubbed loosely over the complex form of the cabbage—without paying too much attention to the precise contours of the leaves. Now you begin to see gradations of tone, such as the light, halftone (or middletone), shadow, and reflected light on the jar and apple. Naturally, the gradation of tone is much softer on the pale surface of the glass.

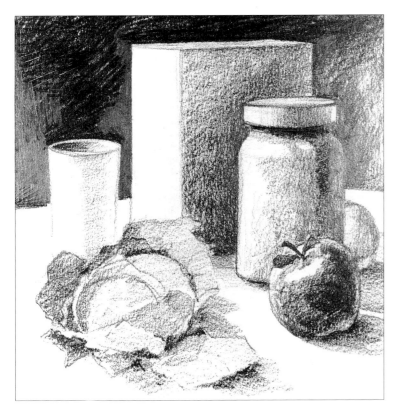

Step 5. Having established broad patches of tone throughout the drawing, the artist starts strengthening the tones. Pressing harder on the 3B pencil, he darkens the shadows on the jar, apple, and glass. He also looks carefully for the darks on the cabbage leaves and strengthens them selectively. He goes back over the cast shadows on the tabletop. And finally, he begins to strengthen the contours of the leaves, jar, and apple with the sharp point of the HB pencil, with which he also adds the stem of the apple.

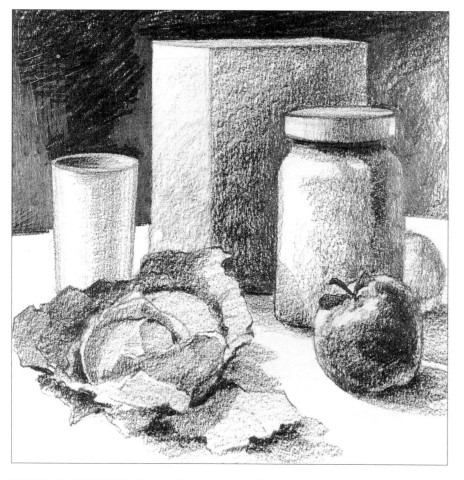

Step 6. The artist continues to build up the tones and contours of the cabbage, which is now more distinct and three-dimensional. The cylindrical shape of the glass is also strengthened with delicate pencil strokes that move vertically from top to bottom; the pencil is used very lightly, suggesting a soft gradation from light to halftone to shadow to reflected light. Notice how a hint of shadow has been added to the lighted plane of the box. The cast shadows under the cabbage are defined more distinctly so the cabbage really stands up from the table.

PROJECT 1: EXPERIMENT WITH STROKES

Subject. Take a walk outdoors and bring home a variety of "found objects" that you can set up to draw another group of geometric shapes. Look for rocks, chunks of wood, broken branches — shapes that are roughly cubical, spherical, cylindrical, or conical. Set up your still life on a table near a lamp or a window.

Materials and Tools. Work with three pencils — HB, 3B, 5B — and a sheet of rough paper.

Technique. Start by drawing the geometric shapes with the sharp tip of the HB pencil. Then go over the contours and draw them with greater precision — again with the HB. Block in the broad shadow shapes with the 3B. Finally, add the stronger darks with the 5B; develop the gradations within the darks with the 3B; and add details and textures with the HB. Move the lamp or turn the setup so you can make a series of drawings in different light.

Tips. Limit yourself to lines and strokes. No smudging! Work with light pressure on the pencil in the first step, more pressure in the next, and still more pressure in the final stages. When you start to build up the shadow areas, try using the side of the pencil lead instead of the point, so you'll make wider strokes.

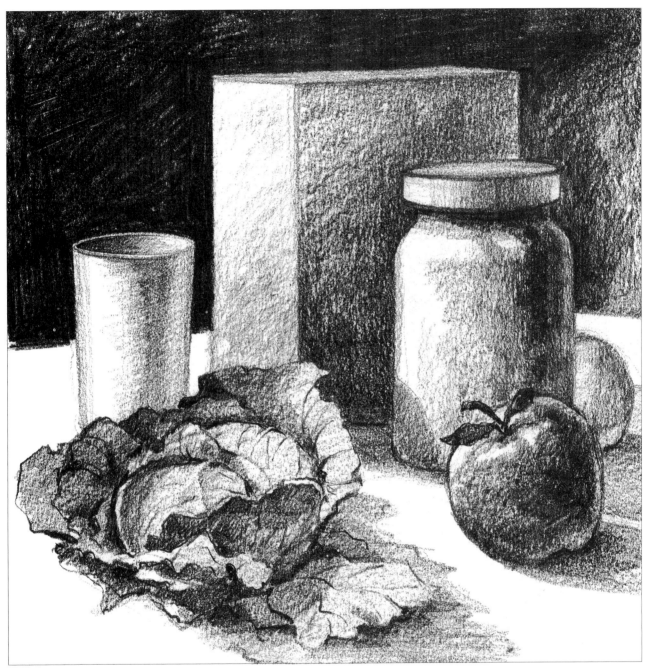

Step 7. This stage is the right time to deepen tones and add details. Using a thick, dark, soft 5B pencil, the artist darkens the background with broad, bold strokes. With this same pencil, he moves back into the shadow areas of the box, jar, and apple; now the gradation of light, halftone (or middletone), shadow, and reflected light is obvious. Using the side of a 3B pencil, he strengthens the tones of the cabbage leaves and deepens the shadows on the glass. He moves the tip of the same pencil carefully around the leaves, delineating the edges and adding linear details within them. In the same way, he darkens the edges of the box, jar, and apple, using the sharp point of the HB pencil. Notice how the cast shadows are extended and strengthened to make all the objects rest more firmly on the tabletop. To strengthen the lights, the artist uses a chunk of kneaded rubber, squeezed to a pointed tip, pressed down carefully, and then pulled away from the patches of light on the apple, jar, box, and glass. He then uses a wedge of pink rubber to clean and brighten the lighted areas of the table.

FLOWERS: DRAWING GEOMETRIC AND IRREGULAR SHAPES

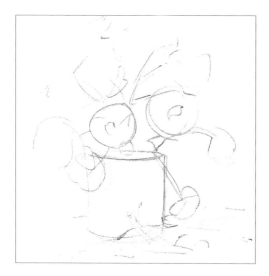

Step 1. A vase of wild flowers will give you a good opportunity to draw a combination of geometric and irregular forms — and also to try out a combination of lines, strokes, and blending. The first step, as always, is a simple line drawing that visualizes the shapes as basic geometric forms — or nongeometric forms that you have to create by observing the subject carefully. Here the artist visualizes the vase as a cylinder and many of the flowers as circular shapes. The drapery doesn't quite fit any geometric form, so the artist draws a few simple shapes as guidelines. Some of the smaller flowers are also irregular in shape. This preliminary drawing is done with an all-purpose HB pencil on fairly smooth drawing paper.

Step 2. Pressing more firmly on the point of the HB pencil, the artist moves over and within the guidelines of Step 1 to draw his subject more realistically. He strengthens the lines of the cylindrical base and converts the guidelines of the drapery to folds. Within the shapes of the circular flowers, he draws radiating petals and circular centers. The leaves are suggested as jagged, irregular shapes. As the artist defines the shapes of the more irregular flowers, he sees them as resembling broken eggshells. Although the lines are more precise than in Step 1, he still draws with light, casual movements.

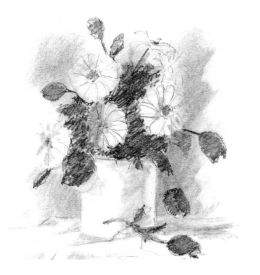

Step 3. To establish the distribution of tones, the artist uses the side of a 3B pencil and scrubs in parallel slanted lines with quick strokes. The dark mass of leaves between the lighter flowers is literally scribbled in with a rapid back-and-forth movement, paying no attention to detail. The egg-shaped flowers are darkened with the same kind of strokes. The artist moves the side of the pencil more lightly over the paper to suggest the shadows on the pale flowers, the vase, the drapery, and the background. To make the pale shadows still softer and more delicate, the artist rubs his fingertip over the strokes and blends them into a more continuous, even tone.

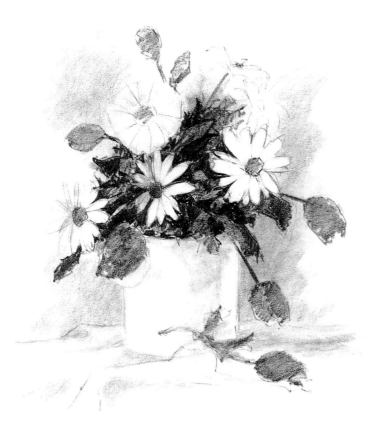

Step 4. Having established the main tonal areas of the drawing, the artist begins to define the smaller shapes more precisely. He extends the dark tones of the leaves into the spaces between the petals of the paler flowers, working with the point of the pencil to get these dark shapes exactly right. He also redraws the edges of some of the petals themselves and begins to suggest individual leaves within the dark mass. The dark centers of the pale flowers are more precisely defined too.

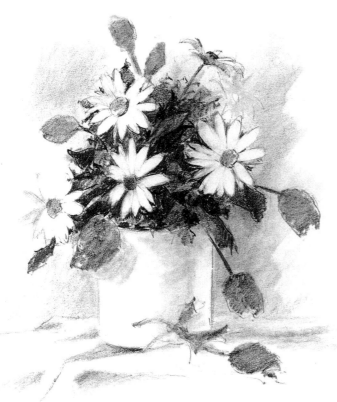

Step 5. The artist continues to strengthen the shapes of the lighter flowers. Now the pale flower at the top becomes more distinct as he extends the shadow tone around the petals and darkens the center. A darker flower is drawn in silhouette at the upper right with loose strokes that don't define the petals too precisely. Using the tip of a pink eraser (in pencil form), he cleans the petals of the pale flowers so they contrast more brightly with the dark, leafy mass behind them. Now the pattern of light and shadow is clearly defined. So are the most important shapes in the picture: the pale flowers. But everything is drawn very broadly. The picture is mostly patches of tone with few distinct lines and very little detail.

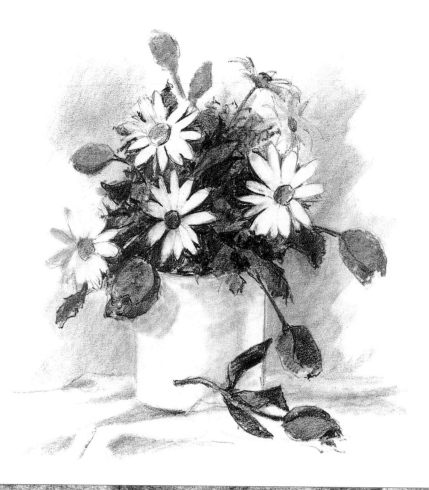

Step 6. At last, the artist begins to sharpen some of the darker shapes. With the point of the HB pencil, he defines the leaves and the dark flowers more distinctly. The dark, jagged shape on the tabletop now becomes a fallen flower with three leaves. He also defines the edges and the stems of the egg-shaped flowers that hang down from the bouquet. Crisp lines also strengthen the petals and the centers of the pale flowers. But the pale flower at the left and the dark ones at the top are still just touches of tone.

PROJECT 2: BEGINNING TO BLEND

Subject. After you've drawn the vase of wild flowers, pull them out of the vase and toss them casually on the tabletop. Gather some objects that are roughly geometric shapes — rocks, chunks of wood, broken branches. Place the bigger objects behind the flowers and the smaller objects among the flowers. Don't arrange the still life too neatly. Let the arrangement just happen.

Materials and Tools. Choose a sheet of charcoal paper that gives your strokes a lovely texture — and allows you to blend them. Work with three pencils — HB, 2B, 3B — plus a fingertip or a stomp, and a kneaded rubber eraser.

Technique. Start with a simple line drawing of basic shapes. Then go over the lines, adding more detail. As you determine the tonal areas, experiment with using your fingertip or the stomp to blend the shadow strokes. Lift out the reflected lights within the shadows with the kneaded rubber eraser. Wherever your tones overrun the lighted areas, brighten them with the eraser. Draw the setup from different angles and be sure to change the light direction.

Tips. You can use your blackened fingertip or the stomp like a brush to spread tones where you need them. Don't blend every stroke or your whole drawing will look as if it's covered with a grayish haze. Leave lots of strokes intact. Let the texture of the paper show through wider strokes.

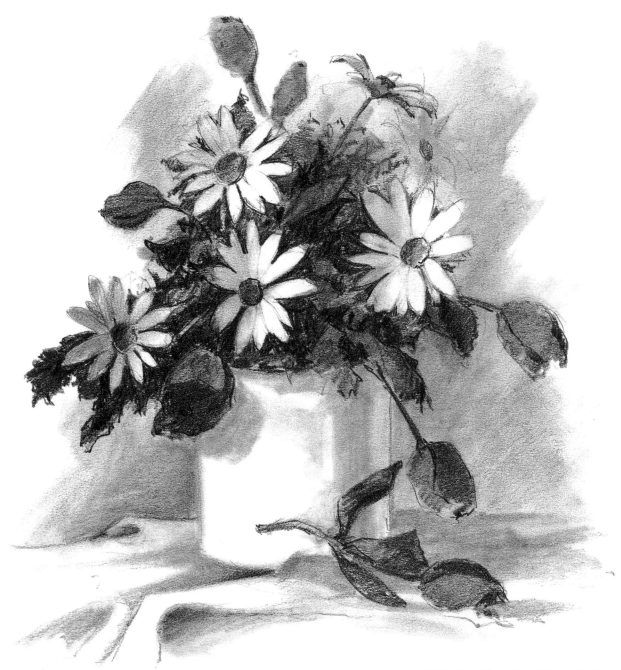

Step 7. Once again, the really precise work is saved for the final stage. A 3B pencil is used in the dark, leafy mass to strengthen the tones, suggest the leaves more distinctly, and darken the edges of the pale petals. The artist blends this dark mass with his fingertip. He uses his graphite-covered finger — like a brush — to carry shadows across the pale flowers. Then he switches to the sharp point of a 2B pencil to go over the contours of the flower shapes and strengthen their centers. The dark egg-shaped blossoms also have more distinct edges now, but they're not as clearly drawn as the pale flowers that

dominate the picture. With the side of the 3B pencil, the artist goes over the background tone, the shadows on the vase, and the tones between the folds on the tabletop — and then he blends these tones with a fingertip so the strokes disappear. The wedge-shaped pink eraser is used to brighten the lighted areas of the background, vase, and tabletop. A kneaded rubber eraser is pressed to a point to brighten the lighted petals. And a soap eraser is moved over the outer edges of the drawing to make the bare paper look bright and clean.

ROCKS: STUDYING LIGHT AND SHADOW PLANES

Step 1. When you're ready to start drawing outdoors, choose some simple shapes like rocks: solid, geometric shapes with distinct planes of light and shadow. Their shapes are so simple that you can often visualize them with just a few lines — as the artist does here. To draw the bold shapes and rough textures of rocks, the artist has chosen a sheet of rough drawing paper that has a distinct, ragged tooth. His pencils are in the 4B – 6B range, with thick, soft leads that make broad, dark strokes. He starts out by visualizing the rocks as a few big, blocky shapes. The distant hills are flattened cones. The base of the rock formation is traced with a zigzag line that curves into the foreground, where the artist suggests more rocks with a few bold lines.

Step 2. Over the guidelines of Step 1, the artist draws the shapes of the rocks more carefully. The three big rocks above the center of the picture, which form the focal point of the drawing, are visualized as cubes with broken sides. The smaller rocks in the immediate foreground also look like fragments of cubes. The big rock formation on the right is drawn as one irregular mass. Within the shapes of the rocks, the artist uses a slightly lighter line to suggest the division between planes in light and shadow. Notice how the patches of foliage above the rocks are drawn as jagged shapes; later they'll be filled with strokes to suggest clumps of weeds.

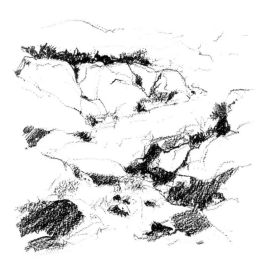

Step 3. Now the artist begins to indicate the strongest darks. With broad, heavy strokes of a thick pencil, he blocks in the dark shadows on the rocks in the immediate foreground; suggests the darkest cracks among the more distant rocks; and scribbles in a dark tone that suggests the texture of the weeds on top of the rocks. Study the foreground shadows and you'll see that the artist pays particular attention to the shapes of the shadows — he doesn't just scribble in a lot of dark strokes at random.

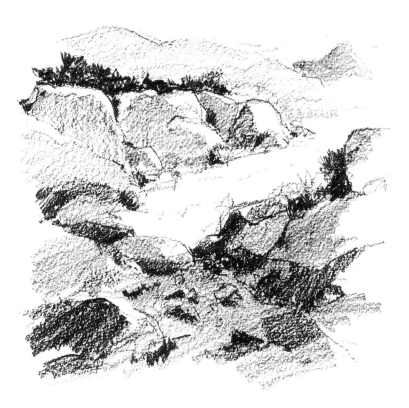

Step 4. After blocking in the darkest notes in the picture, the artist covers the lighter shadow areas by passing the pencil gently over the surface of the paper. Now there's a clear distinction between the light and shadow planes of the rock formation in the distance. The entire foreground is covered with a veil of soft shadow too. The distant hills become a soft, smoky silhouette. The sky and the patch of sunlight in the middleground are bare paper. The entire picture is drawn in just three values: a dark gray, a more delicate gray, and the white paper.

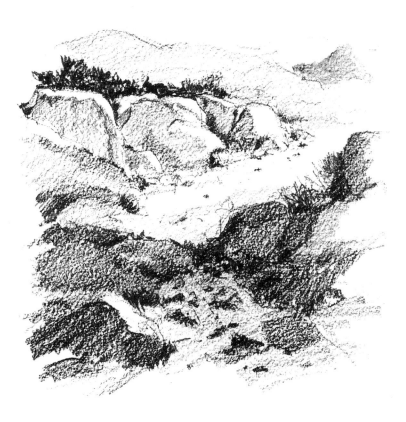

Step 5. Next, the artist decides to strengthen the shadow falling across the foreground in order to create a stronger break between the shaded and sunlit areas of the picture. Most of the foreground is now darkened with broad strokes. Notice how the rough texture of the paper suggests the rugged surface of the rocks. Moving back to the sunlit rocks, the artist begins to add touches of tone within the shadows to make the rocks look more solid and three-dimensional. The sunlit patch of ground is enlivened by a few dark touches that suggest pebbles. In the same way, pebbles are suggested in the immediate foreground.

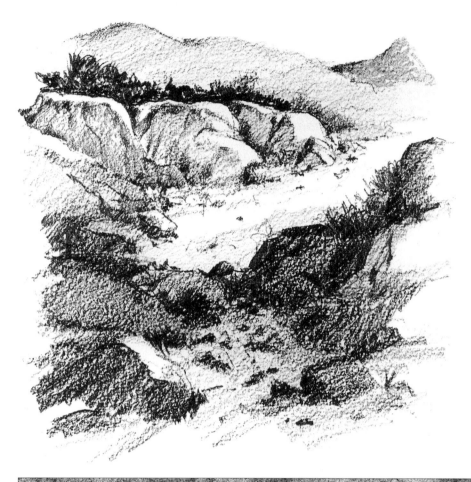

Step 6. The artist continues to develop the distant rocks with lines and touches of tone that suggest cracks and other surface irregularities. Just a few strokes indicate shadows on the sides of the distant hills. Moving into the foreground, the artist begins to add strokes that convert the big patch of shadow into rocky forms. The edges of foreground rocks become more distinct as he carries dark strokes along the contours. He also draws dividing lines between the rocks on the left. Compare the small rock in the lower right with Step 5: by adding a triangle of shadow on the left side, the artist transforms an area of shadow into a blocky boulder, half-buried in the soil.

PROJECT 3: DEALING WITH CHANGING LIGHT

Subject. Take a walk through some part of town where you find lots of buildings of different sizes and shapes. Or find a cluster of farm buildings. Time your walk for early morning or late afternoon when the shadows are most evident. Place yourself where you can see the big light and shadow shapes on the walls and roofs of the buildings, plus the cast shadows that fall on the ground or on the walls.

Materials and Tools. You'll need a small pad of white drawing paper — about the size of this page — and a single drawing tool that slips into your pocket. Try a thick, cylindrical graphite lead in a mechanical holder or a rectangular graphite stick. The right grade is 2B or 3B.

Technique. Draw as fast as you can, working with big, bold, broad strokes — like brushstrokes. Aim for a rough, decisive drawing. Don't be neat. Try to record those shapes in five or ten minutes. As soon as you record the essentials, move to another location and start another drawing. Try to go home with a sketchbook *filled* with drawings.

Tips. Shadows are transparent, full of light; they're not pools of ink. Look for dark-to-light gradations within the shadows. The sun is moving, so your subject will change as you draw. That's why you have to work fast.

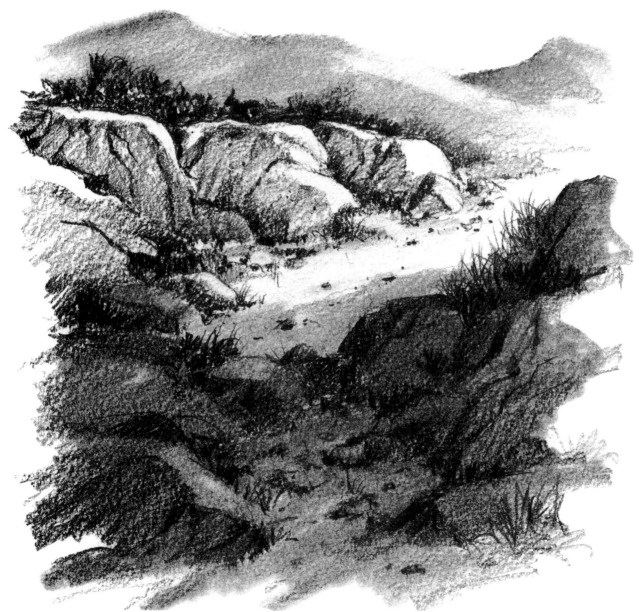

Step 7. In this final stage, the artist moves his thumb over the entire foreground, blending the strokes into a rich, continuous shadow tone. He doesn't rub *too* much — he doesn't want the strokes obliterated, just blurred and softened. He does the same thing with the distant hills, blending the strokes into an irregular, smoky tone that still retains some of the rough texture of the paper. The sunlit slope of one hill is erased with a single sweep of kneaded rubber. Now the final step is to strengthen the darks and add crisp lines for details. The grass at the top of the distant rocks is darkened with quick, scribbly strokes. Then the shadow sides of the rocks are darkened, and more cracks are added with the sharp point of the pencil. The sunlit tops of those rocks are cleaned with kneaded rubber squeezed to a point. Small pencil strokes suggest more grass and pebbles at the base of the sunlit rocks. Moving down into the foreground, the artist darkens the shadows and adds slender, arc-like strokes for weeds and blades of grass. Throughout the finished drawing, the texture of the paper enhances the roughness of the subject.

HILLS: SUGGESTING DETAILS IN A LANDSCAPE

Step 1. After drawing an "outdoor still life" such as a rock formation, choose a more panoramic landscape subject. In this demonstration, the artist draws a stream winding across a meadow with trees and hills in the distance. He begins with a simple line drawing of the biggest shapes in the picture: the hills that look like flattened cones; the ragged, irregular shape of the mass of trees; and the zigzag contours of the stream. Notice that he draws the shoreline with particular care, paying special attention to the long, horizontal shapes of the land. The grassy foreground is merely suggested with a few wispy lines.

Step 2. Pressing harder on the HB pencil point, the artist goes over the guidelines of Step 1 to draw the forms with greater precision. The hill at left is actually covered with foliage and the strips of land are covered with grass and weeds, so he redraws their contours with wiggly lines. He uses the same kind of line to delineate the mass of trees at the base of the hills. In the immediate foreground, he adds the shapes of some rocks; two of them look like slices of cubes and one is more rounded, like a slice of a sphere. Scribbly lines suggest foreground weeds. He doesn't strengthen the contour of one distant hill, but simply lays a veil of soft tone over it by making vertical strokes with the side of his pencil.

Step 3. Now the artist begins to place his strongest darks on the drawing paper. With the side of the lead of a 3B pencil, he scribbles in the texture of the trees with short, horizontal strokes, then suggests trunks with a few vertical strokes. He indicates the dark reflections of the trees in the stream and traces the dark edges of the shoreline. He also darkens the top of the small hill just above the trees with rough, irregular strokes.

Step 4. Still working with the side of the 3B pencil, the artist adds the strong darks of the rocks in the foreground, making a clear distinction between the lighter tone of the sunlit tops and the darker, shadowy sides. The next step is to add the middletones — the grays that fall between the dark values and the white of the paper. The artist covers the big hill on the left with vertical strokes suggesting the tone and texture of foliage. He begins to indicate some middletones on the patches of land with long, horizontal strokes. And he darkens the foreground with broad, scribbly, vertical strokes that suggest the texture and detail of the grass and weeds. Some lighter reflections are added to the water.

Step 5. Having covered the drawing paper with patches of tone indicating the general distribution of darks, lights, and middletones, the artist now moves back into these areas to strengthen the tones. The big hill at the left is solidified with broad, vertical strokes made with a 3B pencil — with the end of the lead sandpapered to a squarish shape. With this same pencil, he darkens the small hill just behind the trees. With the thick lead of a 6B pencil, he darkens the trees with short, horizontal strokes, and also darkens the foreground rocks and the reflection in the stream. The stream and the surrounding land are darkened with long, horizontal strokes, made by the side of the 3B pencil lead.

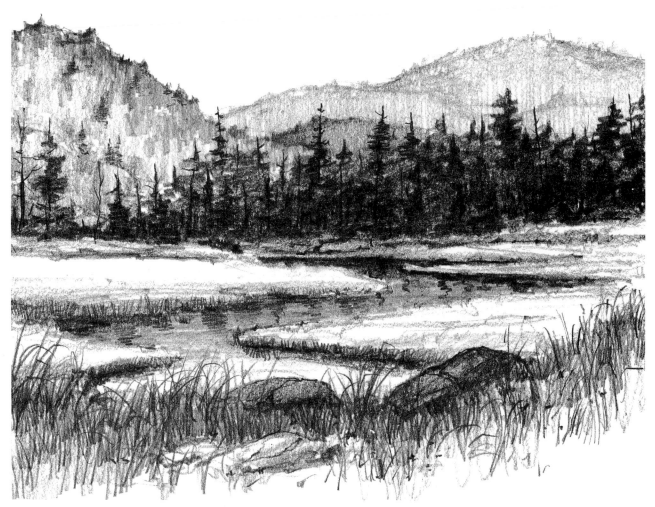

Step 6. Now you can see how all the final details are added. The sharp point of the HB pencil is worked back into the trees to add some trunks and branches. A single dead tree is added at the extreme left with crisp, dark strokes. Reflections of trees are carried down into the water with dark, wiggly strokes. Soft, scribbly strokes are added to the top of the pale, distant hill to suggest foliage — but the hill is just barely darkened by these strokes, so it still looks far away. Just below the trees, the land is darkened to suggest the shadows of the dark mass of evergreens. The stream is now a dark zigzag in contrast with the sunlit patches of shore. (Notice how the parallel banks of the stream gradually converge as they recede into the distance, obeying the rules of perspective.) The artist suggests blades of grass only along the shoreline,

not over the entire meadow; the strokes along the shoreline are just enough to make you imagine the grassy texture of the land. In the same way, the grassy foreground is only partially covered with grass and weeds made with wispy, curving strokes using the sharp point of the HB pencil. The artist also reinforces the contours of the rocks with the sharp point, then uses the side of the lead to darken the ground, suggesting shadows at the base of the weeds. The stream is darkened in the same way. The point of the pencil moves along the shoreline, carrying the reflections of the grass down into the water with horizontal and vertical strokes. Notice how the artist actually leaves a lot of bare paper, but he gives you enough grass and weeds to suggest more detail than he really draws.

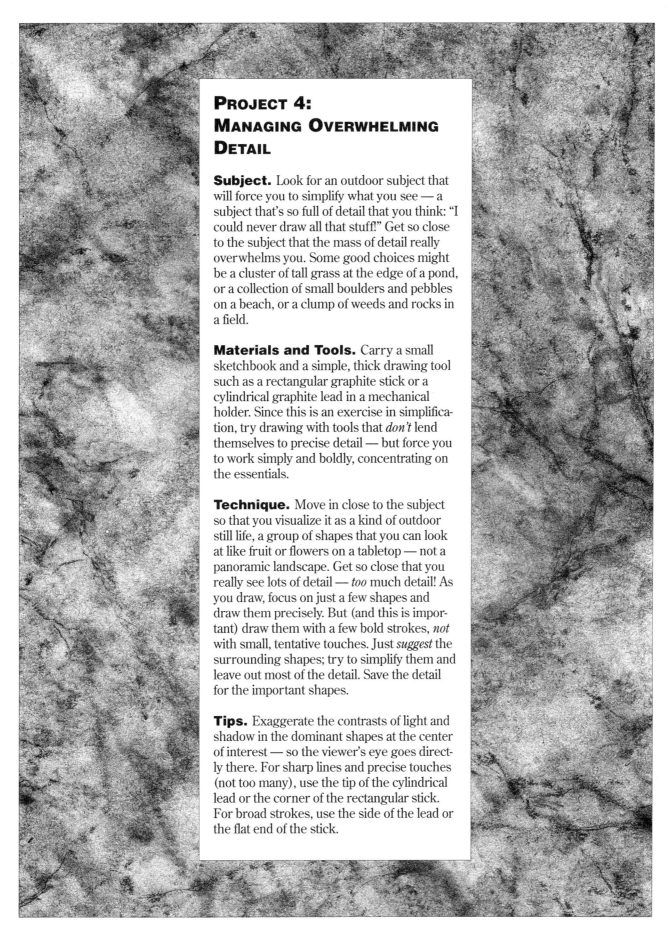

PROJECT 4: MANAGING OVERWHELMING DETAIL

Subject. Look for an outdoor subject that will force you to simplify what you see — a subject that's so full of detail that you think: "I could never draw all that stuff!" Get so close to the subject that the mass of detail really overwhelms you. Some good choices might be a cluster of tall grass at the edge of a pond, or a collection of small boulders and pebbles on a beach, or a clump of weeds and rocks in a field.

Materials and Tools. Carry a small sketchbook and a simple, thick drawing tool such as a rectangular graphite stick or a cylindrical graphite lead in a mechanical holder. Since this is an exercise in simplification, try drawing with tools that *don't* lend themselves to precise detail — but force you to work simply and boldly, concentrating on the essentials.

Technique. Move in close to the subject so that you visualize it as a kind of outdoor still life, a group of shapes that you can look at like fruit or flowers on a tabletop — not a panoramic landscape. Get so close that you really see lots of detail — *too* much detail! As you draw, focus on just a few shapes and draw them precisely. But (and this is important) draw them with a few bold strokes, *not* with small, tentative touches. Just *suggest* the surrounding shapes; try to simplify them and leave out most of the detail. Save the detail for the important shapes.

Tips. Exaggerate the contrasts of light and shadow in the dominant shapes at the center of interest — so the viewer's eye goes directly there. For sharp lines and precise touches (not too many), use the tip of the cylindrical lead or the corner of the rectangular stick. For broad strokes, use the side of the lead or the flat end of the stick.

TREES: LEARNING TO SIMPLIFY

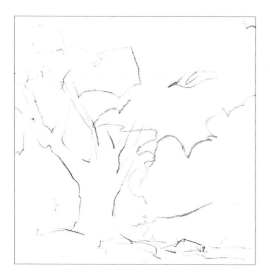

Step 1. Certainly one of the most common landscape elements — and one of the most beautiful to draw — is the bold form of a tree in full leaf. Such a tree is full of intricate texture and rich detail, which you must force yourself to *ignore* in the first stages of your drawing. Observe how the artist draws the masses of leaves as big, jagged shapes, paying no attention to individual leaves, but concentrating entirely on a highly simplified outline. He also looks for gaps where the sky shines through the leaves. And he makes a quick, relaxed contour drawing of the trunk and branches, concentrating on the major shapes and omitting the smaller branches that will appear later. Just a few lines suggest the ground, rocks, and distant hill.

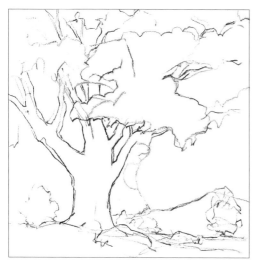

Step 2. Pressing harder on the point of his pencil, the artist goes back over the leafy shapes with short, curving, expressive lines that begin to suggest foliage — but he still doesn't draw a single leaf. He also studies the trunk and branches more closely, drawing the shapes more precisely and indicating some more branches. Finally, he strengthens the contours of the foreground rocks, the shrubs, and the hill in the lower right. The drawing is accurate, but is still very simple.

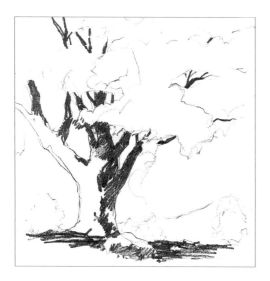

Step 3. The next step is to block in the shapes of the darks. The line drawing has been done with an HB pencil, but now the artist reaches for a softer, darker 3B pencil, which he turns sideways to block in the tones with the side of the lead. He works with broad parallel strokes to create patches of tone. After covering the shadow areas of the main trunk, he moves upward to indicate the shadowy branches showing through the gaps in the foliage. With long, horizontal strokes, he suggests the shadow that the tree casts on the ground. And he blocks in the shadowy side plane of the rock in the foreground.

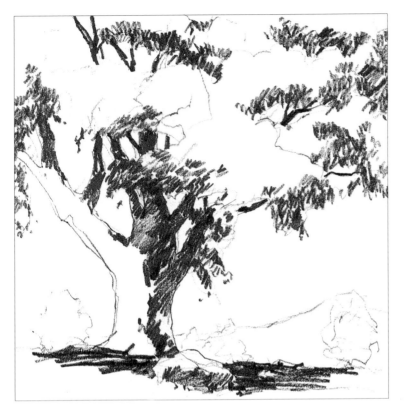

Step 4. Still concentrating on the shadow, the artist switches his attention to the masses of leaves. The shadows appear on the undersides of the leafy masses. He draws them with dark, scribbly strokes that actually suggest the texture of the leaves. As he moves the pencil back and forth, he changes direction slightly to suggest the irregular clusters of foliage. Not a single leaf has been actually drawn, but the expressive strokes give you the feeling that the leaves are really there.

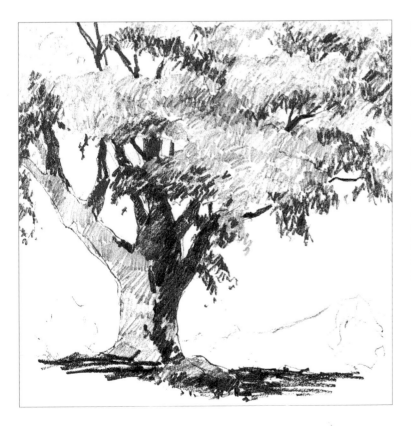

Step 5. The artist moves on to the lighted areas of the trunk, the big branch at the left, and the foliage above. Notice how he works with clusters of parallel strokes that suggest patches of tone on the trunk and branch, while also conveying the texture of the bark. The pale groups of leaves are also drawn with clusters of pencil strokes, but these clusters are smaller and keep changing direction. Some strokes are slanted, while others are more horizontal or vertical. And some strokes are straight, while others curve slightly. This random pattern of leafy strokes is a very simple means of suggesting rich texture and detail. The artist also adds tone to the lighted top of the foreground rock.

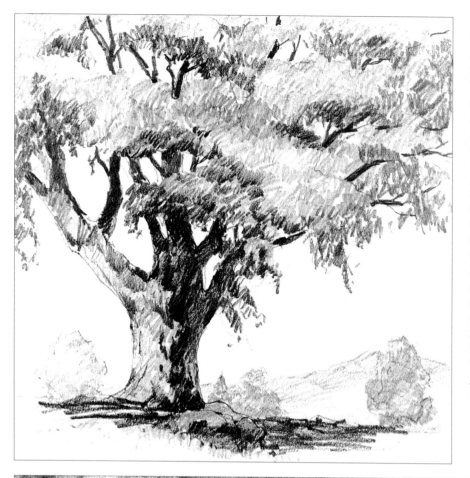

Step 6. Having established the broad distribution of tones on the tree and in the foreground, the artist can now begin to strengthen these tones and suggest more detail. Pressing harder on the side of the 3B pencil, he piles stroke over stroke to darken the shadow sides of the trunk and branches, also suggesting a few cracks in the trunk. (Notice how the trunk is modeled like a cylinder, with a hint of reflected light at the right.) The artist also builds up the dark undersides of the leafy masses with darker, denser, scribbly strokes. He adds more dark branches in the gaps between clusters of leaves. He covers the distant hills and trees with broad, pale strokes that make them seem remote. And a few touches of the pencil suggest grass.

PROJECT 5: EMPHASIZE AND SIMPLIFY

Subject. To continue learning about the job of simplifying a complex subject, search for a landscape that gives you a lot of detail to cope with. A stand of evergreens would be a good challenge. So would a rocky cliff with lots of cracks and fallen boulders.

Materials and Tools. Select a sheet of rough paper that will break up your pencil strokes. This time, draw with sharpened HB, 2B, and 3B pencils — giving yourself the double challenge of working with precise strokes, but still keeping your drawing as simple as possible.

Technique. As you make your first line drawing of the shapes, think about what you want to emphasize and what you expect to simplify — or leave out altogether. Save your strongest contrasts of light and shadow and your greatest amount of detail for the center of interest. Just suggest everything else. Block in the big shadow shapes with multiple strokes and no blending. See if you can create shadows with a pattern of small strokes. As you begin to develop the gradations and the details, try to omit as many small shadows and other small touches as you can manage — keeping only enough detail to make the viewer identify the subject.

Tips. The rough paper will broaden, roughen, and simplify the strokes of the sharpened pencils. Let the paper do its job — making your small strokes look bolder.

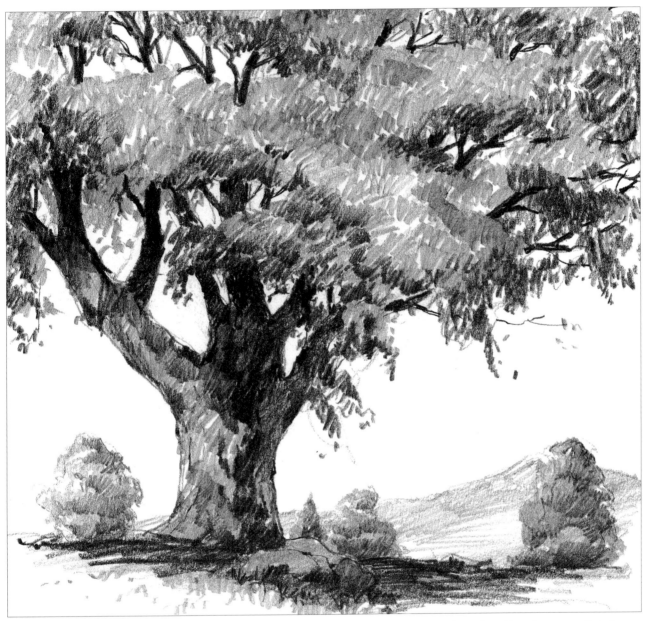

Step 7. In the final stage of the drawing, the artist continues to deepen the tones and add detail and texture. Smaller clusters of strokes enrich the texture of the thick trunk and lower branches. The shadowy undersides of the leafy masses are darkened with short, scribbly strokes — most apparent on the right. The sharp point of a 2B pencil adds slender twigs among the foliage; you can see these most clearly on the right and toward the top of the picture. Here and there, a quick touch of the pencil suggests a single leaf hanging down from the mass of foliage and silhouetted against the sky. The side of the HB pencil is used to darken the shadow on the

ground with horizontal strokes. Pressing more lightly on the pencil, the artist adds shadows to the distant trees and darkens the slope of the distant hill — but these remain distinctly lighter than the big tree. The landscape obeys the rules of aerial perspective: foreground objects are darker and more detailed, while the shapes in the distance are paler and show a minimum of detail. This demonstration is also a good example of a drawing in which a wealth of texture and detail is rendered very simply: the artist relies primarily on clusters of broad strokes made with the side of the pencil.

Meadow: Trying Out Different Strokes

Step 1. It's important to explore all the different kinds of strokes that you can make with a graphite pencil. A subject such as a meadow — with rocks, trees, and hills in the distance — will challenge you to find varied combinations of lines and strokes to suit the various parts of the landscape. As always, it's best to start with a very simple line drawing of the main shapes as the artist does here. It's really impossible to suggest the intricate detail of the meadow at this stage, so the artist draws just the distant rock formation and suggests the trees and one hill beyond. He works with the sharp point of a 2B pencil, gliding lightly over the surface of the drawing paper.

Step 2. Now he sharpens the contours of the rock formation and draws the shapes more precisely, looking for the divisions among the rocks. He also draws the spiky shapes of the trees more distinctly, but doesn't define them too precisely, since the preliminary line drawing will soon be covered with broad strokes. A few slanted lines place the hills in the distance. And a very important scribble establishes the division between the shadowy foreground of the meadow and the sunlit field beyond — a division that won't become apparent until the final stage of the drawing.

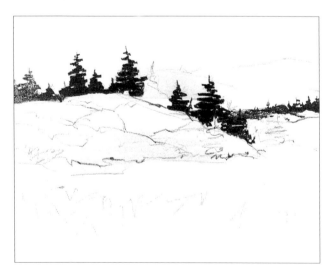

Step 3. With a thick, dark 4B pencil sandpapered to a flattened tip, the artist begins by drawing the darkest notes in the landscape: the evergreens above the rock formation. He draws the clusters of foliage with broad, horizontal lines, allowing gaps of sky to show through. He applies more pressure on the pencil to suggest that some trees are nearer and darker than others. The trees at the extreme left — and the strip of very distant trees at the extreme right — are drawn with lighter strokes to suggest the effect of aerial perspective. The trunk of each tree is a single slender, vertical stroke.

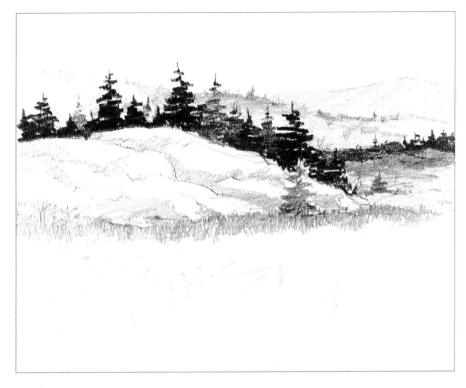

Step 4. With the side of the 2B pencil, the artist blocks in the shadow planes of the rock formation. The sunlit tops and the shadowy sides are clearly defined. He begins to suggest the grass at the base of the rock formation with short, scribbly vertical strokes. He adds paler trees above and below the rocks, again working with horizontal strokes for the masses of foliage. Letting the side of the pencil glide lightly over the paper, he covers the distant hills with tone and suggests a few trees on the long slope behind the darker trees. Notice how the nearest hill at right — the low one that's crowned with a slender grove of trees — is darker than the hills beyond.

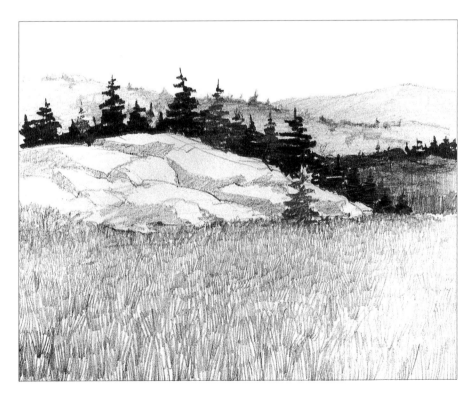

Step 5. The artist covers the entire meadow with clusters of slender strokes, using the tip of the 2B pencil. He applies very little pressure, moving the pencil rapidly up and down, and changing direction slightly so that some clusters lean to the left and others lean to the right. The scribbly marks of the pencil are short and dense in the distance, gradually growing longer as they approach the foreground. You already have a distinct sense of distance, since the foregound grasses are taller and more distinct than those in the background. The artist darkens the low hill at the right with vertical strokes.

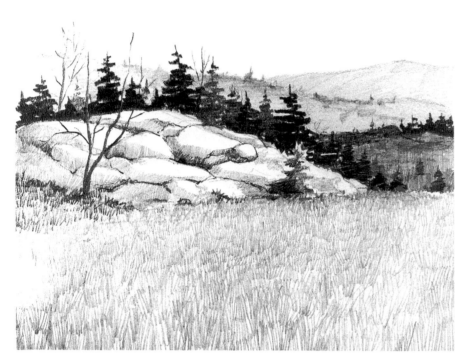

Step 6. Moving away from the foreground for a moment, the artist concentrates on the rocks and trees in the middleground. Pressing hard on the point of a 3B pencil, he draws the cracks between the rocks with strong, dark strokes and begins to darken the shadows within these cracks. He breaks up the original forms to suggest more rocks than were there before. He draws the trunks and branches of some leafless trees at the left along the top of the rock formation, also adding more evergreens at the extreme right. The rock formation casts a shadow on the meadow at the extreme left, which the artist suggests by adding short, dark strokes to the grass.

PROJECT 6: PERFECT YOUR STROKES

Subject. Save this project for a day when you want to work indoors. Rummage through the kitchen — or go to the fruit and vegetable market — and find a variety of shapes and textures that will challenge you to try out the greatest possible number of pencil strokes. Look for complex subjects like cabbage and lettuce, pineapple, celery and carrots with their leafy tops, squashes and melons with textured skins. Throw them casually on a table with a lamp or window nearby.

Materials and Tools. Spread out all your pencils, graphite sticks in holders, and rectangular graphite sticks so you can see them all and use as many as you need. Work on sturdy white drawing paper — *not* a heavily textured sheet like charcoal paper. Your *strokes* will create the texture in the drawing.

Technique. As you study each object on the table, scan your "palette" of pencil drawing tools and pick the right one for the job. Decide what sort of strokes you want to make: thick, thin, light, dark, straight, scribbly, and so on. Sharpen the drawing tool for some strokes. For others, flatten the point on the sandpaper block. Try using the point of the lead and then the side of the lead. See how many different kinds of strokes you can use.

Tips. This is also a good time to experiment with other factors. Try varying your pressure on the tool. Move the tool swiftly over the paper and then more slowly. Hold the tool at different angles: perpendicular to the paper, at various slants, and almost parallel to the drawing surface.

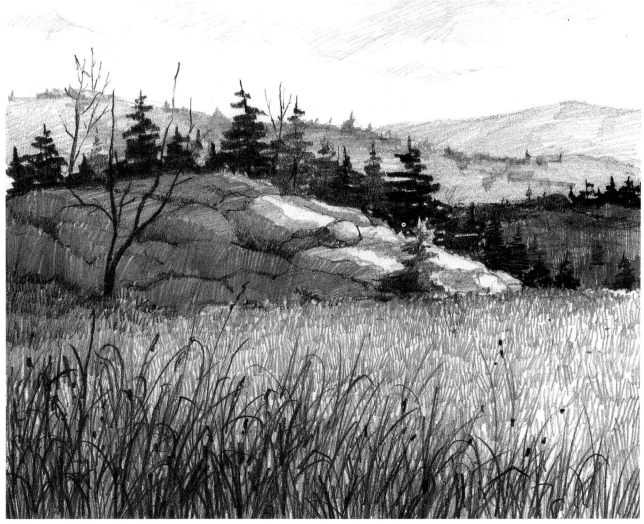

Step 7. Actually, most of the rock formation is in shadow, but the artist waited to add this big patch of shadow until he'd defined the shapes of the rock in Steps 1 through 6. Now he goes back over the rock formation with broad, parallel strokes to cover almost all of the rocks with shadow, leaving only a few patches of sunlight. Suddenly there's a much more dramatic contrast between the shadowy rocks and the sunlit meadow. To make the one bare tree stand out against the shadowy sides of the rocks, he darkens the trunk and branches. But now the artist remembers the scribbly line that appeared across the foreground in Step 2 — and which has long since disappeared. That scribbly line established the division between the dark weeds and grasses in the immediate foreground and the sunny area of the meadow beyond. With the sharpened point of the 2B pencil, the artist adds the rich detail of the weeds and grasses at the lower edge of the picture, working with a lively pattern of slanted and curving strokes, some dark and some light, always leaving gaps between the strokes to let the sunlight shine through. The intricate detail of the meadow is kept entirely in the foreground; the sunlit area is left alone. Too much detail would confuse and distract the viewer — and the artist knows just when to stop. A few groups of slanting strokes suggest clouds in the sky, and the drawing is done.

STREAM: INTERPRETING VARIED TEXTURES

Step 1. To learn how pencil behaves on rough paper, find a landscape subject that contains a variety of textures — like this demonstration combining the smooth texture of water, the rough texture of a rocky shore, and the surrounding detail of trees. This subject is rich in detail, but the artist begins with a very simple line drawing of the main shapes. He draws the edges of the shore and the shapes of the shoreline; the trunks of the trees on either side of the stream; and the masses of foliage — all with a minimum number of lines. The artist visualizes everything as simple shapes in which the subject is barely recognizable.

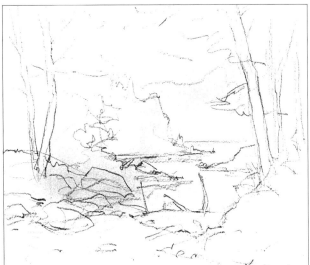

Step 2. Working with the same sharply pointed HB pencil he used in Step 1, the artist carefully converts those few lines into a realistic line drawing of the complete landscape. The shoreline rocks, fallen tree trunk, upright trunks, and distant, tree-lined shore emerge clearly. The pencil lines are still relaxed and casual. They're not too precise because the artist knows that they'll soon disappear under strokes and masses of tone. Notice how this line drawing already begins to obey the rules of aerial perspective: the rocks, trees, and fallen tree trunk in the foreground are drawn with more precision and detail than the simple masses of the distant shoreline.

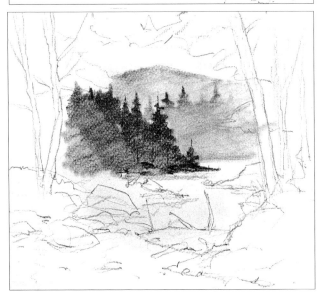

Step 3. Because he wants his drawing to have a sense of deep space, the artist starts with the most distant forms. He moves the side of a 4B pencil lightly over the textured paper and blends the strokes with his finger to create veils of tone for the distant hill and the tree-covered shoreline. For the nearer, darker shoreline, he presses harder on the pencil and blends the tones lightly, allowing some strokes to show. He presses just a bit harder on the pencil to suggest the shapes of some evergreens — drawing the foliage with horizontal strokes and the trunks with vertical ones. The shapes of the distant landscape are in correct aerial perspective.

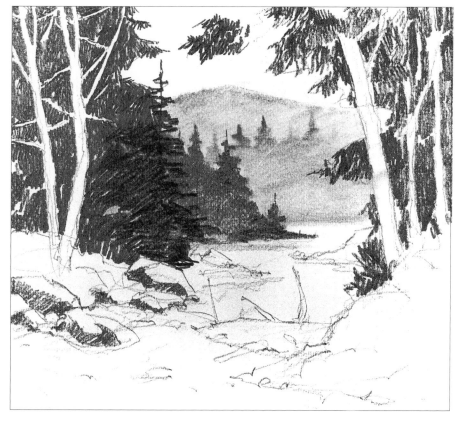

Step 4. Moving to the middleground, the artist switches to a slightly harder 2B pencil, which will draw more precise strokes. Working around the tree trunks on each side of the stream, the artist draws clusters of parallel strokes to suggest the foliage behind and around the trees. To draw the foliage at the right, he presses harder on the pencil and draws more distinct strokes to suggest that the foliage is closer to the foreground. With parallel, slanted strokes, the artist blocks in the shadowy sides of the rocks at the left. Pressing really hard on the pencil, the artist adds a new element to the picture: he creates a dark evergreen at the left of the stream.

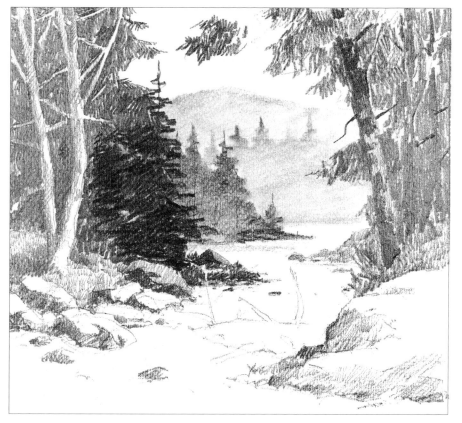

Step 5. The artist blocks in the shadow planes of the rock formation at the lower right and adds grass to both shores with clusters of short, vertical strokes — packing these strokes densely together to suggest the shadow beneath the tree at the left. Moving upward, he models the pale tree trunks at the left like crooked cylinders: you can see the gradation from light to dark. The trees at the right have a rough, patchy tone, which the artist renders with clusters of dark and light strokes. Piling a dense layer of new strokes on the dark evergreen at the left, the artist deepens the tone of the foliage. Between the two groups of trees, he then adds some smaller rocks that jut out into the stream.

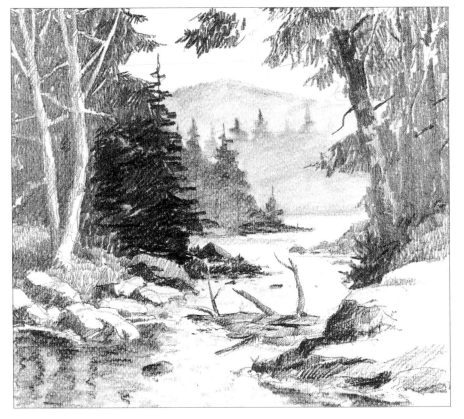

Step 6. Now the artist moves to the foreground. He draws the fallen tree trunk in the stream with a sharply pointed 2B pencil, emphasizing the crisp detail of the trunk and branches — and modeling the tones — with clusters of slender, distinct lines. With the side of a thick, soft 4B pencil, he darkens the shadow planes on the rock formation at the lower right and then adds broad, wiggly strokes to the water, suggesting the movement of the stream and the lively reflection of the trees at the left. He blends these tones with a stomp, making more wiggly lines with the darkened tip of the stomp. Then he adds even darker reflections over the blended tones at the lower left.

Project 7: Get the Values Right

Subject. Find an outdoor subject that will demand that you render a variety of textures. A good challenge would be a dry stream bed filled with small rocks and pebbles, surrounded by larger rock formations or trees or both. Or look for a wintry landscape, such as a rocky cliff and evergreens partially covered with snow, that leaves some rocks, trunks, and branches partially exposed.

Materials and Tools. Pull out a sheet of charcoal paper with a hard surface and a ribbed texture. Work with two sets of drawing tools: thick, blunt pencils or leads in holders, 2B or 3B or softer; and charcoal pencils or sticks in holders.

Technique. Start out with the pencils or graphite sticks, making a quick drawing of the subject with lines so light that they'll soon disappear as you build up the tones over the lines. Now, concentrating on value — not texture or detail — build up your tones with broad strokes. Try to visualize the subject as large masses of light grays, dark grays, and blacks. When the values look right, *then* go back in and develop textures and touches of detail within and over the tones. Having drawn the subject with pencils or graphite sticks, start over again; try it with the charcoal pencil or sticks.

Tips. Your job is to get the values right. Then come texture and detail — which you render with care, but which are subordinate to value.

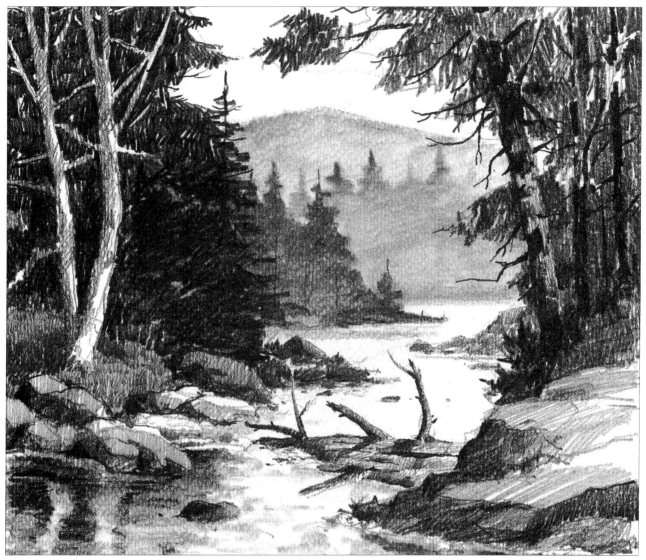

Step 7. Next, the artist uses a sharply pointed 3B pencil to add crisp touches of detail, and a blunt-tipped 4B pencil to darken the tones. Fresh clusters of parallel strokes darken the foliage. The pointed pencil is used to add more branches and twigs. Now the pale tree trunks at the left stand out more brightly against the dark background of the foliage. To make the darker trunks at the right stand out too, he uses the thick pencil to darken the trunks with vertical black strokes. Switching back to the sharp pencil, he darkens the grass with dense clusters of vertical strokes — which are also carried over the rocks, leaving occasional patches of bare paper to suggest flashes of sunlight. He strengthens the jagged contours of the fallen tree trunk, darkens the cracks in the trunk, and deepens the shadows. Still using the sharp pencil, he also adds wiggly strokes on the lower left to darken the reflections. He uses the stomp to blend some of these strokes, but leaves others intact — and then adds soft, wiggly

strokes to the sunlit center of the stream with the graphite-coated point of the stomp. Finally, he goes back over the pale hill silhouetted against the sky and the tree-covered shoreline in the distance to darken these shapes very slightly; he uses the stomp to blend the pencil strokes into soft tones. He squeezes a kneaded rubber eraser to a narrow wedge shape and carefully cleans the areas of bare paper. He draws the sharp point of a pink rubber eraser across the foreground stream to suggest bright lines of sunlight reflected in the water. Finally, the tip of the kneaded rubber eraser is squeezed to a point to brighten the sunlit patches on the tree trunks and rocks at the left. The rough texture of the paper performs two very different functions. The tooth of the paper enlivens the rich pattern of strokes that render the foliage, grass, and rocks. The pebbly texture of the paper lends a soft, airy quality to the smudged sections — in the water and in the distant hills.

ROCKY SHORE: COMBINING TEXTURES AND BLENDED TONES

Step 1. One of the great advantages of textured paper — whether it's charcoal paper or something even rougher — is that you can do a lot of blending without making the drawing look vague and blurry. The texture of the paper makes the blended tones look bold and vital. A coastal landscape, with its smooth sand and rugged rocks, will give you a good chance to combine soft blending with bold strokes. In this preliminary line drawing, the artist concentrates entirely on the silhouettes of the big rock formations and the zigzag lines of the shore. The lines are drawn lightly with an HB pencil; they'll disappear under firmer lines in Step 2.

Step 2. Studying the shapes of the rocks and shoreline more closely, the artist draws the exact contours with darker lines. He's free to redesign nature when necessary, so he decides that the big central rock is too low — and he dramatizes the form by pushing it higher into the sky. Inside its dark contours, as well as those of the smaller rock on the lower left, he draws lighter lines to suggest the division between light and shadow. This division will become more apparent in Step 3. Notice how carefully he draws the shape of the tidal pool that wanders across the beach in the foreground.

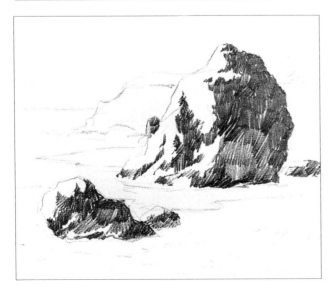

Step 3. The artist squares up the tip of a 2B pencil by rubbing it against a sandpaper pad. Then he renders the shadowy sides of the foreground rocks with clusters of parallel strokes. Notice how the groups of strokes change direction slightly to suggest the ragged, irregular shape of the rock. Compare the rendering of the shadows here with the delicate line that divides light from shadow in Step 2. That line in Step 2 may look casual, but it becomes a very useful guide when the artist begins to render the tones in this step. Observe how the rough paper breaks up the pencil strokes and emphasizes the rugged texture of the rocks.

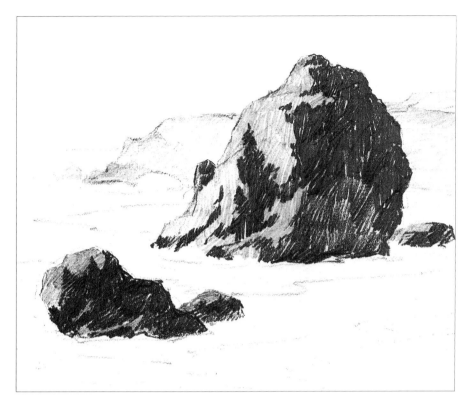

Step 4. Pressing lightly on the squarish end of the same pencil, the artist covers the lighted planes of the rocks with clusters of pale, parallel strokes. As he's done in the shadows, he changes the direction of the clusters to suggest the irregular shapes of the rocks. Moving into the distance, he adds a still paler tone to the rocky headland and to the small rocks in the sea at the tip of the headland. To render this pale tone, the artist glides the pencil lightly over the surface of the paper; the strokes are almost invisible.

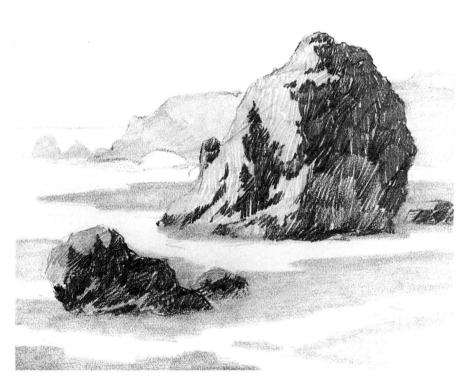

Step 5. It's easy to blend the broad strokes of a soft pencil. So now the artist picks up a 4B pencil with a blunted tip and lets it skate very lightly over the pebbly surface of the paper to darken the tones of the beach — leaving bare white paper for the tidal pool. He blends these pale strokes with a stomp, merging them into delicate gray shapes. He also goes over the shape of the distant headland with the stomp, making the tones softer and more remote. The drawing begins to display a dramatic contrast between the rough strokes of the rocks and the soft, blended tones of the sand.

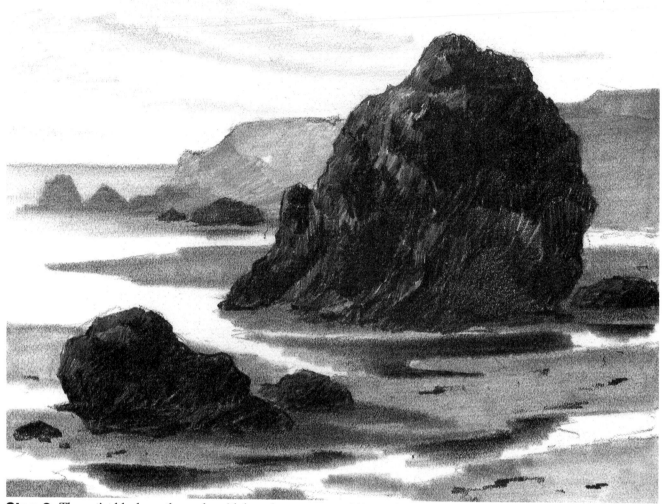

Step 6. The artist blackens the rocks with broad strokes of the blunt-tipped 4B pencil. Notice how the pencil strokes are drawn in clusters, allowing hints of white paper to show through in order to suggest areas of the rock that receive more light. The tooth of the paper breaks up the strokes and adds to the illusion of texture in the rocks. This is also true of the lighter planes, which the artist darkens with the side of a 2B pencil. The strips of sand are all darkened slightly and blended with the stomp. Shadows are added to the right of the foreground rocks — with pencil strokes carefully blended by the point of the stomp. The tidal pools, which reflect light from the sky, remain bare paper, but the dark reflections of the rocks are added with the soft pencil. These reflections are carefully blended with the stomp. The soft pencil is glided lightly over the shape of the distant headland to add just a bit more tone; once again, the headland is blended with the stomp to produce a smooth gray tone. A few light pencil strokes suggest the edge of the sea at the left; these strokes are blended with the tip of the stomp. Finally, the blackened end of the stomp is used like a thick pencil to draw some streaky clouds in the sky. To brighten the sky and the strips of bare paper that represent the sunlit water, the artist uses two different erasers. First he squeezes the kneaded rubber to a point that can get into the intricate shapes of the tidal pools and the foreground. Then to clean the broader areas of the sea and sky, he uses a wedge-shaped pink rubber eraser. You can see how the finished drawing displays a wonderful contrast between the rugged strokes of the pencil, the delicate veils of tone produced by blending, and the brightness of the bare paper.

CHALK DRAWING

Section 3 focuses on techniques for drawing with chalk. by varying or combining techniques and trying different kinds of paper, you can draw a wide range of subjects. Important keys to remember are:

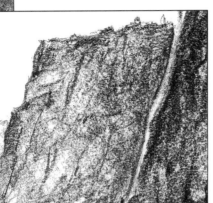

Block in shapes with bold strokes for both simple and complex subjects. Use broad strokes to capture large areas of light and shade. Strokes also give an interesting effect on rough-textured paper.

Chalk is versatile, allowing you to make a variety of marks ranging from slender lines to broad strokes. Study your subject and choose the technique that captures it best. Once you've seen what your chalks can do, try something different, such as a black pastel pencil or Conté crayon.

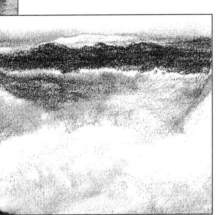

Blend for light and atmosphere, enhancing your strokes with the soft stokes of the stomp. You can also create lovely shadows with this technique. Surprisingly, you can get a similar affect with strokes, too.

Capture the essence of your subject with bold, expressive strokes. You can communicate the character of the various elements simply by changing your strokes. You can also use strokes to create many different textures.

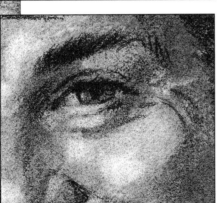

Interpret your subject by combining crisp lines, broad strokes, and blended tones. Match the techniques you use to the effect you want, but plan your drawing to keep it unified.

Smudge for velvety flesh tones in portraits. Once you've established the contours of the face, create a living face with a range of tones. Or let your strokes flow together to make a continuous tone.

EXPLORING CHALK TECHNIQUES

Strokes on Drawing Paper. When you're learning to render light and shade, begin by seeing what strokes look like on ordinary drawing paper (cartridge paper in Britain). A stick of chalk will make a variety of strokes. The blunt end will make broad strokes, while the sharp corner will make quite slender lines. You can see both in this drawing of a cabbage. To darken your strokes, you press harder on the chalk or go back over the strokes several times. The drawing paper has a slight texture that adds vitality to the chalk mark.

Strokes on Charcoal Paper. Now look at the same subject drawn with broad strokes made by the blunt end of the chalk on the rougher texture of charcoal paper. Compare this broad-stroke technique with the thinner strokes in the preceding illustration. Notice how the distinct, ribbed texture of the charcoal paper roughens and breaks up the strokes to give a bolder effect. Charcoal paper isn't just for charcoal drawing — it works just as well for chalk and even for pencil.

Blending on Smooth Paper. Your fingertip (or a cylindrical paper stomp) will soften and blend chalk strokes to give you more delicate gradations of tone. This section of a portrait is drawn with Conté crayon on fairly smooth paper. The tones are roughed in with broad strokes, using the blunt end of the crayon. Then a finger is moved over the strokes, lightly enough to blur them, but not enough to eradicate the strokes entirely. The tones grow softer and richer, but the drawing retains the lively, expressive character of the strokes.

Blending on Rough Paper. Hard pastel and pastel pencil blend more softly than Conté crayon. Here the same head is drawn with hard pastel on rough-textured paper. The tooth of the paper breaks up and softens the strokes, which are then blurred and blended with a fingertip so they virtually disappear. The finger works like a brush and the chalk responds like paint. The result is soft, continuous tone, with very little trace of the original chalk strokes.

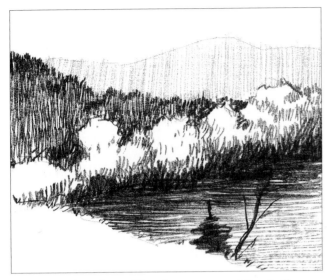

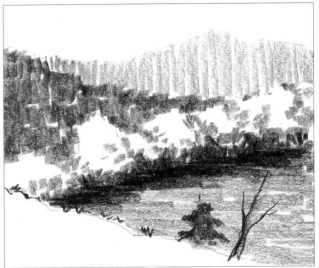

Slender Strokes. The sharp corner of the chalk can build tones with quite slender lines. And chalk in pencil form will make lines as slender as a graphite pencil. In this section of a larger landscape, the tones are created with clusters of slim lines. The sharp corner of the chalk glides lightly over the paper to create the palest tones; heavier pressure creates the darker ones. The chalk marks are tightly packed to create the strongest darks.

Broad Strokes. Here's the same subject with the tones rendered in clusters of broad strokes. For his palest tones, the artist presses lightly on the chalk and leaves gaps between the strokes. He presses harder and packs the strokes tightly together to create darker tones. The direction of the strokes is also important: the slopes of the mountains are drawn with vertical strokes; the flat water is drawn with horizontal ones.

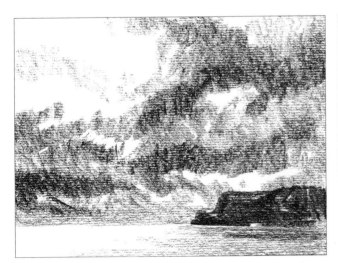

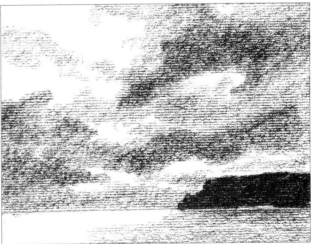

Separate Strokes. When you start a drawing, it's important for you to decide just what kind of strokes you expect to make. You can keep all your strokes separate and distinct, as you see in this group of clouds from a larger coastal landscape. Although the artist groups and overlaps his strokes, you can see the marks of the chalk quite distinctly. The lively pattern of independent strokes gives a feeling of movement and turbulence to the sky. And the ribbed texture of the charcoal paper roughens the chalk marks, making the clouds seem softer and more atmospheric.

Continuous Tone. If you work on rough-textured paper — such as charcoal paper — you can let your strokes flow together softly so that the viewer doesn't see the individual chalk marks. The technique is to move the chalk lightly back and forth over the paper, never pressing hard enough to let a distinct stroke show. To darken an area you go over it several times with light strokes so that the granules of chalk pile up very gradually. This technique is easiest on a rough-textured sheet, since the tooth of the paper shaves off and grips the granules of the chalk.

CLIFF: MASTERING THE BROAD STROKE METHOD

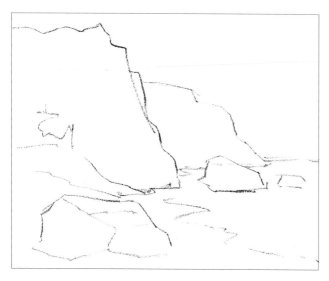

Step 1. Rendering a massive shape like a cliff is a good opportunity to try out a chalk-drawing technique that relies on broad strokes. In this first stage, the artist sketches the shapes of the cliff, rocks, and shoreline with the sharp corner of a stick of hard pastel. In drawing the near cliffs, the artist simply indicates their outline, paying no attention to the internal detail of the rock formation, which will come later. He handles the distant rocks in the same way. The shoreline is simply a quick zigzag. However, the rock in the foreground is distinctly blocky: lines suggest the top and two side planes.

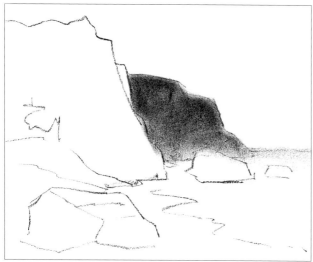

Step 2. The artist wants to make sure that the more distant cliff really seems far away, so he begins with the soft tone of this shape. He picks up a small piece of chalk — either a broken chunk or a stub that's been worn down — and rubs the side of the chalk lightly over the cliff, depositing a thin layer of tone. He then blurs this tone with his fingertip, carefully staying inside the lines he drew in Step 1. Coated with chalk, his fingertip can be used like a brush to suggest the tone of the distant sea. A single horizontal stroke with his fingertip will deposit a soft veil of tone at the horizon.

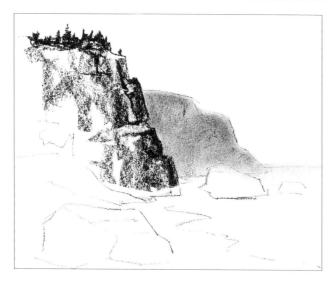

Step 3. Still working with the side of the short piece of chalk, the artist begins to draw the near cliff with broad strokes. (He's working on rough-textured drawing paper that breaks up the strokes of the chalk, suggesting the granular texture of the rocks.) At the edge of the cliff, the artist changes his grip on the chalk and works with the squarish end of the stick, pressing harder to make darker, more precise strokes. At the top of the cliff, he presses hard on the corner of the chalk to make short, irregular strokes that suggest trees silhouetted against the sky.

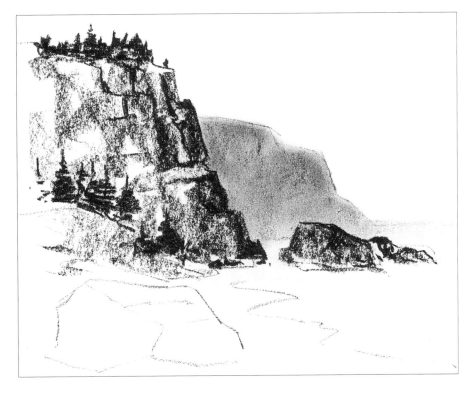

Step 4. Again working with the flat side of the short piece of chalk, the artist moves to the left, continuing to block in the rocky slope with broad strokes. In the same way, he blocks in the dark shapes of the rock formation in the water at the foot of the cliff. The sharp corner of the chalk is pressed hard against the paper to delineate the big, shadowy cracks in the side of the cliff, and to suggest the evergreens farther down. Notice how the trunks of the evergreens are drawn with vertical strokes, while the foliage is drawn with horizontal ones.

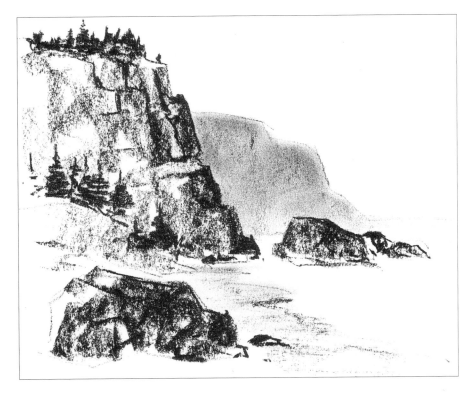

Step 5. Moving into the immediate foreground, the artist follows the same procedure in drawing the big rock on the lower left. He begins by drawing the tones with the side of the chalk, then shifts to the sharp corner to reinforce the outlines and draw the cracks. In all these rocky areas, he leaves patches of bare paper between the strokes to suggest the play of light and shade. Turning the chalk on its side once again and pressing very lightly against the paper, he moves his drawing tool gently along the edge of the shore, following the guideline he drew in Step 1. Now the edge of beach becomes a soft tone, while the water remains bare paper.

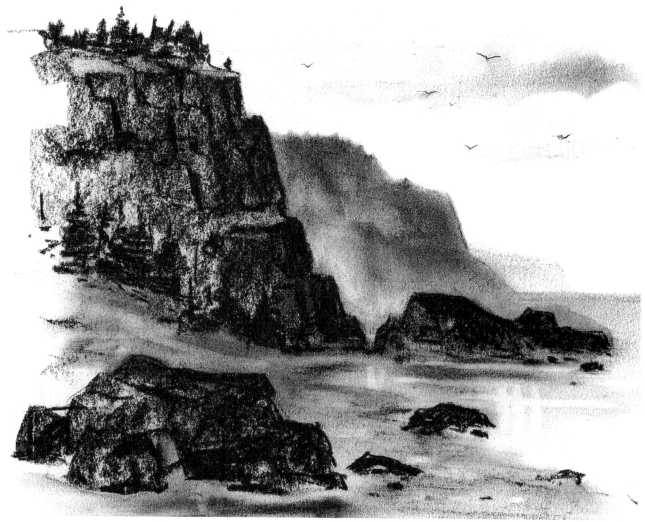

Step 6. The artist goes back to work on the dark cliff once again, working with the side of the chalk to deepen the tone, and pressing particularly hard on the sharp end of the chalk to strengthen the shadowy edge of the cliff and the dark cracks. He uses the same technique on the big rock formation at the lower left, then strengthens the edges and cracks with dark strokes, using the sharp corner of the stick. He also strengthens the form of the low rock formation in the water at the foot of the dark cliff. Small rocks of various sizes are added to the shoreline with dark strokes. He moves the side of the chalk along the beach and the distant cliff once again to strengthen the tone, then blends this tone with a fingertip. Thus the tough, granular texture of the rocks contrasts nicely with the softer, smoother texture of the sand. While his fingertip is still coated with black chalk, the artist uses his finger like a brush to place a soft tone over the water. He also uses his blackened fingertip to suggest clouds in the sky with a few dark smudges and

to indicate a small, pale, very remote headland just above the horizon at the right-hand side of the picture. Notice how a dark smudge of chalk beneath the low rocks in the water suggests a reflection; the same thing happens beneath the big rock formation at the lower left, where a smudge suggests a reflection in the wet sand. Using the sharp corner of the chalk, the artist draws a few gulls in the sky — one curving stroke for each wing — and adds more horizontal strokes to darken the foliage of the evergreens at the lower left. A wad of kneaded rubber is squeezed to a blunt shape and used for cleaning the bare areas of the sky and water. In this landscape, the artist has reversed the usual sequence of operations by starting with the pale tones in the distance, moving to darker tones in the middleground, and then concentrating on the darkest tones in the foreground. He does this to ensure that the drawing has the proper sense of distance, which depends upon strong contrast between the pale and dark shapes.

PROJECT 8: DRAWING TREES WITH BROAD STROKES

Subject. It makes obvious sense to draw the solid, slab-like forms of a cliff with broad strokes. But the broad stroke technique lends itself to many other subjects — not as simple as rocks. To learn more about the potential of the broad stroke method, find some complex subject like a tree with masses of leaves. Choose a time of day when you can see large areas of light and shade on the trunk, branches, and foliage.

Materials and Tools. Use a stick of hard pastel with a rectangular end and flat sides. Choose a sheet of sturdy white drawing paper that has a slight, but unobtrusive texture — just enough to grip the chalk as it moves over the surface.

Technique. Draw the main shapes of the tree with firm strokes made by the sharp corner of the chalk. Most important, try to visualize the masses of leaves as big, simple shapes, not jumbles of small details. Don't think about the individual leaves. With the flat end and the side of the chalk, block in the middletones and shadows on the trunk and branches — and on the leafy clusters, which you should still draw as big, simple shapes. Finally, add details, such as bark, twigs, and a few small leaves.

Tips. If you have trouble seeing the leaves as large shapes without detail, half-close your eyes until the leaves blur and you just see light and shadow planes. Don't do any blending. Work with strokes — the bigger, the better.

MOUNTAINS: VARYING YOUR STROKES

Step 1. This demonstration drawing of mountains and evergreens will give you an idea of the variety of marks you can make with a stick of chalk — ranging from slender lines made with the sharp corner, to broad strokes made with the squarish end or the flat side. As always, the artist begins with a very simple line drawing, using the sharp corner of the chalk. He draws the silhouettes of the cliffs, which look like irregular squares. He visualizes the cluster of evergreens at the foot of the cliff as a single mass — and he encloses this mass with just a few lines. The cluster of evergreens on the left-hand side of the picture is suggested with a zigzag line.

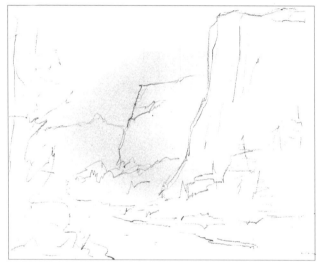

Step 2. Still working with the sharp corner of the chalk, the artist draws the contours of the cliffs more carefully. Along the top and side of the big cliff on the right, he draws a second line to suggest strips of light. At the bases of the rocky shapes, he moves inside the original guidelines to draw shapes that look more like trees, although he still works with just a few casual lines, knowing that they'll soon be covered with heavier strokes of tone. At the extreme left, he adds a rough vertical stroke to suggest a tree trunk that will show more clearly at a later stage of the drawing.

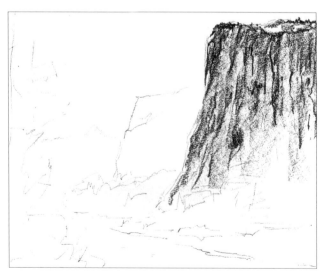

Step 3. With the squarish end of the chalk, the artist begins to block in the shadows on the face of the big cliff. Then turning the chalk so that the sharp corner touches the paper, he draws deep, dark cracks that run in wavy lines down the cliff. He also begins to sharpen the contours of the top. Although the overall shape of the cliff is more or less square, the rocky forms on its face look like irregular cylinders — on which the artist suggests the gradation from light to shadow to reflected light that you see on cylindrical forms. At the top of the cliff, you can see the patch of light that the artist outlined in Step 2.

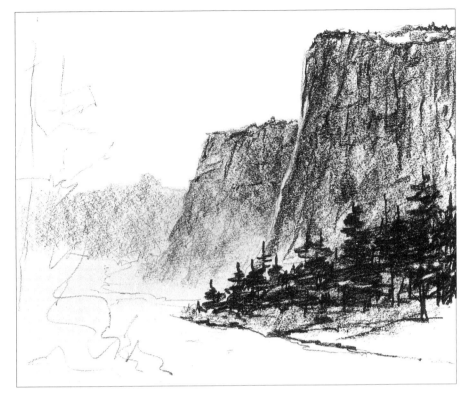

Step 4. The artist picks up a short chunk of broken (or worn down) chalk. With the flat side of the broken stick, he darkens the big cliff and blocks in broad tones on both the central cliff and the pale mountain in the distance. He uses a sharp corner to draw more cracks. With the squarish end of the stick, he draws the dark foliage with thick horizontal lines. Then he draws slim vertical lines for the trunks with the sharp corner of the chalk. He places a shadow on the shore beneath the trunks with the flat side of the chalk, and then he draws the shoreline with the corner.

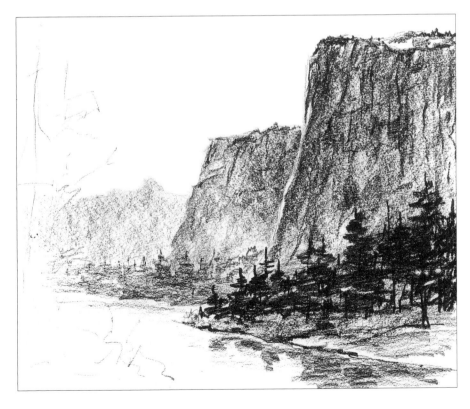

Step 5. Pressing more lightly on the square end of the chalk, the artist draws the paler, more distant mass of evergreens, adding a few crisp strokes with the corner of the stick to suggest a few trunks. He also uses the squarish end of the stick to block in the reflections of the evergreens in the water with horizontal strokes. Notice that the reflections are lighter than the trees.

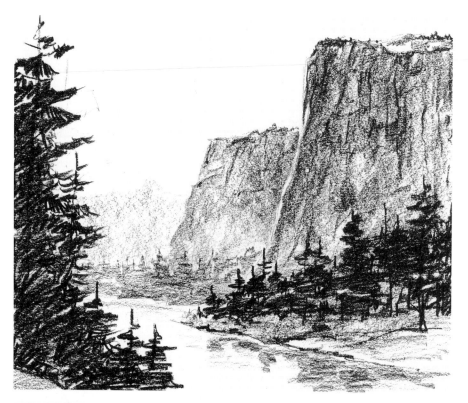

Step 6. As the stick of chalk wears down, its tip becomes blunt and slightly rounded, making a stroke that's thick, but no longer squarish. Now the artist draws the dense foliage of the evergreens at the left, making clusters of horizontal and diagonal strokes with the blunt end of the chalk. He leaves spaces between the strokes to suggest the light of the sky breaking through the foliage. Then, working with the sharp corner of a fresh piece of chalk — or sharpening a worn piece on the sandpaper pad — he adds crisp vertical lines to suggest trunks and a few branches.

PROJECT 9: EXPERIMENT WITH TOOLS

Subject. If you've already done a landscape like the one in this demonstration, you've learned a lot about the varied strokes that you can make with a rectangular chalk. Now try a similar landscape, but new tools. You can actually do the same one if you like: mountains and trees and a stream. But *any* landscape will do if it has a variety of shapes and textures. If you live in the desert, cactus will do just as well as trees.

Materials and Tools. This time, work with chalks in cylindrical form: a mechanical holder with a thick lead; and a black pastel pencil or Conté pencil. For your drawing surface, use ordinary white drawing paper with a very slight texture. Sharpen the pencil. Grip the mechanical holder at an angle and rub the lead on the sanding block, thus flattening one side of the lead. Now you have two different kinds of drawing tools to work with: the thin, sharp end of the pencil and the broad side of the thick lead in the holder.

Technique. Sketch the landscape with the sharp tip of the pencil. Then block in the broad areas of middletone and shadow with the flattened side of the chalk in the holder. Alternate between the two tools as you experiment with varied strokes to complete the landscape. Use the pencil to add the last details.

Tips. As the tips wear down, their shapes will change. The pencil point will grow flatter or rounder. The stick in the holder may grow rounder or broader. See what kinds of strokes you can make with these changing shapes. Notice also that the thicker lead may develop a broad, sharp, spade-like tip. See what you can do with it as you move it horizontally, vertically, and diagonally.

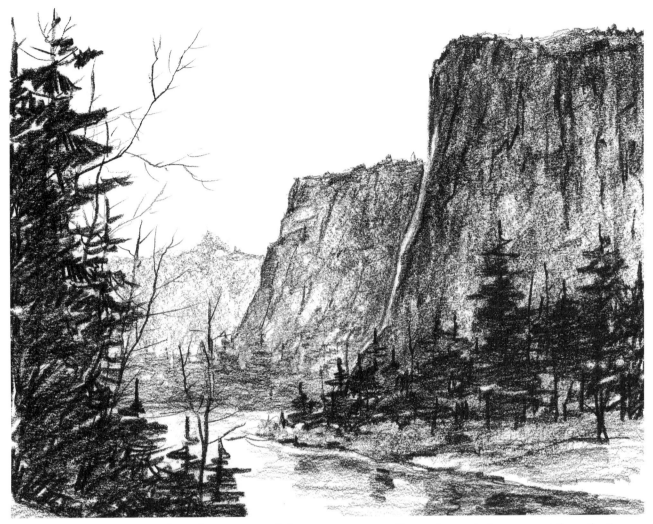

Step 7. In this final stage, the artist goes over all three mountainous shapes with the flat side of a short chunk of chalk, darkening them with broad strokes. With the sharp corner, he adds more cracks to the two nearby mountains, but he remembers the rules of aerial perspective and adds no details to the pale, distant mountain. With the blunt end of a worn stick, he darkens all the trees with a dense layer of horizontal strokes and then darkens the shoreline and reflections on the right in the

same way. Heavy zigzag strokes suggest the reflections of a few individual trees in the stream. Finally, the artist sharpens the chalk to a point and adds the precise lines of branches and twigs to the cluster of trees at the extreme left. This part of the picture is closest to the viewer, so that's where the artist concentrates his precise details — remembering the rules of aerial perspective once again.

Snow and Ice: Conveying Light and Atmosphere

Step 1. Chalk, like charcoal, blends easily and can be moved around on the drawing paper the way oil paint is moved around on canvas. This atmospheric winter landscape will show you how to make a "black-and-white painting" by blending chalk as if it's wet oil paint. Because the finished drawing will contain many soft, blended tones, the preliminary line drawing is extremely simple. The artist uses the sharp corner of the chalk to draw the silhouettes of the mountain and the tree-covered shore in the distance, as well as the rocky, snow-covered shore of the frozen lake in the foreground. He doesn't indicate individual trees at all, except for a single tree trunk just left of center.

Step 2. Still concentrating on silhouettes, the artist draws the distant mountain and tree-covered shore more carefully, but he doesn't indicate the shape of a single tree in the distance. He draws the shoreline more precisely, adding more rocks and the trunks of a few more trees. But he makes no attempt to define the irregular shapes of the foliage on the trees, since this will be done later with the broad strokes of the chalk and the stomp.

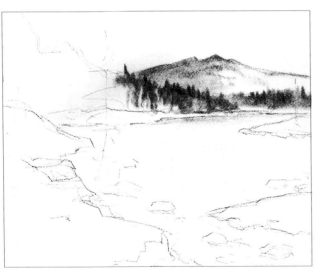

Step 3. Since a feeling of distance is important to this landscape, the artist begins to draw the remote forms of the mountains and the tree-covered shore at the far end of the frozen lake. He moves the blunt end of the chalk lightly over the slopes of the mountain and immediately blends the strokes with a stomp. He begins to draw the distant mass of evergreens with vertical strokes and then blends these tones with vertical strokes of the stomp. The stomp is now covered with black chalk, so he uses this versatile tool to make additional tree strokes that have a particularly soft, magical quality.

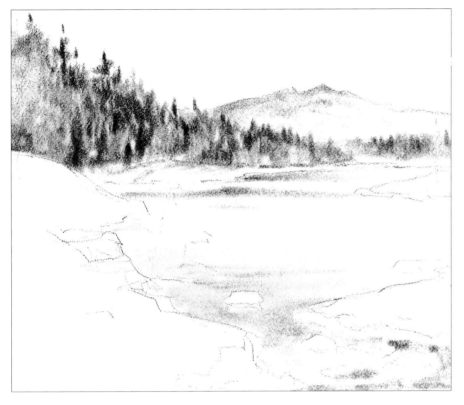

Step 4. Continuing to work on the mass of distant evergreens, the artist alternates short, vertical strokes of the blunt chalk with strokes of the stomp. The stomp blends the chalk strokes and then adds its own special kind of soft strokes. The artist begins to add streaky tones to the icy surface of the frozen lake. He moves the chalk lightly over the paper and then blurs the strokes slightly with touches of the stomp. Now you are able to see clearly that he's working on a rough sheet of drawing paper that's particularly responsive to blending.

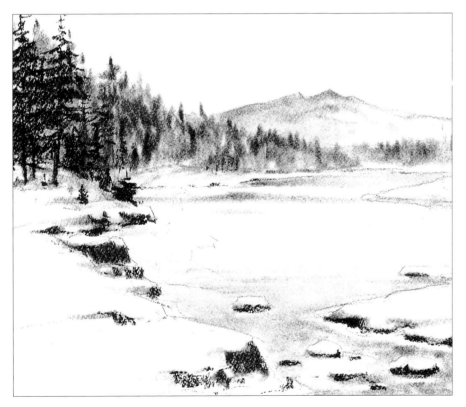

Step 5. Having established the soft, misty tone of the most distant elements of the landscape, the artist begins to add the strong darks to make sure that they contrast properly with the paler tones. In the foreground and middleground, he blocks in the shadow sides of the snow-covered rocks and shore, letting the rough texture of the paper show and leaving the strokes unblended. At the extreme left, he draws the trunk and foliage of a clump of evergreens, again leaving the strokes unblended and allowing the pebbly texture of the paper to suggest the detail of the foliage.

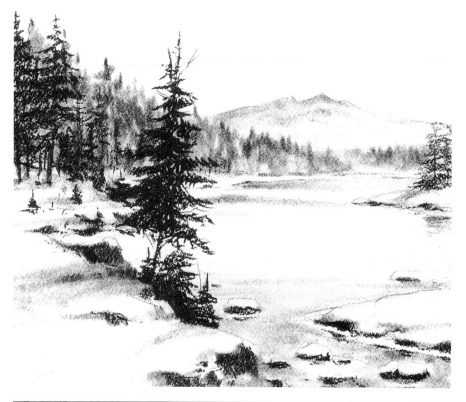

Step 6. Remember the single tree trunk that appeared in Step 1? Now this becomes the focal point of the picture: a dark evergreen that's drawn with clusters of short diagonal strokes to suggest foliage, plus a few slender strokes for the trunk and branches. The artist adds more evergreens on both sides of the lake and leaves the strokes unblended. Now he uses the sandpaper pad and the stomp in a new way. He presses the stomp against the blackened surface of the sandpaper, picks up the dark dust the way a brush would pick up paint, and begins to draw the shadows of the trees across the snowy shore. In the same way, he adds touches of shadow along the edges of the snowbanks.

PROJECT 10: TRY THE "SEPARATE STROKE" TECHNIQUE

Subject. Blending — handling chalk as if it's wet oil paint that you can smudge — is only one way to create an atmospheric landscape or seascape. Now find a new subject and try it another way. A foggy shoreline landscape would be a good subject. If you live inland, try a landscape that's shrouded in morning mist or an oncoming storm.

Materials and Tools. All you need is a single stick of hard pastel — the kind with a rectangular shape and a squarish end — and a sheet of charcoal paper with the usual ribbed surface.

Technique. For this project, you're going to draw an atmospheric scene entirely with strokes. No blending! The idea is to build up your tones with distinct strokes that you make with the end and the side of the chalk. (You can break the stick in half to make shorter strokes with the side.) Lay the strokes side by side and over one another, pressing harder and piling up the strokes for the darker areas. Let the strokes show — like the strokes in an Impressionist painting. And let the texture of the paper show too. For a sample of this technique see page 83, and read the caption that's headed "Separate Strokes."

Tips. Try *not* to draw any lines, even at the very beginning. Start out with very light pressure on the chalk, making very pale strokes. Work from light to dark, increasing the pressure on the chalk as you go back over the light strokes. Leave patches of bare paper for the lightest areas — don't cover the whole sheet with a gray mist.

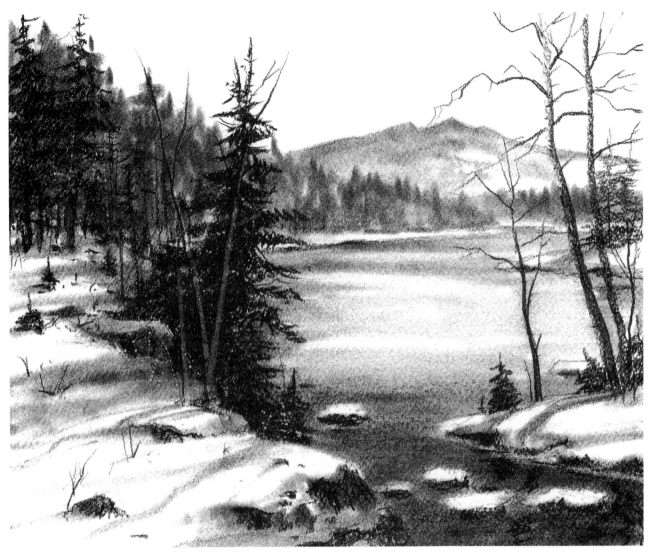

Step 7. Now the artist concentrates on enriching his tones and adding detail. He darkens the mountain against the horizon and the mass of evergreens on the distant shore with more strokes of the chalk, which he blends with the stomp. He moves the stomp diagonally over the shape of the mountain and vertically over the shapes of the distant trees. The artist glides the squarish end of the chalk lightly across the center of the frozen lake; he applies more pressure to suggest the dark reflections of the trees on the far shore and the reflections of the trees in the immediate foreground. Using the stomp, he blends the tones of the lake with long horizontal strokes. The artist darkens the evergreens on the left with a dense network of strokes, pressing hard against the paper and leaving these tones unblended. Then he uses a sharpened stick of chalk to draw more trunks and

branches on the left — and adds a whole new group of bare trees on the right. He adds still more evergreens on the low shore at the right. Working with the blunt end of a stick of chalk and the blackened end of the stomp, he draws more lines of shadow across the snow to indicate shadows cast by the trees. He moves the kneaded rubber carefully between the shadows on the snow to brighten the patches of bare paper that suggest sunlight on the shore. The rubber is also used to brighten the tops of the snow-covered rocks in the water and to draw pale lines across the center of the lake to suggest sunlight glistening on the ice. The kneaded rubber is moved across the sky to pick up any trace of gray that might dim the paper. And finally, the kneaded rubber is squeezed to a sharp point to pick out pale trunks that appear against the dark mass of the evergreens on the left shore.

DRIFTWOOD: WORKING WITH EXPRESSIVE STROKES

Step 1. Look for an "outdoor still life" subject — something with a big, simple shape that you can draw with bold, expressive strokes. In this demonstration, the artist draws a piece of driftwood on a beach with dark evergreens in the distance. The subject has an irregular, nongeometric shape, which the artist indicates with a few curving guidelines. The distant evergreens at the upper left are also ragged shapes, which the artist suggests with quick, zigzag lines. The curve of the ground beneath the driftwood is indicated with short, curving lines. And the distant horizon is a single horizontal line. These first guidelines are made with the sharp corner of the chalk.

Step 2. In the first step, the artist searches for simple forms that capture the overall design of the subject. In the next step, still working with the sharp corner of the chalk, he studies the subject carefully and goes over the guidelines of Step 1 to record the intricate contours of the actual subject. He presses harder on the chalk so the lines are sharper and darker. Now the subject begins to look like real wood. However, the artist still concentrates on the major shapes and pays no attention to precise details — which he's saving for later.

Step 3. The strongest dark notes in the picture are the distant evergreens, and these come next. Working with the blunt end of the chalk and pressing hard against the paper, the artist blocks in the dark tones with short, expressive strokes. Some of the strokes have a scribbly character, while others are short curves — all carefully planned to communicate the rough, spiky character of the evergreen foliage. The sharp corner of the chalk is used for thinner, crisper strokes. The driftwood becomes a bright silhouette against the darkness of the trees.

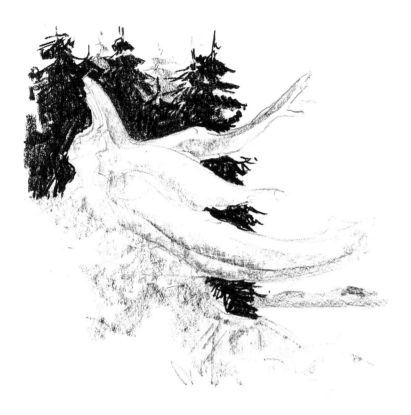

Step 4. After the darks come the middletones that fall between the strongest darks in the drawing and the areas of paper that will be left pure white. The blunt end of the chalk skates swiftly over the paper in long, curving strokes to render the shadows on the driftwood. The distant shoreline in the lower right is drawn with horizontal strokes. For the rough, irregular shadow tone on the ground beneath the driftwood, the artist takes a broken piece of chalk and places it flat on the paper, using the *side* of the stick to make broad strokes.

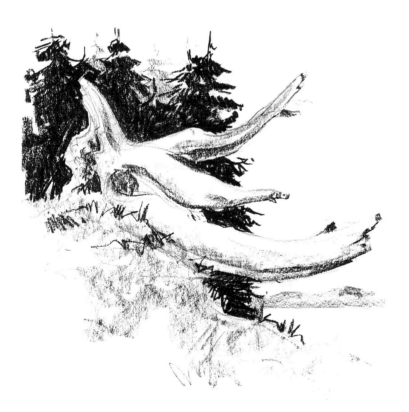

Step 5. By the end of Step 4 the darks, middletones, and lights have all been identified. In the upper left, you can even see some very distant trees indicated with soft, gray strokes. Now the artist begins to strengthen the tones of the driftwood. Pressing harder on the blunt end of the chalk, he deepens the shadows on the wood with long, curving strokes. He models the wood as if it's a group of curving cylinders: there's a distinct tonal gradation from light to halftone to shadow to reflected light. With scribbly strokes, he begins to suggest the grass beneath the driftwood. He uses the sharp corner of the chalk to strengthen some of the edges of the wood.

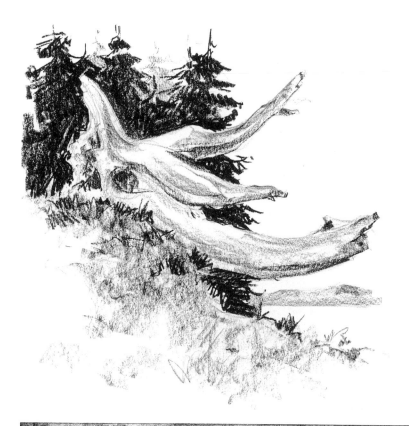

Step 6. To suggest the texture of the driftwood, the artist goes back over the curving shapes with lighter strokes that curve in the same direction as the darker shadow strokes. Now the wood begins to look realistic and three-dimensional, even though it contains virtually no detail. More dark scribbles are then added with the corner of the chalk to indicate grass on the ground. And the broken chunk of chalk is used once again to darken the ground with broad strokes.

PROJECT 11: CREATING TEXTURE WITH YOUR STROKES

Subject. Assemble a group of objects for a still life: rocks, chunks of wood, broken branches, a bunch of flowers. Toss them on the table and practice expressive strokes in chalk. Place a strong lamp at one side of the still life — or place the setup alongside a window — so the "side lighting" exaggerates the textures, as well as the lights and shadows.

Materials and Tools. Draw on a sheet of white paper that has only a very moderate texture — just enough "tooth" to grip the chalk granules — so the strokes, not the paper, will create the texture. Lay out three drawing tools: a cylindrical stick of chalk in a mechanical holder; a hard pastel pencil; and a rectangular stick of hard pastel.

Technique. Sketch the still life with very light pencil strokes. Then look carefully at each item and *plan* the strokes before you touch chalk to paper. Try to use the greatest possible variety of strokes: straight, curved, zigzag, thick, thin, long, short, wide, narrow. Decide when to use the tip of the drawing tool or the side. See if you can start out with the tip and turn the tool so you end up using the side — all in one stroke.

Tips. If a stroke looks wrong, erase it or lighten it by pressing down hard with a kneaded rubber eraser. Don't scrub the eraser back and forth, smearing the stroke and leaving an unpleasant smudge. The kneaded rubber may not lift *all* the chalk, but you can lighten the stroke sufficiently to draw over it.

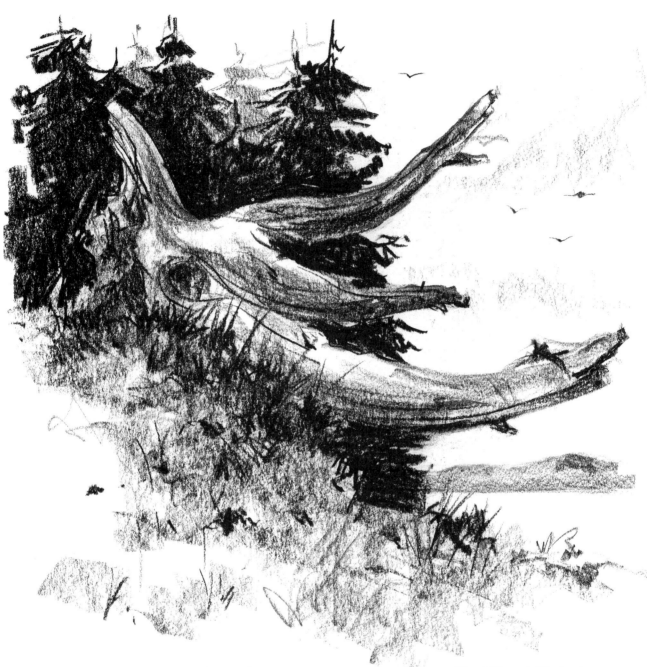

Step 7. The final operations are to deepen the tones, suggest more texture, and add detail. With the blunt end of the chalk, the artist darkens the trees adjacent to the driftwood, accentuating the contrast between the dark trees and the lighter wood. Broad, curving strokes darken the shadows on the wood itself, making the forms look rounder and more solid. The sharp corner of the chalk is used then to draw crisp, dark lines over the wood to suggest cracks and other broken textures. The artist draws sharp, slender lines to indicate blades of grass overgrowing the base of the driftwood. The broken chunk of chalk is placed on its side once again and is moved with quick back-and-forth strokes to darken the ground. The same piece of chalk is moved lightly over the sky to indicate a few indistinct clouds. And the corner of the chalk is used to draw gulls in the sky — with just two curving strokes for each gull. The patches of light on the driftwood are cleaned and brightened with kneaded rubber, as are the bare parts of the sky and ground.

SURF: COMBINING LINES, STROKES, AND BLENDED TONES

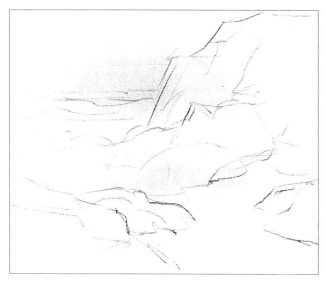

Step 1. Like charcoal, chalk lends itself equally well to a combination of crisp lines, broad strokes, and blended tones. A seascape, combining the rugged forms of rocks and the softer forms of water, is a good subject for exploring this combination of chalk drawing techniques. In his preliminary line drawing, the artist draws the hard, distinct shapes of the rocks and the softer, less distinct shapes of the surf and waves with equal care. Although the sea keeps moving, the waves and surf assume repetiiive shapes, which the artist studies carefully and then draws quickly with curving lines. Of course, many of these lines will eventually disappear when the tones of the surf are blended.

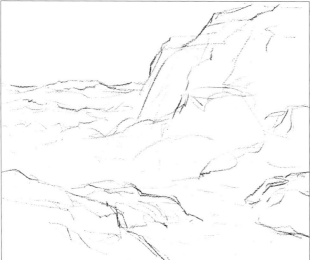

Step 2. Working over and within the guidelines of Step 1, the artist draws the rocks in more detail. He adds smaller shapes within the big shapes that were defined in the original guidelines. He draws the distant waves more precisely, but avoids adding more lines to the soft, curving shape of the foam between the rocks, since this soft shape will be rendered with blended tones, rather than lines or strokes.

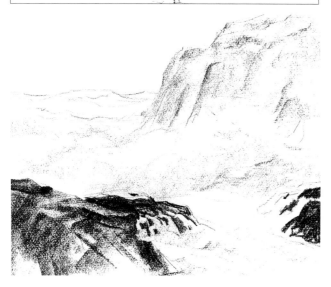

Step 3. Reaching for a short piece of chalk, the artist uses the flat side of the stick to suggest tones on the distant rock formation on the right and to block in the soft, blurry shadows on the surf between the rocks. Pressing harder on the side of the chalk, he begins to block in the darks of the rocks at the left. Then he uses the squarish end of a fresh stick to draw more distinct strokes on both rock formations in the foreground. Here and there, he uses the corner of the stick to add a sharp line. Notice how he leaves areas of bare paper to suggest foam running over the rocks.

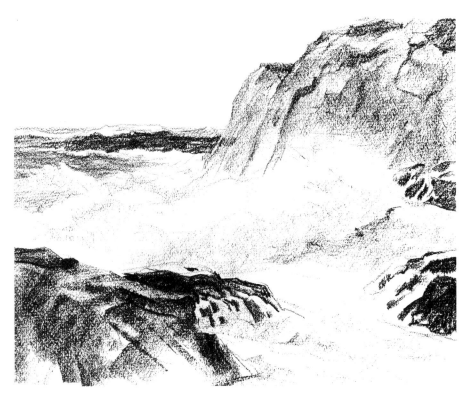

Step 4. With a blunt-ended stick, the artist draws the shadowy faces of the distant waves. Irregular strips of bare paper are left for the bands of foam at the crests of the waves. Along the lower edge of the oncoming foam (at the center of the picture), the artist uses the side of the chalk to suggest the shadow that is cast by the wave onto the foaming water between the rocks. With the side of the stick, he darkens the big rock formation on the upper right and begins to add some thick, shadowy cracks with the end of the chalk. He also adds another small, dark rock at the extreme right.

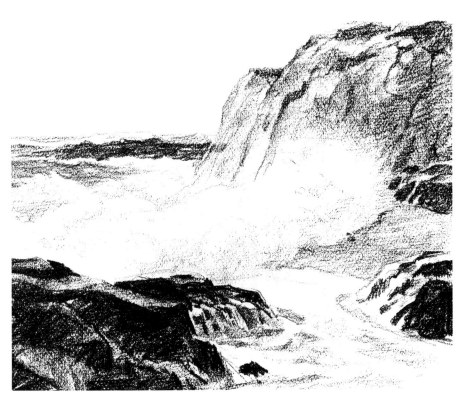

Step 5. The blunt end of the chalk is used to darken the side of the rock formation on the upper left with a cluster of parallel strokes. A few more cracks are added. The shadowy sides of the rocks on the lower left are darkened in the same way, so now there's a clear distinction between the lighted top planes and the dark side planes. Short, curving strokes are added to the foreground to suggest foam running down the sides of the rocks and swirling between them. On the right, the artist moves his chalk lightly over the paper to darken the shadow that's cast by the mass of the oncoming foam.

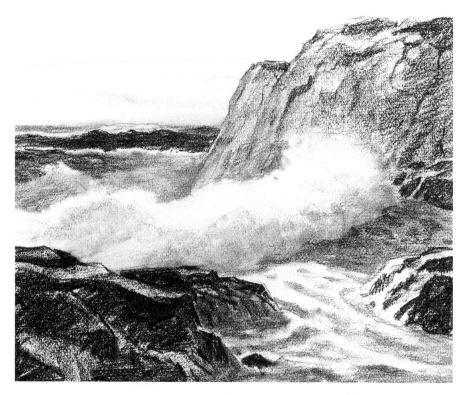

Step 6. The artist moves the flat side of the short chalk along the shadowy face of the foamy mass. Then he blends this tone with a stomp. He also darkens and blends the foamy sea beyond the white mass on the left. In the same way, he darkens and blends the shadow that's cast by the mass of surf on the right, adding a few dark strokes for detail. He adds some short, curving strokes to the churning foam on the lower right and blends these as well.

PROJECT 12:
CHOOSING AND PLANNING YOUR DRAWING TECHNIQUE

Subject. Make more practice drawings of subjects that lend themselves to combinations of lines, strokes, and blended tones. Try to find subjects — like the seascape in this demonstration — that combine solid objects, lots of texture and detail, and motifs that are blurry and seem hard to draw. Mountains and clouds are a good combination. Or try to draw a marsh with sharply defined grass in the foreground and fuzzy shapes in the distance.

Materials and Tools. Work with your full range of chalks in all forms — rectangular sticks, sticks in holders, pastel pencils — and a stomp for blending. Choose a sheet of white drawing paper with a moderate texture, so the texture of the paper won't dominate the drawing.

Technique. This is your chance to use all the techniques you've learned so far: expressive lines and strokes, blending with the stomp (or your fingertip), lifting out the lights with the kneaded rubber — anything goes. After you've made your preliminary line drawing of the main shapes, plan the technique that you'll use to render each section of the drawing. Decide what to do before you do it! Then do your work quickly and decisively — trying to avoid erasing, except when you want to lift out a light area.

Tips. Don't forget to look at *all* the shapes as if they're solid. The clouds, just like the mountains, have planes of light and shadow. And don't overwork your drawing. See how *few* strokes will do the job. Stop blending before the tone turns to gray mush; let some strokes show.

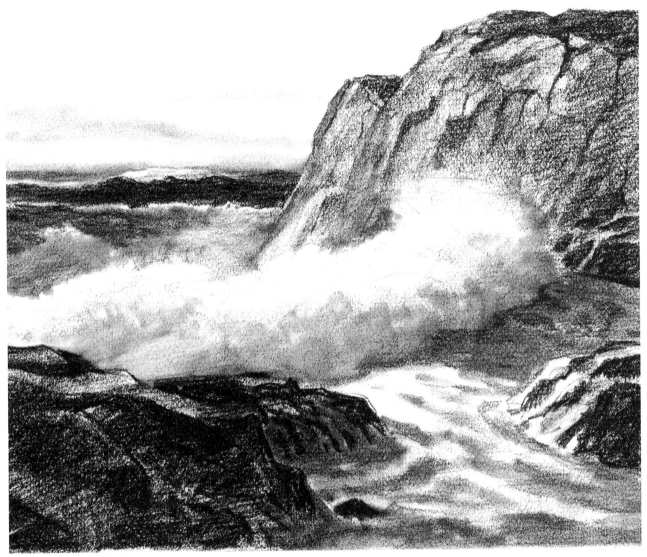

Step 7. The artist strengthens his tones and adds the last important details. He darkens the big rock formation on the upper right by moving the blunt chalk lightly over the paper, and then he adds more cracks and deep shadows with a sharpened stick. With the side of the chalk, he adds more tone to the shadowy front of the mass of surf — and to the shadow that the surf casts on the water — blending these tones with short, curving strokes of the stomp. The soft shape of the foam has a clearly defined lighted plane — where the sun strikes the top of the form — and a shadowy side plane. Thus, the foam is as solid and distinct as any other three-dimensional form. The blunt end of the chalk is used to carry long, wavy strokes across the churning foam on the lower right; these strokes are blended with the stomp, leaving gaps of bare paper to suggest sunlight flashing on the white water. The rock formation on the lower right is darkened with another layer of broad, slanted strokes, making these

shapes seem still closer to the viewer. The artist uses the point of the stomp to do just a bit of blending on the distant waves, making their tones seem slightly smoother. The blackened end of the stomp is used like a brush to paint some delicate cloud layers just above the horizon. The sunlit areas of the foam are carefully cleaned with a wad of kneaded rubber that's squeezed to a point to get into the intricate shapes in the lower right. The bare paper of the sunny sky is brightened by pressing the kneaded rubber against the paper and then lifting the eraser away. By now, you've certainly discovered that this drawing is done on a rough-textured sheet of drawing paper. The ragged tooth of the paper roughens the strokes that are used to draw the rocks, thus heightening the rocky texture. At the same time, the irregular surface of the paper softens the strokes of the stomp to produce beautiful, furry tones in the surf and sky.

MALE HEAD: MODELING LIGHTS AND SHADOWS

Step 1. Chalk is a wonderful medium for drawing portraits because the strokes can be smudged so easily to create rich, soft flesh tones. It's best to start with a simple line drawing that visualizes the head as an egg. The artist draws the egg tilted slightly, since the head is leaning forward a bit. He adjusts the shape of the egg so that it comes closer to the actual form of the sitter's head. The lines of the forehead and jaw are flattened on the left. On the right, the side of the egg is extended to suggest the curve of the jaw. The upper half of the egg is also extended at the right to suggest the back of the head. And the top of the head is flattened to conform to the shape of the hair. Next, the artist draws guidelines for the features. A vertical center line is crossed by horizontal guidelines for the eyes, nose, mouth, and lower lip. The eyes are halfway down from the top of the head. The underside of the nose is midway between the eyes and chin. The line between the lips is one third of the distance down from the nose to the chin, while the lower lip is midway between nose and chin.

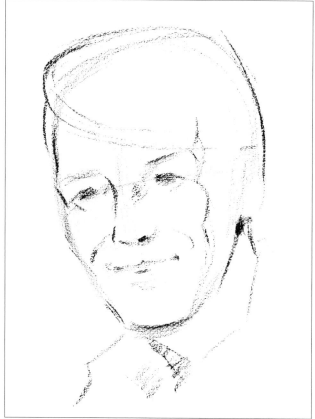

Step 2. Over the guidelines of Step 1, the artist begins to draw the actual contours of the head with darker lines. (Step 1 is drawn with light touches of the sharp corner of the chalk; slightly stronger pressure is applied to the chalk in Step 2.) The chalk is moved around the contours of the face, tracing the curves of the forehead, brow, cheek, jaw, and chin. The artist draws the hair as a big, curving shape. He adds the line of the back of the neck and then lightly suggests the edge of the collar that encloses the neck. Turning to the features, he places the eyes, the underside of the nose, and the dividing line of the mouth on the guidelines of Step 1. Then he adds the eyebrows, the line of the nose, and the lines that radiate from the corners of the nose along the undersides of the cheeks. Down the side of the face — on your right — he draws a curving line that carefully traces the division between the lighted front plane and the shadowy side plane of the head. This guideline becomes important in the next step.

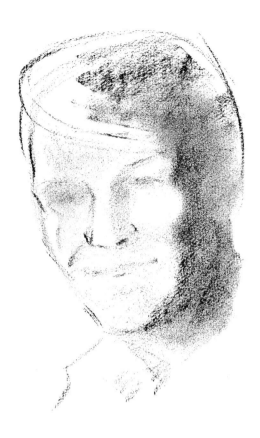

Step 3. Picking up a short piece of chalk that's been broken or worn down, the artist turns the chalk on its flat side to begin blocking in the tone of the hair and the shadow side of the face and neck. Working with broad strokes, he moves the chalk carefully from the hair down to the brow, cheek, jaw, and neck, following the guideline that appears in Step 2. Working with the squarish end of the chalk — which will make a narrower stroke than the flat side — the artist begins to suggest the paler tones on the forehead, within the eye sockets, along the side of the nose, beneath the cheeks, under the nose, and on the chin. He blends and softens all the tones on the face with a fingertip. At this point, you can see that he's working on rough-textured paper that breaks up and softens his strokes. Textured papers in general, and charcoal paper in particular, are ideal for drawing portraits in chalk.

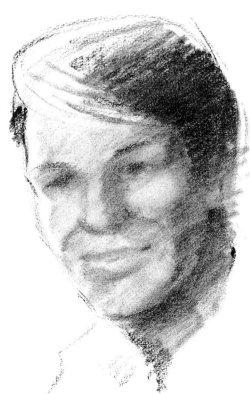

Step 4. Having suggested the general distribution of tones on the head, the artist begins to strengthen these tones with a stick of chalk that's been worn down (or perhaps sandpapered down) to a slightly rounded, blunt end. He darkens the hair with parallel strokes, pressing harder on the chalk for the deeper tones. He continues to work with parallel strokes as he deepens the shadow tones on the side of the face, neck, and nose. He works freely, and some of these strokes actually go beyond the contour of the face at the right — but these strokes will soon blend into shadow. With the end of the chalk, he darkens the eyes and eyebrows; strengthens the lines of the underside of the nose, cheeks, and mouth; and darkens the lower lip and chin. Once again, he uses his fingertip to soften and blend the tones. The kneaded rubber eraser is pressed gently against the lighted areas of the cheeks, nose, lips, and jaw to strengthen the contrast between light and shadow.

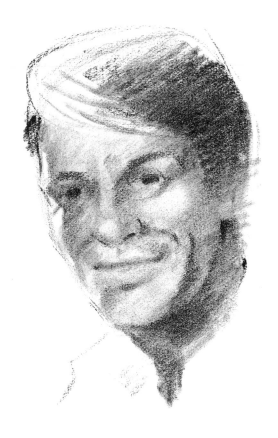

Step 5. Having established the general distribution of tones in Steps 3 and 4, the artist can now begin to strengthen these tones selectively and start work on the features. Working with the blunt end of the chalk, he thickens the eyebrows, darkens the eyes, and deepens the shadows in the eye sockets. He strengthens the darks that surround the nose, cheeks, mouth, and jaw. He darkens the shadow beneath the chin. And he adds a few lines to define the nostrils. But he still saves the really detailed work for the final stages.

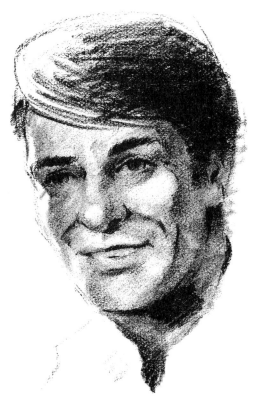

Step 6. At this point, the artist is ready to begin work on the details of the features. With the sharp corner of the chalk, he indicates the shape and texture of the eyebrows, and then he moves down to draw the eyelids with crisp, dark lines. He darkens the pupils and the corners of the eye sockets. The nostrils and the other side of the nose are drawn more distinctly, while dark lines sharpen the creases that radiate from the nostrils along the undersides of the cheeks. The lines of the lips are strengthened too, and the shadow beneath the lower lip is darkened. The inner detail of the ear is suggested, and the contour of the earlobe is strengthened by placing a shadow beneath it at the corner of the jaw. The chalk strengthens that important edge where the lighted front plane of the face meets the shadowy side plane. The hair is darkened with horizontal, scribbly strokes. And the artist begins to darken the neck with scribbly strokes that he'll blend and soften in the final stage.

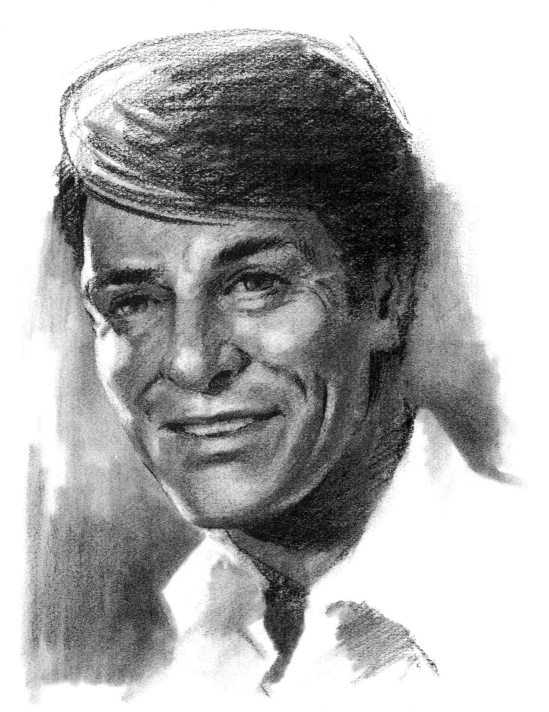

Step 7. Now the artist goes over the entire face, darkening and blending the tones. He darkens and blends the forehead, cheeks, nose, mouth, jaw, and neck. The shadowy side of the face is darkened and blurred into the lighter tones so they flow smoothly together. The artist presses the kneaded rubber eraser against the brow (just above the bridge of the nose), cheeks, tip of the nose, upper and lower lips, and chin. With the eraser, he wipes away the light lines around the jaw and chin, makes bright lines under the eye at the right — and even lightens the teeth. He uses the sharp corner of the chalk to indicate the eyelashes, the wrinkles at the corners of the eyes, the dark corners of the mouth, the lines between the teeth, and the dark crease along the jaw. The artist surrounds the face with broad strokes to form a background tone, which he then blurs with his thumb.

PROJECT 13: EXPERIMENT WITH CONTINUOUS TONE

Subject. After you've drawn a portrait head similar to the one in this demonstration, try another portrait in the continuous tone technique. Place the sitter alongside a window so that there are strong contrasts of light and shadow. Or place a strong lamp at the side of the sitter's head, so you see the shadow planes clearly.

Materials and Tools. Choose a stick of hard pastel or Conté crayon. The rectangular end of the chalk should be fairly crisp — not rounded by wear — so you can make broad, flat strokes, almost as if you're working with a brush. Your drawing surface ought to be a sheet of charcoal paper with a ribbed tooth.

Technique. After you make a light sketch of the forms with the sharp corner of the chalk — in wispy lines that will soon disappear — build up the tones by moving the chalk gently back and forth over the paper. Don't press too hard. The strokes should flow together softly to create continuous tones enlivened by the texture of the paper. Individual chalk marks shouldn't show too distinctly. Press gradually harder and harder to darken the shadows. Don't do any blending.

Tips. If the side of your hand starts to smudge the chalk strokes, slip a small piece of paper or thin cardboard under your hand as you work. To make broader strokes, you can break the chalk in half and use the side of the stick.

Keys to Section 4

CHARCOAL DRAWING

Section 4 demonstrates how versatile a medium charcoal is. You can produce everything from rich tonal effects to slender, expressive lines, capturing simple shapes or areas rich in detail. Important keys to remember are:

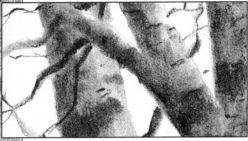

Create light and shadow patterns with blending. You can capture gradations from light to shadow and create velvety flesh tones by blending. (You can also create beautiful portraits with strokes.)

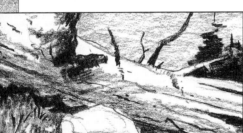

Render rugged textures in landscapes with bold strokes. Suggest foilage with short irregular strokes; build up strokes to create continuous tone for shadows.

Suggest a sense of space by combining soft, blended tones and crisp lines. Once you're comfortable working this way, try building up tone with strokes.

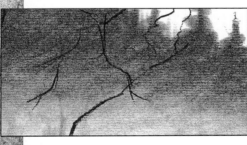

Capture complex subjects by using lines and strokes. Create a variety of textures, tones, and subtle effects of light with only lines and strokes. You can simplify and suggest details with these same techniques.

Make light areas by erasing, lightening some places and creating highlights in others. This technique is especially useful when you're drawing a night scene.

Blend tonal gradations from deep blacks to misty grays easily with charcoal. Create everything from soft, smoky tones to crisp, expressive lines. An alternative way to create lights is to add white chalk to your drawing.

EXPLORING CHARCOAL TECHNIQUES

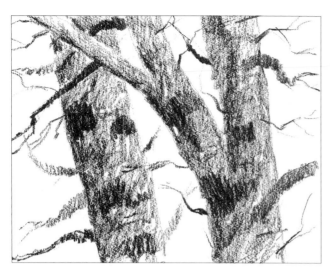

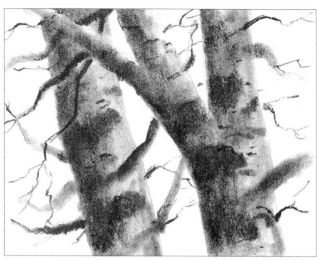

Lines and Strokes. The simplest way to draw with charcoal is to combine slender lines with broader strokes on common drawing paper (cartridge paper in Britain). In this section of a landscape drawing, the thick, blunt end of a medium charcoal pencil is scribbled back and forth to render the tones of the tree trunks. The artist presses harder to make the darker tones on the trunks. Then he switches to the sharp, slender point of a hard charcoal pencil to draw the branches and twigs with more precise lines.

Lines and Tones. To produce soft, blurry tones (like blended oil paint) the artist works with medium and hard charcoal pencils, then blends the tones with a stomp. First he draws the lighter tones of the tree trunks and blends his strokes with the stomp. Then he draws the darker patches and blends again. The thicker branches are blended with the point of the stomp, but the narrow twigs are drawn with charcoal pencil lines and left untouched by the stomp. It's important to know when to stop blending — or your drawing will look mushy.

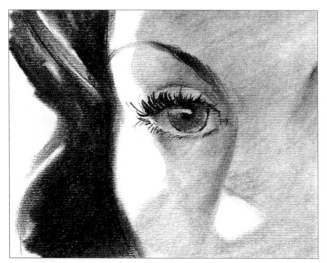

Charcoal Paper. Made specifically for charcoal drawing — but equally good for chalk and pencil — charcoal paper has a slightly ribbed surface that's extremely tough. The surface is lovely for blending soft flesh tones, as you can see in this section of a portrait. You can also do lots of erasing without damaging the paper, as shown in the lighted areas of the face. The surface is equally fine for broad strokes like the hair and precise lines like the eyes in the picture.

Rough Paper. Rough textured papers — with even more tooth than charcoal paper — are also fine for charcoal drawing. These irregular surfaces make blended areas more lively; notice the pebbly texture of the shadow on the skin. Broad strokes, like the hair, look even bolder on this kind of paper. And sharp lines — like the eyelashes and eyebrow — look rough and vital.

110

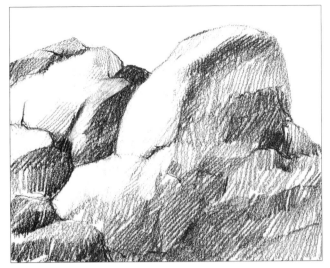

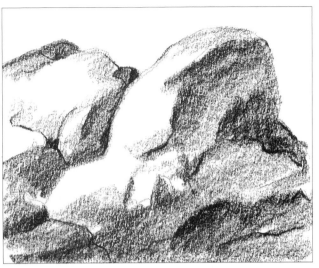

Slender Strokes. People generally think of charcoal as a medium for rough strokes and rich tonal effects. But a sharpened charcoal pencil or a sharpened stick of charcoal can produce slender, expressive lines. Here, the tones are rendered with clusters of parallel lines. Several layers of lines overlap to produce darker tones. And if the tones become too dark in some area they're easily lightened by pressing a wad of kneaded rubber against the paper — as you see in the sunlit planes of the rocks.

Broad Strokes. This drawing of the same rocks is typical of the way most people use charcoal. The preliminary drawing is made with slender lines, but then the tones are rendered with broad strokes of the side of the pencil or charcoal stick. Darker tones are produced by pressing harder on the charcoal or by going over the same area several times. Charcoal smudges easily, but the artist leaves the drawing unblended, recognizing that his rough strokes produce a rugged, rocky feeling.

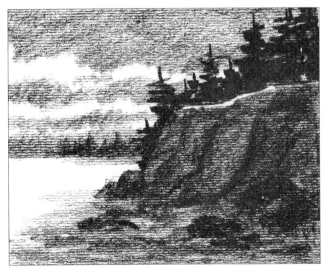

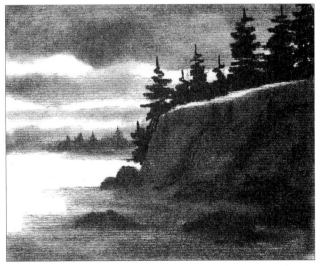

Building Tone with Strokes. On the ribbed surface of charcoal paper, you can build a rich tonal effect entirely with strokes — without blending. As you move the charcoal pencil or stick lightly back and forth, the tooth of the paper gradually collects black granules. With each stroke you build more tone. In this section of a landscape drawn at sunset, the mark of the drawing tool is obvious only in the trees, which have been drawn with firm, heavy strokes. The rest of the picture has been built up gradually by laying one soft stroke over another.

Building Tone by Blending. What many artists love about charcoal is its soft, crumbly quality, which makes the strokes easy to blend with a fingertip or stomp. Here the same subject has been drawn on charcoal paper with strokes of soft natural charcoal, blended so that the strokes disappear and become rich, smoky tones. Kneaded rubber brings back the whiteness of the paper, as you see in the sky, the water, and the bright top of the cliff. The trees are drawn with firm, dark strokes and left unblended.

FEMALE HEAD: CREATING A FULL RANGE OF VALUES

Step 1. Charcoal is an excellent portrait medium because it smudges easily so you can make soft, velvety flesh tones and beautiful gradations from light to shadow. Once again, the artist begins with the classic egg shape. He draws a vertical center line to help him locate the features. Then he draws horizontal guidelines to locate the eyes halfway down the head; the nose halfway between the eyes and chin; the mouth one third down from the nose to the chin; and the lower lip midway between the nose and chin.

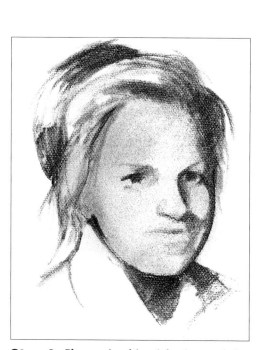

Step 2. With a stick of soft, natural charcoal, he draws a light tone over the entire face and blends this tone with his thumb. The face is covered with a pale gray — still preserving a hint of the original guidelines — which he can lighten with kneaded rubber and darken with additional strokes as he goes along. He blocks in the darks of the hair and the shadow on the neck, blending these slightly with his finger. Here you can see the texture of the rough drawing paper, which breaks up and enlivens the blended tones.

Step 3. Sharpening his stick of natural charcoal on a sandpaper pad, the artist blocks in the tones of the eyes, nose, and mouth, paying particular attention to the curving shapes of the shadows on the cheek at the right. He blends these tones carefully with a fingertip. Then he extends the shape of the hair with dark strokes, suggests a few hanging curls with curving strokes on the left, and indicates the shoulders.

112

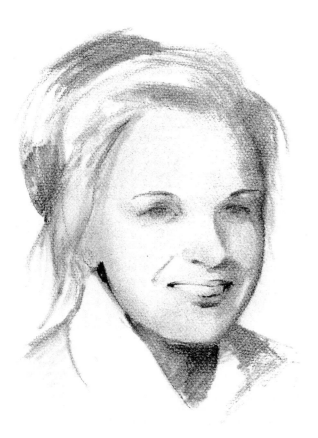

Step 4. Having blocked in the major tonal areas, the artist begins to strengthen the contours of the features with the sharpened end of the charcoal stick. He indicates the lines of the eyebrows, eyes, nostrils, and mouth. But he keeps these lines pale and tentative. At this point, all the tones remain soft, and detail is still kept to a minimum.

Step 5. The artist begins to strengthen the tones on the face and hair, and starts to define the features with darker strokes. He carries some dark strands of hair down the shadow side of the face, and then he softens the strokes of the charcoal stick with a fingertip. He deepens all the shadows on the dark side of the face with small strokes and blends them to form soft, smoky tones. Then he picks up the kneaded rubber and presses it carefully against the forehead, cheeks, nose, upper lip, jaw, and chin to lift away some of the gray tone that first appeared in Step 2. Magically, the skin begins to glow. Sharpening the charcoal stick, the artist darkens the lines of the eyebrows, eyes, nostrils, and mouth. He strengthens the contour of the shadowy cheek and jaw. And he extends the hair at the left with strokes that he blurs with a fingertip.

Step 6. As the face grows lighter, it needs surrounding darks to dramatize the pale tone of the skin. So the artist changes the color of the dress, blocking in a dark tone with broad strokes that he blends slightly with a fingertip — without actually obliterating the strokes. He then darkens the hair crowning the pale forehead. (The strokes of the sharpened charcoal curve to match the movement of the hair.) The artist deepens the shadows on the hair at the left with curving strokes; then he uses the kneaded rubber, squeezed to a point, to pick out some light. Notice how the kneaded rubber is also used to brighten the sitter's teeth and to pick out the whites of the eyes.

PROJECT 14: VARYING YOUR PORTRAIT TECHNIQUE

Subject. Blending charcoal to create soft, smoky tones — as you see in this demonstration — seems so natural that you must force yourself to work another way, especially when you're drawing a portrait. So draw another portrait head. Seat the subject in a comfortable chair and locate a lamp slightly to one side — and slightly above — the head. This will give you the three-quarter "form lighting" that portrait painters prefer because it dramatizes the planes of light and shadow.

Materials and Tools. You'll need hard and medium charcoal pencils or charcoal leads in holders. Avoid the softer grades, which tempt you to blend your strokes. Choose a sheet of drawing paper with a moderate tooth so your strokes will really stand out.

Technique. Make a careful line drawing of the head with the tip of a hard pencil or lead. Then build up the halftones and shadows *entirely with strokes* — no blending. Start with light strokes laid side by side. Then place another layer of strokes over the first layer to build up the darker tones. Work with the *tip* of the pencil or the lead so you can see each stroke distinctly. The strokes of the lead in the holder will be thicker and rougher, but make them as distinct as you can.

Tips. Experiment with the *direction* of your strokes. Try curving the strokes to follow the curving form of a cheek or a brow. Try angular strokes to model the bony angles of a nose or a sharp chin. The strokes should express the form.

Step 7. But the artist isn't satisfied with the portrait! With a cleansing tissue, he wipes away the hair at the left, leaving a soft gray tone. Working into this tone with broad strokes, he carries the hair down over the shoulder and then blurs the strokes with a fingertip. He picks up the kneaded rubber and wipes away the light on the hair. At the right, he brings the hair down to the shoulder with long, curving strokes, blended with a fingertip. His blackened finger blends darker tones into the skin, leaving smaller patches of light on the forehead, nose, cheeks, upper lip, and chin — brightened by touches of the kneaded rubber. The eraser lifts the dark tone of the collar to create a patch of light on the neck. The line of the collar is redrawn. The final portrait exhibits the rich darks, smoky grays, and luminous lights that are typical of a good charcoal drawing.

FALLEN TREE: EXPRESSING COMPLEX TEXTURES

Step 1. Charcoal is excellent for drawing with bold strokes that express the rugged textures of outdoor subjects such as foliage, tree trunks, grass, and rocks. This "outdoor still life" includes all these elements. The artist begins by drawing the forms very simply with the sharpened point of a hard charcoal pencil. He doesn't press too hard on the pencil, but lets the point glide lightly over the drawing paper, tracing the contours with relaxed, casual strokes. He concentrates on the silhouette of the fallen tree trunk and draws the distant evergreen as a jagged shape without detail. In drawing the foreground rocks, he keeps in mind their blocky character and indicates the planes of light and shadow.

Step 2. Pressing harder on the pencil and drawing more carefully, the artist follows the guidelines of Step 1 to define the exact contours of the tree trunk and the rocks. He suggests only a few details, such as the big cracks in the trunk, plus some small branches and twigs. Along the bottom edge of the trunk, a zigzag line suggests the grass that overlaps the wood. The same kind of line suggests the grassy bases of the rocks at the lower left. He does no further work on the outline of the distant evergreen because the original guidelines will disappear in the next step.

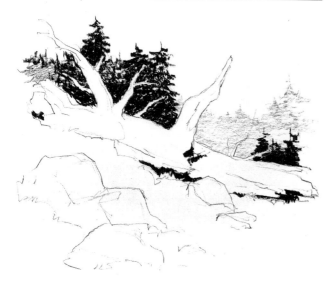

Step 3. Now the artist begins to block in large masses of tone. He starts with the darkest notes in the picture: the clumps of evergreens, plus the few touches of deep shadow on the tree trunk and beneath it. He uses a soft charcoal pencil — which makes a thick, black mark — and indicates the foliage with short, irregular strokes. The same pencil scribbles patches of shadow on the tree trunk. A medium charcoal pencil blocks in the pale tone of the more distant evergreens with light horizontal strokes that overlap and merge to form a continuous tone. Throughout Step 3, he works with the side of the charcoal pencil lead.

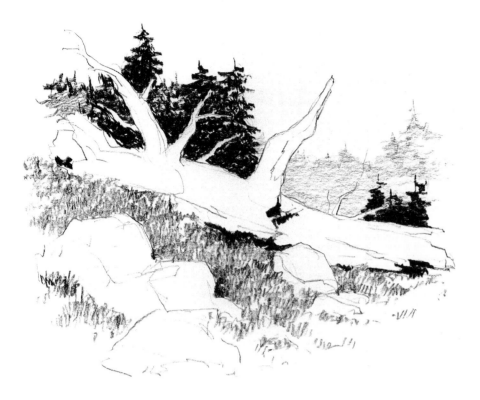

Step 4. Moving into the foreground, the artist suggests the grass with the side of the medium charcoal pencil. The texture of the grass is indicated with scribbly up-and-down strokes. Between the strokes, there are lots of empty spaces to suggest the play of light and shade on the grass. These scribbles overlap the lower edge of the tree trunk and the rocks at the left, where the contours of the solid shapes disappear among the foliage.

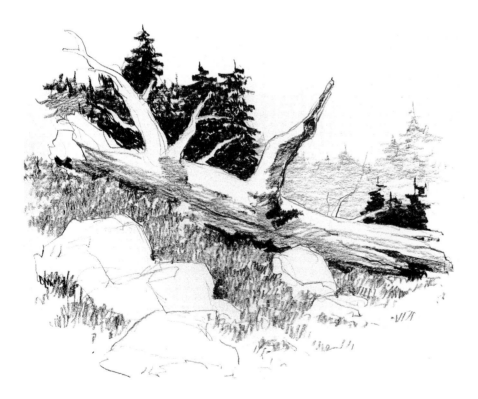

Step 5. Until now, the trunk has remained bare paper, but the artist is ready to begin work on the shape of the trunk itself. Visualizing the trunk as a ragged cylinder, he renders its shadowy underside with long strokes, using the side of the medium charcoal pencil. The strokes move along the length of the trunk, suggesting not only shadow, but the texture of the bark. With darker strokes, he blocks in the shadow of the broken branch silhouetted against the sky and places a shadow farther to the left, under the other broken branch. The tree trunk begins to show the gradation of tones that we expect to see on a cylinder.

117

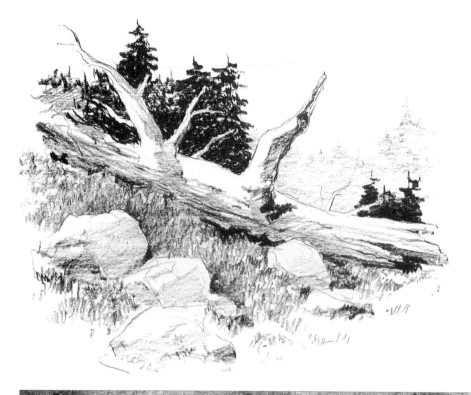

Step 6. Again working with the side of the medium charcoal pencil, the artist blocks in the shadows on the rocks. Now there's a clear distinction between the sunlit top planes and the shadowy sides. The rocks are visualized as broken cubes, and we begin to see the distribution of light and shadow that we would expect on a cube. At the far left, the end of the broken tree is darkened with free strokes that run down the length of the trunk. On the grass to the right of the foreground rocks, the artist begins to add suggestions of cast shadows.

PROJECT 15: CREATING DRAMA WITH BROAD STROKES

Subject. To continue learning about expressive charcoal strokes, select a subject whose bold shapes lend themselves to a broad stroke technique. Rocky shapes like mountains, mesas, buttes, and headlands are ideal — and fun to draw with broad strokes. If you can plan your day, go out and make your drawings (yes, make as many as you can) when the sun is low in the sky. This means early morning or late afternoon, when the shadows are most dramatic.

Materials and Tools. Choose a sheet of white drawing paper with a moderate tooth that won't blur your strokes. Work with one or two thick leads in holders. The hard and medium grades make more distinct strokes, as you've seen. Hold each lead at an angle against the sandpaper block, and rub the lead so the end has a sort of wedge shape that makes a broad stroke.

Technique. Study the subject closely and try to dive right in, rendering the light and shadow planes with broad strokes — and no preliminary line drawing. Keep the number of strokes to a minimum, pressing lightly for the middletones and harder for the darks. Avoid scrubbing back and forth. And avoid blending. Do your best to make the right stroke — and stop.

Tips. Plan each stroke before you touch charcoal to paper. Think about the direction of the stroke — and make the stroke follow the form. The rocky shapes will "tell" you when to use vertical, horizontal, diagonal, or curving strokes.

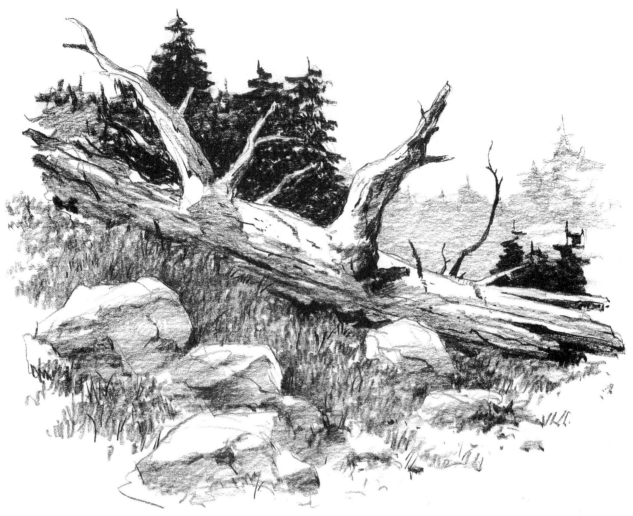

Step 7. Continuing to work on the rocks, the artist strengthens the tones with the side of a medium charcoal pencil. The shadow planes are partly darkened — at the top — and remain lighter farther down, so the shadow contains a hint of reflected light from the distant sky. Moving back into the grass, the artist darkens the tone with another layer of scribbly strokes. The darker grass strengthens the sunlit silhouettes of the rocks. The shadows on the tree trunks are reinforced with additional strokes that reemphasize the texture of the bark. Finally, working with the sharp point of the hard charcoal pencil, the artist adds crisp lines to suggest detail. Here and there, he draws individual blades of grass in the foreground — but not too many. He draws cracks in the rocks. He moves along the tree trunk, adding more cracks and suggestions of texture. He darkens the contours of the two broken branches silhouetted against the sky — one at the upper left and the other at the center of the picture — and strengthens the shadows. Toward the right, he adds some slender dark branches, silhouetted against the pale tone of the distant evergreens; each of these branches casts a slim shadow on the tree trunk. It's important to bear in mind that this entire picture, with its rich variety of tones, is drawn with just three charcoal pencils: hard, medium, and soft. Charcoal smudges so easily that the beginner is tempted to *always* blend his tones, even when blending isn't suitable for the subject. There are many subjects that are best drawn with a variety of strokes and *no smudging at all* — like this one.

WOODED ISLAND: SUGGESTING A SENSE OF SPACE

Step 1. The right landscape subject often gives you an opportunity to combine delicate blending with crisp lines and broad strokes in a charcoal drawing. To demonstrate this combination of techniques, the artist chooses a distant wooded island surrounded by mist and framed by trees in the foreground. He draws the shape of the island as a simple, jagged silhouette, adding a few horizontal lines for the shoreline. Applying just a bit more pressure to his hard charcoal pencil, he draws the trunks and branches of the trees, again concentrating on their silhouettes. A casual, wandering line defines the shape of the ground at the foot of the foreground trees.

Step 2. With Step 1 as a guide, the artist redraws the contours of the trees with firmer, more precise lines. Working with the sharpened point of the hard charcoal pencil, he searches for the small irregularities that lend realism to the trunks and branches. He adds a few rocks to the shape of the land at the bases of the foreground trees. Then he looks more carefully at the shapes on the distant shore and reinforces the guidelines of Step 1 with more exact contours — bearing in mind that these lines are going to disappear when he begins to apply tones in later steps.

Step 3. It's important for this drawing to have a feeling of deep space, which depends upon strong contrast between the pale shapes in the distance and the dark shapes in the foreground. So the artist reverses the usual process and begins with the palest tones. Switching to a medium charcoal pencil, he indicates the most distant mass of evergreens with light strokes that he smudges carefully with a stomp, using its charcoal-covered tip to draw the trunks and branches silhouetted against the sky. Look closely at this tone and you can see the ribbed texture of the charcoal paper, which is ideal for a drawing in which you're going to do a lot of blending.

Step 4. Going on to the darker mass of trees on the big island, the artist again uses the side of the medium charcoal pencil to block in his tones. He applies more pressure to the strokes at the top of the mass of evergreens and less pressure toward the bottom, where the island disappears into the mist. He blends the tones with the slanted end of the stomp, again using its charcoal-covered tip to draw the tops of the trees, which are soft and blurred. To lighten the misty lower half of the island, he uses a wad of soft cleansing tissue, which doesn't remove the tone completely, but leaves a soft gray veil.

Step 5. Using the sandpaper block to sharpen the point of a soft charcoal pencil, the artist draws the dark trunks and branches of the trees in the immediate foreground. He uses the tip of the stomp to blend the thick trunks and produce a solid, dark tone, but carefully avoids blurring their edges, which he reinforces with the tip of the pencil. At the top of the picture, some of the slender branches are drawn with the pencil point and some with the blackened tip of the stomp.

121

Step 6. The broad side of the thick, soft charcoal pencil is used to block in the dark tone of the immediate foreground with heavy, ragged strokes. Shifting to the sharpened end of the pencil, the artist strengthens the contours of the rocks and adds a few dark strokes to suggest blades of grass silhouetted against the pale tone of the water — which is still just bare paper. He uses his fingertip to blend the foreground tones *slightly*, but stops rubbing before he eradicates the important strokes that suggest the texture of the ground.

PROJECT 16: BUILDING TONE WITH STROKES

Subject. For this project, you can try a subject similar to the one you've seen in the demonstration, or you can draw any outdoor subject that will challenge you to convey a feeling of deep space. Another good subject might be a series of headlands receding into the distance, growing paler as they move farther away. You might also like to draw a series of mountain ranges, one ranked behind the other.

Materials and Tools. Use flattened, wedge-shaped leads and a sheet of charcoal paper. You can also use two of those charcoal pencils that come in tear-off paper cylinders, graded hard and medium, and flatten them on a sanding block.

Technique. Move the flattened side or the wedge-shaped end of the charcoal stick over the paper, letting the ribbed surface of the charcoal paper collect the dark granules. Lay one stroke over another, pressing harder for the darks. Don't blend. Work gradually from light to dark, building up more tone. Try not to make your strokes too obvious.

Tips. Be sure to reread the section called "Applying Aerial Perspective" (page 18). If the tones start to smudge under your hand, work with a small piece of cardboard or stiff paper under the side of your hand. Try the same technique on a sheet of rough paper.

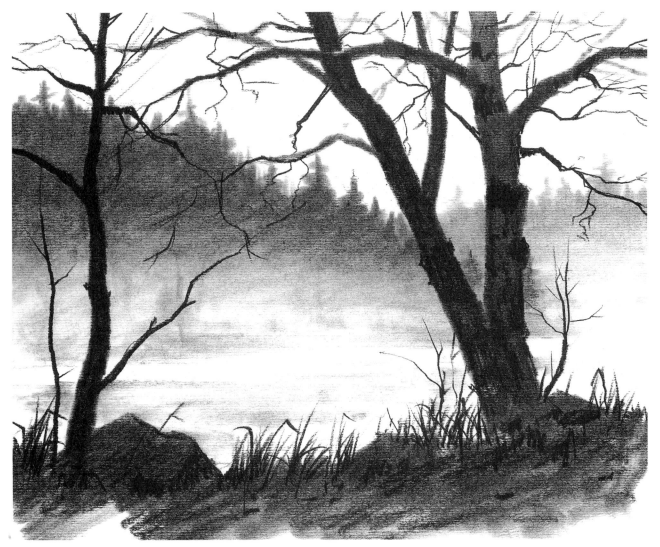

Step 7. To darken the upper section of the misty, wooded island, the artist goes back over the area with the side of the soft charcoal pencil and then blends his strokes with the slanted side of the stomp. He also uses the stomp to create soft gradations from dark to light where the lower half of the island disappears into the mist. And he uses the sharp, blackened tip of the stomp to redraw the silhouettes of the individual trees at the top of the island. He carries a few horizontal strokes across the water and softly blends these with a fingertip, moving in the same direction. Then he sharpens a medium charcoal pencil to reinforce the dark shapes of the tree trunks and add dark branches. To add the slender twigs, he uses the medium pencil to draw crisp strokes across the top of the picture; then he also draws the dark blades of grass silhouetted against the pale tone of the water. Look closely at the dark tree trunks on your right and you'll see some textural detail, scribbled in with the sharpened end of the soft charcoal pencil. Like so many successful landscapes, this is a picture in four values: the white paper of the sky and water, the pale gray of the distant evergreens on the right, the darker gray of the bigger wooded island, and the blackish tone of the trees and grass in the foreground. And this is a particularly good example of how you can combine soft, blended tones with crisp lines.

FOREST: RENDERING RICH DETAIL

Step 1. To test out the different kinds of lines and strokes you can make with charcoal, find a subject that has a lot of texture and detail, such as a densely wooded landscape. Get yourself several charcoal pencils — hard, medium, and soft. The artist starts this demonstration by drawing the contours of the tree trunks with the sharpened point of a hard charcoal pencil. He defines the path through the woods with a few wavy lines, but he makes no attempt to draw the contours of the leafy masses, which are so scattered that they have no distinct shape. Later on he'll draw the clusters of leaves with clusters of strokes.

Step 2. Because he wants to create a sense of distance between the dark shapes of the trees in the foreground and the pale, distant trees, the artist begins with the remote tone of the evergreens that appear far off, seen through the opening in the forest. Resting the side of the lead lightly on the paper — which is just ordinary drawing paper — the artist moves the hard charcoal pencil from side to side with an erratic, scribbling motion. The forms of the trees are gradually built up by laying one light stroke over another. The artist presses harder on the pencil when he draws the darker trees on the left.

Step 3. Still working with the hard charcoal pencil, the artist begins to work on the tree trunks that are just beyond the big trees in the foreground. Pressing somewhat harder on the pencil, he builds the tone of a darker tree and branches with clusters of parallel strokes. He lets the strokes show to suggest the bark. On the left, he draws paler, more distant trunks and branches in the same way. To the right of the gap in the forest, he suggests shadowy tones and the pale silhouettes of tree trunks with groups of slanted strokes. Toward the top of the picture, the artist begins to suggest sparse foliage with scattered groups of small, scribbly strokes.

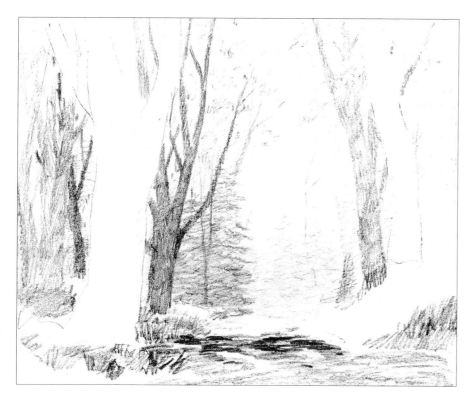

Step 4. On either side of the picture, the artist adds slightly darker trunks with clusters of strokes, still using the hard pencil. Now he moves into the foreground, covering the woodland path with groups of horizontal strokes, and leaving gaps of bare paper to suggest sunlight on the path. He suggests a shadow across the path by pressing harder on the pencil. Clusters of scribbly, slanted strokes indicate the undergrowth. The direction of the strokes varies with the subject: horizontal strokes for the ground; vertical ones for the tree trunks; and slanted strokes, leaning in various directions, for the grasses and weeds.

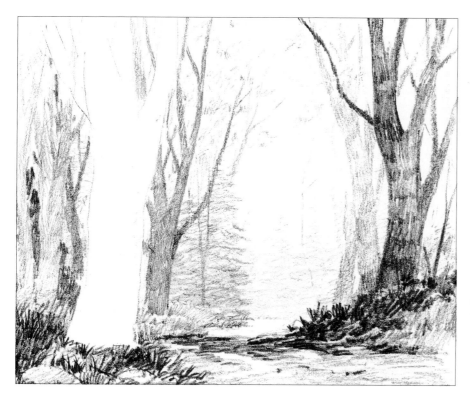

Step 5. To add darker tones to the foreground, the artist reaches for the medium charcoal pencil. He builds up the clumps of grasses and weeds with groups of spiky, irregular strokes that point erratically in various directions, as the subject does. At the left, he adds touches of dark shadow among the trees. And then he introduces a big, darker trunk and branches at the extreme right, again working with overlapping groups of parallel strokes that suggest the texture of the bark. Around the dark tree, he adds some slender strokes for smaller, younger trees. The grassy strokes beneath the tree are darkened to suggest its shadow.

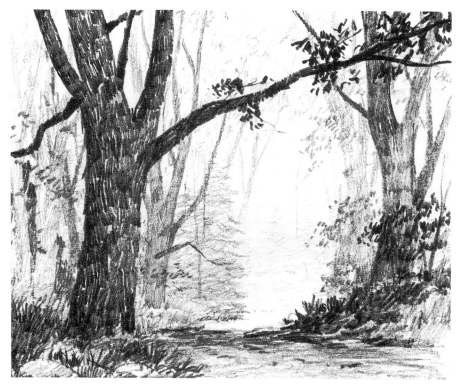

Step 6. The artist uses the flattened tip of the medium pencil to draw the rough, dark shape of the big tree at the left. The clusters of strokes are large and distinct, so that the ragged texture of the bark is obvious. The artist piles stroke upon stroke to darken the branches that reach out from the main trunk — particularly the branch that arches across the center of the picture. Around the big branch, the artist dashes in small, dark strokes with the blunt tip of the pencil to create leaves. In the distance, the hard pencil is used in the same way to suggest paler clusters of leaves. The hard pencil is also employed to add slender trunks and branches in the distance.

PROJECT 17: SEE YOUR SUBJECT IN A DIFFERENT WAY

Subject. Having done your best to render the complex detail of this demonstration, now try another approach. Redraw the same subject. Or find another subject that seems, at first glance, to be filled with more detail than you can cope with: a dense pine forest perhaps, or a dry stream filled with stones and surrounded by boulders and fallen trees.

Materials and Tools. A sheet of rough paper — such as cold pressed watercolor paper — will help you to *simplify* and *suggest* detail without rendering the subject precisely. Work with three charcoal pencils or leads in holders: hard, medium, and soft. You can also add a stomp to your "palette" of drawing tools.

Technique. The rough paper won't let you draw with neat, precise strokes, so you're forced to *simplify*. Because your strokes are roughened and broadened by the texture of the sheet, you can make only a few lines and strokes to *suggest* your subject. Knowing that you have to do the job with a minimum of strokes, you have to visualize each shape very simply, draw that shape broadly, and add just a few touches of detail. It's like painting on a small, rough canvas with big brushes. You have to make each stroke count.

Tips. You may find it helpful to block in a few broad areas of tone, spray the drawing with fixative, let it dry, work on it some more, fix it again, and so on. Try to work in *four stages*: preliminary line drawing, broad areas of tone, broad strokes, and details.

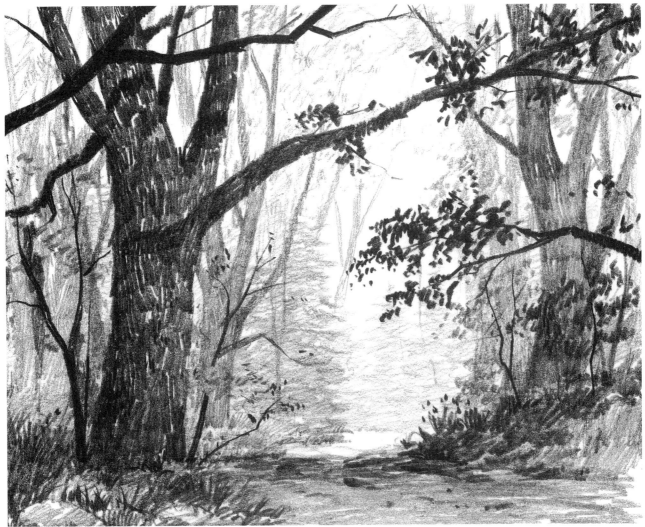

Step 7. The artist uses the medium pencil to darken the trunks, branches, and foliage of the distant trees, adding small, scattered strokes to suggest more foliage. The trunk and branches of the big tree on the right are darkened with vertical strokes. Strokes are added to the clumps of weeds and grasses on either side of the forest path, so now the growth seems dense and shadowy. Another layer of horizontal strokes is scribbled across the path itself to accentuate the contrast between the shadowy section of the path in the foreground and the sunlit patch in the distance. The deep, dark tone of the soft charcoal pencil is saved for the very end. Now the pencil is sharpened and brought in to add the rich blacks of additional trunks, branches, and foliage on both sides of the picture. Using the sharpened point of the medium charcoal pencil, the artist adds the more delicate lines of the twigs. Study the many different ways in which the charcoal pencil is used to render the varied textures, tones, and details of this complex drawing. And notice that all the subtle effects of light and atmosphere are created entirely with lines and strokes.

POND: DRAWING, BLENDING, AND ERASING

Step 1. Now look for a landscape subject that will give you an opportunity to combine slender lines, broad strokes, and smudged tones. For this demonstration, the artist chooses a pond that's surrounded by trees and rocks. This preliminary line drawing, made with a hard charcoal pencil, simply defines the group of tree trunks on the right, the rocky shorelines across the center of the picture, and the soft shapes of the trees on the far shore. The artist makes no attempt to draw the details of the light and shadow in the water, which he'll block in with broad tones in the next step.

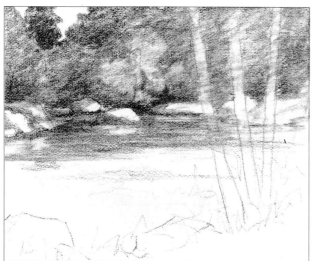

Step 2. The artist has chosen a rough sheet of paper. Its texture will suggest the details of foliage and also permit him to do a lot of blending. Working with the side of a medium charcoal pencil, he blocks in the tones of the mass of trees on the far shore, building stroke upon stroke to darken the shadow areas. He also blocks in the shadowy sides of the rocks. Then he begins to draw the dark reflections of the trees in the water, using long horizontal strokes. He blends all these tones lightly with a fingertip, but he doesn't rub hard enough to obliterate the strokes. He brightens the sunlit tops of the rocks with the kneaded rubber eraser.

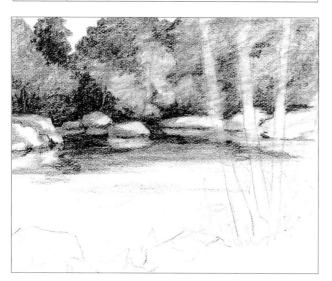

Step 3. Working with the medium charcoal pencil, he blocks in the darks among the distant trees — and their reflections in the water — with short, curving strokes that suggest the character of foliage. He doesn't blend these strokes, but allows them to stand out dark and distinct among the gray tones that appeared in Step 2. He uses the kneaded rubber to lighten some clusters of foliage and suggest patches of sunlight among the trees.

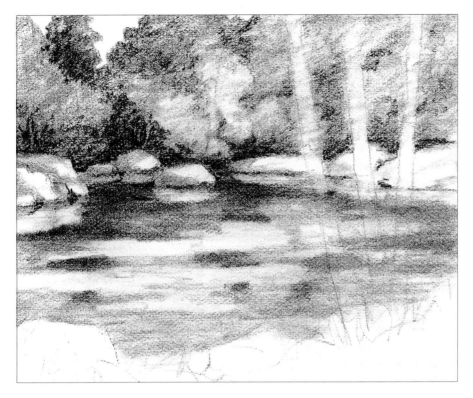

Step 4. Moving down across the water, the artist continues to block in the pattern of light and dark with horizontal strokes. Next, he moves his fingertip horizontally across the paper to turn the strokes into subtle, smoky tones. He carries patches of darkness down into the water, suggesting more reflections of the trees on the distant shore. And he wipes away streaks of sunlight on the water with a kneaded rubber eraser. Notice that the lines of the three tree trunks on the right are almost obliterated. But this is no problem because the trees will soon reappear.

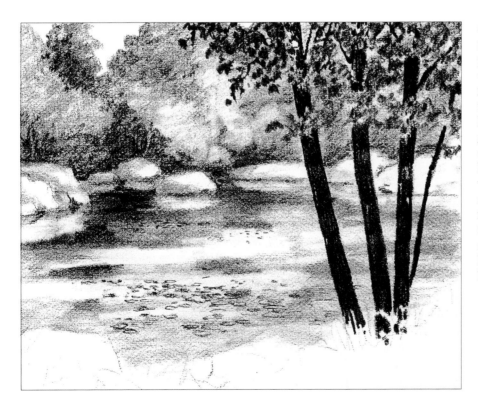

Step 5. The artist sharpens the medium pencil on the sandpaper block to draw the crisp, dark detail of the foreground. He fills the dark shapes of the three tree trunks with clusters of parallel strokes, leaving an occasional gap to suggest a flicker of light on the rough bark. The pencil has become blunt once again, which is perfect for making short, thick strokes that suggest foliage at the top of the dark trees. Delicate elliptical lines, made with touches of a sharp, hard pencil, suggest the floating lily pads.

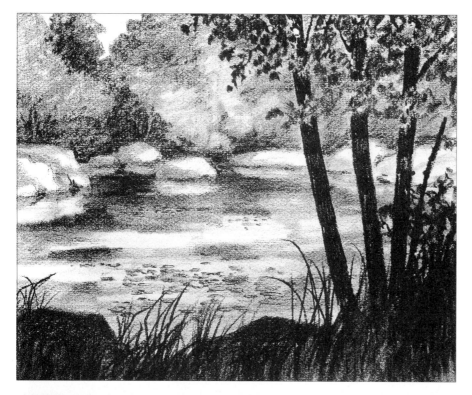

Step 6. The artist covers the ground with broad, rough strokes and blends them lightly with a fingertip. Now the rocks have a blocky, dark silhouette. Sharpening the point once again, he draws the graceful lines of the foreground weeds with arc-like movements of the pencil.

PROJECT 18: TRY A NIGHT SCENE

Subject. By now, you know that the kneaded rubber is more than an eraser — it's a drawing tool. To explore the full potential of this tool, go back through these drawing projects and redraw any one of them as a night scene.

Materials and Tools. You'll need a stick of natural charcoal and a full range of charcoal pencils: hard, medium, and soft. Your drawing surface ought to be a hard, textured sheet of charcoal paper or something even rougher, such as a sheet of cold pressed watercolor paper. Most important of all is a fresh, clean kneaded rubber eraser.

Technique. Before you start to draw, cover the entire sheet with scribbly strokes of natural charcoal. With a wad of cleansing tissue or a crumpled paper towel, spread the charcoal evenly over the entire sheet, which should now be covered with a kind of gray fog. Then use a hard, sharply pointed charcoal pencil to draw the main shapes in the picture. With the medium and soft pencils, block in the halftones and the shadows. Now use the kneaded rubber to lift out the lighted areas by removing the gray fog and uncovering the white paper. Finally, add textures and details with the charcoal pencils.

Tips. You can repeat these operations again and again — darkening areas, strengthening the halftones and the shadows, adding detail, lifting the lights — until you get it right. At some points, you may want to spray the unfinished drawing with fixative to "freeze" what you've done so far. Then you can go back and do some more work on the fixed surface.

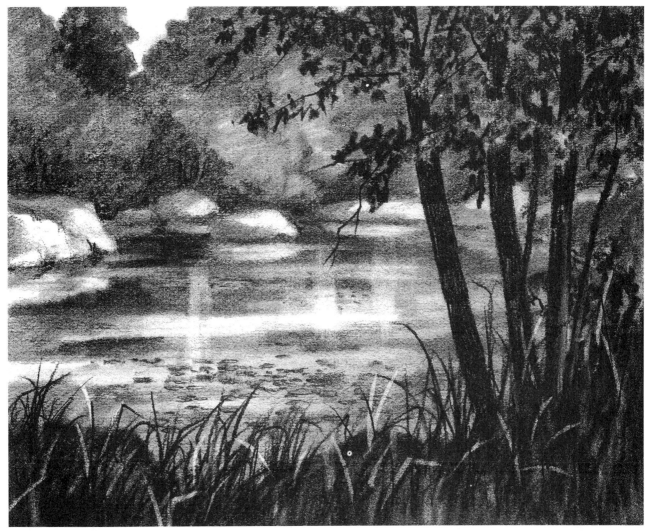

Step 7. Picking up a soft charcoal pencil, the artist moves it lightly over the mass of trees on the far shore and blends the strokes softly with a fingertip to darken the entire area. He then uses his charcoal-covered fingertip to darken the shadows on the rock and the shadowy patches in the water. (If he runs out of charcoal on his fingertip, he can easily blacken his finger again by pressing it against the blackened sandpaper pad.) He uses the tip of the medium charcoal pencil to add more foliage in the upper right with quick, scribbly strokes. With the sharp point of the pencil, he adds more twigs and branches, and then moves down to add more grasses and weeds to the foreground. To strengthen the contrast between light and shadow, the kneaded rubber eraser comes into play. It's squeezed to a sharp point to clean jagged patches of sky and the sunlit areas of the rocks. Then the eraser is moved very lightly across the water — horizontally and then vertically — to add splashes of light on the shadowy surface of the pond. The eraser creates a flash of sunlight on one tree trunk at the extreme right. Squeezing the eraser to a sharp point, the artist picks out some pale lines among the foreground grasses to suggest blades caught in sunlight. Throughout the drawing, the rough texture of the paper adds boldness to the strokes, suggests detail among the distant clumps of foliage, and adds vitality to all the blended tones.

DUNES: CREATING LUMINOUS LIGHTS AND DARKS

Step 1. For blended tones — with subtle gradations from deep blacks to misty grays — no medium compares with natural charcoal. To demonstrate the beauty of this simplest of all drawing mediums, the artist chooses the soft lights and shadows of dunes on a beach with a brooding sky overhead. Sharpening a stick of natural charcoal on a sandpaper pad, the artist draws the silhouettes of two big dunes, suggesting patches of beach grass at the top of each dune. He draws a horizontal line for the horizon of the sea in the distance.

Step 2. The blended tones of natural charcoal are particularly beautiful on rough paper, and so the artist has chosen a sheet with a distinct tooth. He blocks in the dark clouds with broad strokes and then blends these strokes with a fingertip, moving his finger across the paper with a wavy motion that suggests the movement of the clouds. He uses his charcoal-covered finger like a brush to add veils of pale gray over the lighter areas of the sky. The dark, inverted triangle of sea, glimpsed between the dunes, is drawn with firm, dark strokes and blended slightly with a quick touch of the finger.

Step 3. The big dune on the left is covered with a soft veil of tone. This is done by passing the side of the charcoal stick very lightly over the paper, applying practically no pressure on the stick, but simply letting it glide over the sheet and deposit the lightest possible strokes. Then the artist moves his finger gently over the paper, softly merging the pale strokes into a misty, continuous tone. The strokes disappear altogether and become a delicate, transparent shadow. To suggest pale shadows on the sandy foreground, the artist touches the paper lightly with his charcoal-covered fingertip.

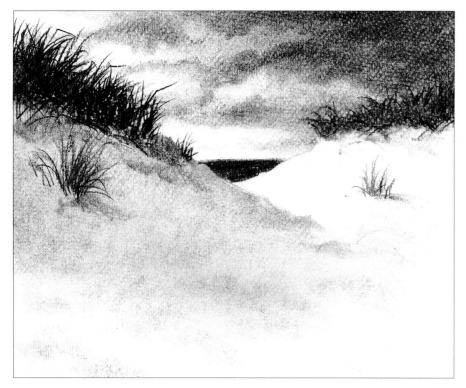

Step 4. Leaving the smaller, more distant dune untouched by the charcoal, the artist allows the bare paper to suggest brilliant sunlight on the sand. Now he scribbles a dark tone at the top of each dune and blends it with his finger to make a smoky blur. Over this blur, he draws dark strokes of beach grass with the sharpened tip of the charcoal stick. Notice that some of the grassy lines curve, while others are spiky diagonals. The artist changes the direction of his strokes for variety. He draws smaller clusters of beach grass on the sides of the dunes in the same way. A single sweep of a blackened fingertip suggests shadows at the bases of the clumps of beach grass.

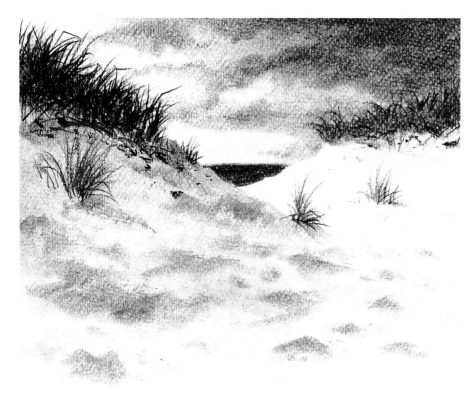

Step 5. Quick, spontaneous touches of the sharpened charcoal stick suggest smaller plants and bits of debris below the clumps of beach grass. Another cluster of beach grass is added at the center of the picture and then slightly blurred with a touch of the fingertip, which creates a shadow. The artist presses his finger against the blackened sandpaper pad to pick up more tone. His finger spreads blobs of tone across the foreground to indicate shadowy curves and irregularities in the beach. Between the dark strokes made by his fingertip, the artist brightens patches of sand with the eraser, suggesting splashes of sunlight.

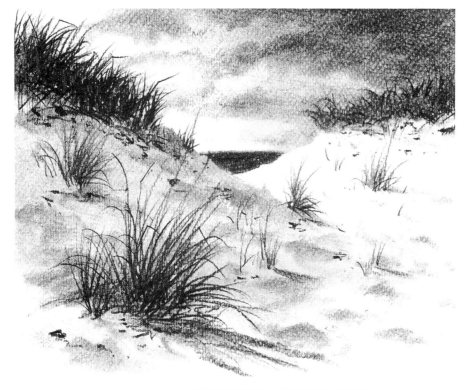

Step 6. Again sharpening the charcoal stick on the sandpaper pad, the artist adds a big clump of beach grass in the foreground. Then turning the stick on its side, he draws long shadows slanting downward toward the right. He leaves these shadow strokes unblended. Now he moves the charcoal stick across the beach, adding blades of beach grass here and there, plus touches to suggest the usual shoreline debris. Except for the shadows cast by the beach grass, the dune at the right remains bare white paper. Surrounded by so much tone, this patch of white paper radiates sunlight.

PROJECT 19: USING WHITE CHALK

Subject. For your final project, you're going to try another way of creating luminous lights. Your subject can be similar to the dunes in this demonstration. Or you might like to try mountains with bright, sunlit patches of snow on the dark slopes. You may also want to do a moonlit night scene — what Whistler called a "nocturne" — like the one you did in Project 18.

Materials and Tools. You'll need the usual charcoal pencils or leads in holders: hard, medium, and soft. But now choose a *gray* sheet of charcoal paper. (You've probably seen colored charcoal papers in the art supply store.) And add a stick of white hard pastel or white Conté crayon to your "palette."

Technique. By now, the steps should be familiar. Make a preliminary line drawing of the main shapes. Block in the halftones and shadows. Do some blending if you like. But then — instead of lifting lights out of the gray fog — draw the lighted areas with the white chalk. Use the sharp corner of the rectangular stick for the smaller touches of light, and use the flat end or the side of the stick for the bigger areas of light.

Tips. You can blend the white chalk with your fingertip. But don't overdo it and turn the white strokes into pale, formless smoke. It's better to let the strokes show. Yes, you can erase the white chalk with the kneaded rubber if the area looks too light — but don't forget to just press and lift, not scrub.

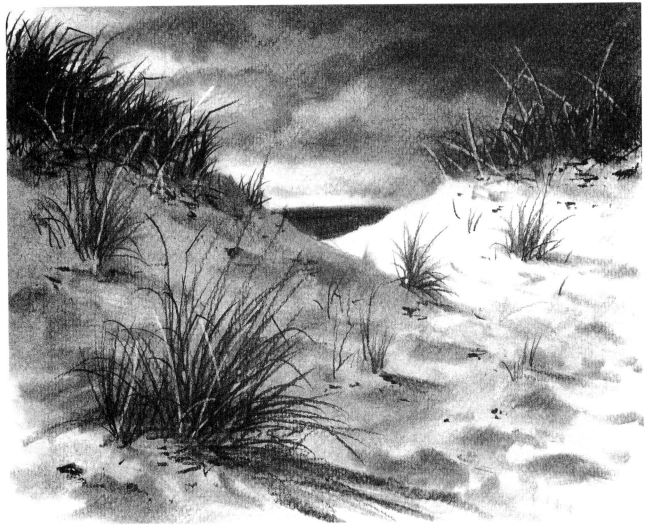

Step 7. To strengthen the darks of the sky, the artist picks up more charcoal dust on his fingertip and softly blends this into the clouds. Working very carefully, he performs the same delicate operation on some of the shadowy areas of the big dune on the left. He adds a few more touches of shadow to the foreground with his finger. To indicate that some of the stalks of beach grass are caught in the bright sunlight, he squeezes the kneaded rubber eraser to a sharp point and picks out slender lines among the clusters of darker strokes. Working carefully with the tip of his little finger, the artist blends the dark, inverted triangle of the sea to make it look smoother and darker; now it contrasts even more dramatically with the sunlit edge of the dune at the right. He takes a final tour around the drawing with the kneaded rubber, looking for areas of bare paper that have accidentally accumulated a hint of gray from the side of his hand. It's easy to lift tones from the hard surface of the rough paper, so the artist brightens not only the sunlit areas of the dunes, but also the strip of sky just above the dark sea. The finished drawing is a dramatic example of the versatility of natural charcoal, which can create everything from soft, smoky tones to crisp, expressive lines.

INDEX

More Great Books for Artists!

Sketching and Drawing—You'll find great advice for beginning artists on how to draw believable trees, fruit, flowers, skies, water and more. Simple step-by-step directions and demonstrations show you how to put it all together into a finished product. Also included are easy and useful tips for blending, shading, perspective and other techniques to help you create realistic drawings. *#30719/$18.99/128 pages/121 illus./paperback*

1996 Artist's & Graphic Designer's Market—This marketing tool for fine artists and graphic designers includes listings of 2,500 buyers across the country and helpful advice on selling and showing your work from top art and design professionals. *#10434/$23.99/720 pages*

Basic Portrait Techniques—Roberta Carter Clark, Jan Kunz, Claudia Nice, Charles Sovek and six other noted artists show you how to capture the essence of your subject while creating realistic portraits in all mediums. *#30565/$16.99/128 pages/150 + color illus./paperback*

Basic Figure Drawing Techniques—Discover how to capture the grace, strength and emotion of the human form. From choosing the best materials to working with models, five outstanding artists share their secrets for success in this popular art form. *#30564/$16.99/128 pages/405 b&w illus./paperback*

Basic Still Life Techniques—Following the instructions and advice of 20 esteemed artists, you'll discover the secrets of form, value, lighting and composition that are essential to creating fine still lifes. *#30618/$16.99/128 pages/250 color illus./paperback*

Basic Drawing Techniques—Seven outstanding artists, including Bert Dodson, Charles Sovek and Frank Webb, share their drawing techniques and teach you how to use popular drawing mediums. *#30332/$16.95/128 pages/128 illus./paperback*

Basic Watercolor Techniques—Discover how to take advantage of watercolor's special properties as seven noted watercolorists show you how to master the use of color, design and technique in this wonderful medium. *#30331/$16.99/128 pages/150 color illus./paperback*

Basic Oil Painting Techniques—Learn how to give your artwork the incredible radiance and depth of color that oil painting offers. Here, six outstanding artists share their techniques for using this versatile medium. *#30477/$16.99/128 pages/150 + color illus./paperback*

The Complete Book of Caricature—Extensive samples from top professionals combine with step-by-step lessons and exercises to make this the definitive book on caricature.

#30283/$18.99/144 pages/300 b&w illus.

How to Draw and Sell Cartoons—Discover the secrets to creating all types of cartoons, including political! *#07666/$19.95/144 pages/74 color, 300 + b&w illus.*

Keys to Drawing—Proven drawing techniques even for those of you who doubt your ability to draw. Includes exercises, chapter reviews and expressive illustrations. *#30220/$21.95/224 pages/593 b&w illus./paperback*

Perspective Without Pain—A hands-on guide featuring simple language and exercises to help you conquer your fears about perspective in drawing. *#30386/$19.99/144 pages/185 color illus./paperback*

The Pencil—Paul Calle begins with a history of the pencil and discussion of materials, then demonstrates trial renderings, various strokes, making corrections and drawing the head, hands and figure. *#08183/$21.99/160 pages/200 b&w illus./paperback*

The Complete Colored Pencil Book—Bernard Poulin's comprehensive book offers everything from how to buy the right tools, to how to draw rich landscapes and create textures, to how to outfit a portable studio. *#30363/$27.99/144 pages/185 color illus.*

The Very Best of Children's Book Illustration—Spark your creativity with nearly 200 reproductions of the best in contemporary children's book illustration. *#30513/$29.95/144 pages/198 color illus.*

Drawing Nature—Discover how to capture the many faces and moods of nature in expressive sketches and drawings. In addition to learning specific pencil and charcoal techniques—such as circular shading, angular buildup, cross-hatching and blending, you'll learn how to work with different materials and surfaces and how to render the most common elements of outdoor scenes. *#30656/$24.99/144 pages/237 b&w illus.*

Drawing: You Can Do It!—No talent required! Here over 100 fun and easy projects will help anyone learn to draw, or to expand his drawing skills. *#30416/$24.95/144 pages/200 + b&w illus.*

The Colored Pencil Pocket Palette—This handy guide packed with color mixes ensures you'll pick the right colors—every time! *#30563/$16.95/64 pages/spiral bound with spine*

Setting the Right Price for Your Design & Illustration—Too high prices will drive clients away and too low prices will cheat you out of income. Easy-to-use worksheets show you how to set the right hourly rate plus how to price a variety of assignments. *#30615/$24.99/160 pages/2-color throughout/paperback*

The Best of Colored Pencil—This definitive collection is much more than an introduction to colored pencils—it shows what outstanding effects can be created with this simple and versatile medium. *#30503/$24.95/160 pages/300 + color illus.*

How to Draw Lifelike Portraits from Photographs—Using blended-pencil drawing techniques, you'll learn to create beautiful portraits that only look as though they were hard to draw. *#30675/$24.99/144 pages/135 b&w illus.*

Sketching Your Favorite Subjects in Pen & Ink—The first complete guide—for all types and levels of artists—on sketching form life in pen and ink. Written by Claudia Nice, a master of the subject, this book is presented in easy-to-follow step-by-step fashion. *#30473/$22.95/144 pages/175 b&w illus.*

The Figure—Through step-by-step illustrations and instructions, Walt Reed shows you how to simplify the complex figure into a variety of basic shapes. *#07571/$18.99/144 pages/160 b&w illus./paperback*